AUBREY BEARDSLEY

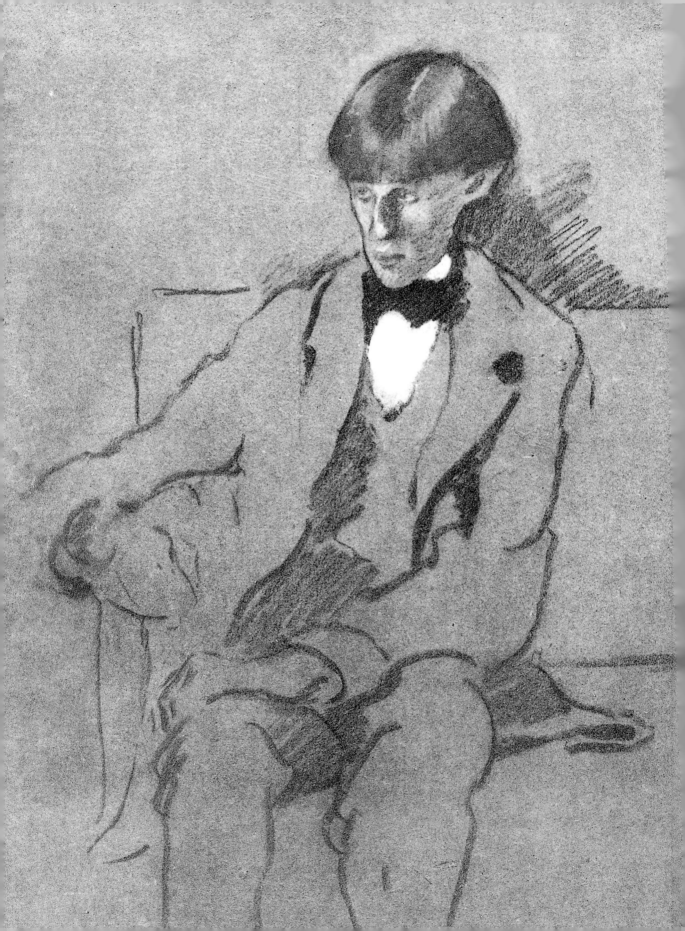

AUBREY BEARDSLEY

Stephen Calloway

HARRY N. ABRAMS, INC., PUBLISHERS

Library of Congress Cataloging-in-Publication Data

Calloway, Stephen.
 Aubrey Beardsley / Stephen Calloway.
 p. cm.
 Includes bibliographical references and index.
 ISBN 0-8109-4009-4 (clothbound)
 1. Beardsley, Aubrey, 1872-1898--Criticism and interpretation.
 2. Erotic drawing--England. I. Beardsley, Aubrey, 1872-1898.
 II. Title.
 NC242.B3C36 1998
 741'.092--dc21 97-27611

Designed by Gillian Greenwood

Photography by Richard Davis, V&A Photographic Studio

First published in 1998 by V&A Publications, London

Copyright © 1998 The Board of Trustees of the Victoria and Albert Museum

Published in 1998 by Harry N. Abrams, Incorporated, New York

Printed in Hong Kong

 Harry N. Abrams, Inc.
100 Fifth Avenue
New York, N.Y. 10011
www.abramsbooks.com

Works illustrated are by Aubrey Beardsley unless otherwise stated

Every effort has been made to seek permission to reproduce those images not belonging to the V&A, and we are grateful to the individuals and institutions who have assisted in this task. Any omissions are entirely unintentional, and details should be addressed to the publishers.

FRONTISPIECE: William Rothenstein, *Aubrey Beardsley*, 1893

To Lawrence Mynott
in celebration of thirty years of friendship
and shared fascination with the art of Aubrey Beardsley

A sinful love of peacocks' feathers, Louis XIV wigs, untied shoes,
candle flames and their obscene tricklings of wax, powder puffs
saturated with rice powder, black velvet masks and vine leaves
acting as masks lower down the body. . .
Comte Robert de Montesquiou-Fezensac
on *The Art of Aubrey Beardsley*, 1900
(*Assemblé de Notables*, Paris 1909)

AUTHOR'S ACKNOWLEDGEMENTS

More than thirty years ago three key figures originally awakened my interest in Aubrey Beardsley. It was my father, Tom Calloway who first showed me Beardsley's illustrations; William Bland, my school art master gave me a copy of Robert Ross's little 1909 volume on the artist; and the painter Derek Mynott gave me an exquisite proof print from the artist's own collection of his work, which still hangs in its frame beside me as I write. It is a sadness that none of these three begetters of this book lived to see the fruits of their inspiration and encouragement.

In the long intervening period so many people have shared their enthusiasm with me and offered illuminating observations, supplied references or guided me towards information and helped in the pursuit of Beardsley rarities, that I fear I shall never be able to remember everyone to thank them; but to all I owe a great debt. However, over many years the following have, each in their particular way, been memorably generous with their help or expertise: Lynn Blatchford, the late Andrew Block, David Colvin, Paul Delaney, Frank Dickinson, Anne and Anthony d'Offay, the late Siegried von Frieblisch, Christopher Gibbs, David Gould, Mark Haworth-Booth, John Hart, Simon Houfe, Chris James, Ian Jones, the late Stephen Jones, the late Ian Kenyur-Hodgkins, Miss E.King, Susan Lambert, Lionel Lambourne, Alexia Lazou, Antony Little, the late Clifford Maggs, Edward Maggs, Barry Marks, Lawrence Mynott, Peter Nahum, Susan Owens, Michael Parkin, Ronald Parkinson, Julia Rosenthal, Max Rutherston, Mark Samuels Lasner, Martin Steenson, Eric Stevens, Matthew Sturgis, Mr and Mrs Anthony Walker, Linda Zatlin, and last, but not least, my wife Oriel Harwood.

Mary Butler, Geoff Barlow and Miranda Harrison of V&A Publications gave their vital support in the creation of this book; Celia Jones was a sympathetic editor, and, with a neat touch of symmetry, Gillian Greenwood, who laid out Brian Reade's seminal 1967 volume on Beardsley, returned to the subject thirty years on to arrange these pages with elegance. Suzanne Fagence and Howard Batho of the V&A Exhibitions Department went far beyond the call of their respective duties to help at every stage of the book. Colleagues in many parts of the Museum, in particular in the Print Room, but also in Conservation and in the National Art Library, have been, as ever, remarkably helpful. I would like to thank, too, the staffs of the British Library and of the London Library for unfailing courtesy and kindness.

Finally I would like to thank the proprietors and staff of those most under-rated repositories of miscellaneous knowledge and centres of arcane research, the second-hand bookshops of London.

S.C.
Walworth, June 1997

CONTENTS

Chapter one
AUBREY BEARDSLEY AND THE 1890s SCENE

Frederick Evans (1853–1943), *Aubrey Beardsley*, summer 1894.
Photograph. V&A 29x.1972

Evans, the bookseller who befriended and helped the young Beardsley, was also
a talented amateur photographer. Beardsley affected the pose of the Notre
Dame gargoyle Le Stryge for this portrait, probably taken at the artist's
Cambridge Street house; the most celebrated image of the artist, it was
subsequently used as the frontispiece for *The Later Work of Aubrey Beardsley* (1901).
Evans had exhibited a print with a surround reproducing a Beardsley border
design from *Le Morte Darthur* at the Photographic Salon of the Linked Ring in
October 1894.

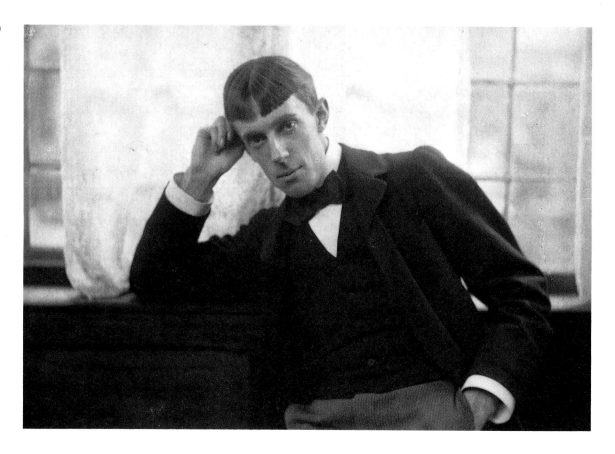

Frederick Hollyer (1837–1933),
Aubrey Beardsley, c.1894. Photograph.
V&A 7745-1938

Hollyer made a successful career as
a photographer of works of art,
specialising in the paintings of
Rossetti and Burne Jones. For his
own pleasure he made three albums
of superbly incisive portraits of the
writers and artists of the period.

It is given to very few artists to stamp their personality so distinctly upon
their era as did Aubrey Beardsley in the short and hectic years of his preco-
cious maturity in the 1890s. Even before his death at the age of just twenty-
five, people had began to speak of the 'Beardsley Period'; today we find the
quintessence of *fin-de-siècle* sensibility, with its unparalleled flowering of
subtle symbolism, its eroticism, its sensuous ornamentalism and, not least, its
precious, self-consciously perverse and decadent aestheticism, mirrored pre-
cisely in his exquisite black-and-white drawings.

Beardsley first came to public notice and instant notoriety in 1893, when
a highly enthusiastic article about his work appeared in the first number of
the new art magazine, *The Studio*. From that moment his life, and the extra-
ordinary career which both delighted and outraged those around him,
spanned a mere five years until his tragic premature death from consump-
tion, at the very height of his powers, exactly one hundred years ago in 1898.

In that short time he made hundreds of drawings to illustrate celebrated
texts, such as Oscar Wilde's banned masterpiece *Salomé* and his own brilliant,
bizarre, unfinished erotic tale *Under the Hill*, and many more ephemeral books
of the day, which, but for his decorations would now be utterly forgotten. In
addition, Beardsley created the scandalous imagery of, and was in a more
general sense the driving force behind the pictorial side of the two great
'decadent' periodicals of the period, *The Yellow Book* and *The Savoy*. Moving

Elliot and Fry, *Oscar Wilde*, c.1894. Cabinet portrait photograph. V&A 889-1956

By the beginning of the nineties Wilde had quite abandoned the long hair and sartorial excesses of his Aesthetic phase in favour of a highly fashionable, if notably opulent convention. Henceforth his extravagances would be confined to lavish rings and ostentatiously well-made buttonholes – 'the only connection between Art and Nature'.

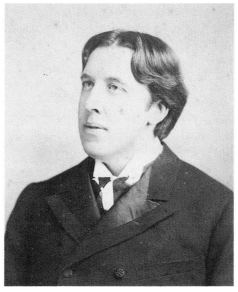

Max Beerbohm (1872–1956), Caricature of Aubrey Beardsley, c.1894. Pen, ink and wash. Reproduced courtesy of Mrs Eva Reichmann. V&A E.1379-1931

Beerbohm drew Beardsley no fewer than nine times. He claimed to prefer drawing caricatures to writing: 'How I rejoice in them,' he wrote to his future wife Florence, 'they are what I was put into the world to do.'

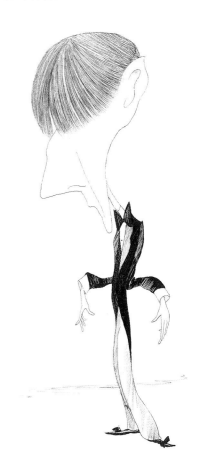

amid the most intriguing artists, writers and publishers of the nineties, Beardsley designed or embellished a number of the most significant books of his period; the beautiful, highly wrought original editions of these volumes, for the most part published in strictly limited editions, are among the most numinous artefacts of their era and the rarest and most desired of collector's items.

Just as the singular nature of Beardsley's genius as a draughtsman was quickly realised, so too was the recognition of his status as a key figure in the creation of a new sensibility in English and, indeed, European art remarkably rapid. For Julius Meier-Graefe, the great German Aesthete and critic, Aubrey was the most startling figure of what he termed, with just a slight Nietzschean echo, the generation of 'Superboys' of the 1890s; writing of Beardsley in his vast study *Modern Art*, he observed that 'of a hundred important artists born within so many years, a certain number are indispensable . . . because they affect their age and because they are symbolical of ourselves. To have seen every one of [Beardsley's] fragments is a more urgent necessity than to know a single picture by Burne Jones or Watts.'

The critical reception of Beardsley's work was always in black and white. He lived all his short career in the heady atmosphere of continually alternating, but always totally exaggerated praise or blame. He revelled in the attention of the Press and the public, and delighted, as Arthur Symons observed, when he succeeded in his constant aim to '*épater les bourgeoises*'. But in judging Beardsley's contemporary reputation it is important to remember how unlike other artists' careers was the path he chose for himself, and, in spite of his celebrity, how little the bourgeois public really knew of his work and intentions.

His work was for books, many of which were issued in editions of five hundred or less. Even at the height of his notoriety, the circulation of the *Yellow Book* was numbered in a few thousands. In his lifetime he exhibited

William Nicholson (1872–1949), *Queen Victoria*, 1899. Woodcut with lithographic colouring, as issued in *Twelve Portraits*. V&A E.1210-1899

Nicholson's woodcut of the old queen, characterised as 'an animated tea-cosy', epitomised the new irreverence and iconoclasm of the younger generation of writers and artists of the nineties. Originally commissioned by Heinemann at the instigation of Whistler at the time of the Diamond Jubilee in 1897, the publisher had misgivings about the image; instead, W. E. Henley, the energetic editor of the *Saturday Review*, first issued it as a supplement, before Nicholson reworked the subject for his portfolio of portraits.

William Nicholson (1872–1949), *James McNeill Whistler*, 1899. Woodcut with lithographic colouring. V&A E.1218-1899

The mercurial Whistler, 'butterfly, wasp and wit', was an obvious choice from among the 'sacred monsters' of the period for Nicholson's portfolio of *Twelve Portraits*, published by Heinemann in 1899.

hardly a single work in a public exhibition, and thus few but his immediate circle ever saw the originals of his drawings. Printed by the then still novel means of the photo line-block, most people who saw his work examined it on the printed page alone, his extraordinary images rendered starker by the mechanical means of reproduction. Many knew him only from the parodies of his work in *Punch*, and of his most shocking, explicitly erotic works, no more than a handful of people, the collectors of such specialised *curiosa*, had any real knowledge. For the wider audience, the novelty and surprise of his imagery was as much a matter of style as of content. It was his individuality which fascinated; the originality of his manner which shocked.

Passing rapidly from style to style, he was always totally original, always shocking. Like all artists he was open to other influences, and indeed often beguiled by their possibilities; but all that he borrowed he made inalienably his own. As Meier-Graefe observed, 'In one day he could be Baroque, Empire, Pre-Raphaelite or Japanese. Yet he was always Beardsley', or as John Rothenstein, the son of Beardsley's friend, the painter William Rothenstein, wrote, 'the greatest among Aubrey Beardsley's gifts was his power of assimilating every influence and yet retaining, nay constantly developing, his own peculiar individuality . . . He had in addition a passion for great fame which he knew he could only achieve by sensational means. . .'

Always, in everything Beardsley did, there was this desire to astonish. In the atmosphere of the 1890s, an era increasingly intrigued by sex, but harbouring a great fear of its power, and living in a state of mingled fascination with, and mortal dread of degeneracy and decline, it was clear that espousal of the new French *décadence* was a sure way for a young man to achieve not only a distinct artistic voice, but also, as Max Beerbohm said of Beardsley, 'to fill his few working years with the immediate echo of a great notoriety.' The public's reaction to Beardsley, as to Oscar Wilde, was in a sense all too

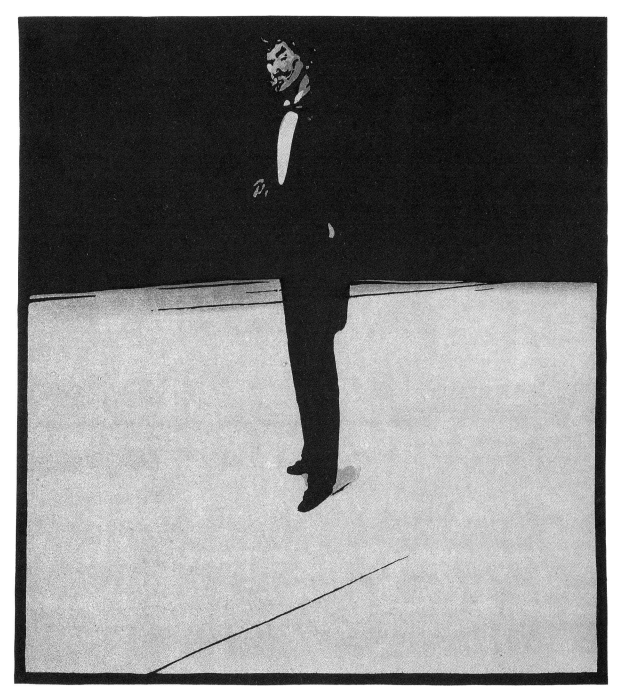

predictable. As Robert Ross, who was close to them both, put it, 'When an artist frankly deals with forbidden subjects . . . we fly for the fig-leaves'.

'At one time or another everyone has been brilliant about Beardsley' wrote Ross, himself one of the most brilliant of observers. He quoted D. S. MacColl as having said of Beardsley that, 'born Puck, he died Pierrot', and that famous line in which Roger Fry gnomically dubbed Aubrey 'the Fra Angelico of Satanism', an impressionistic phrase which the great Beardsley scholar Brian Reade rightly observed is highly evocative, but like many a poetic phrase in fact means nothing at all. Wilde's clever pen-portrait, in which he characterised Beardsley 'with his face like a silver hatchet, and grass-green hair', is often quoted. His more considered appraisal deserves to

William Rothenstein (1872–1945), *Max Beerbohm*, 1898. Lithograph. From the estate of Sir William Rothenstein. V&A E.2143-1920

Beerbohm, the subtlest humorist and most benevolent caricaturist of the day, modelled his carefully contrived manner upon that of the Regency leader of fashion Beau Brummell, of whose pose of wit and essentially understated dandyism he

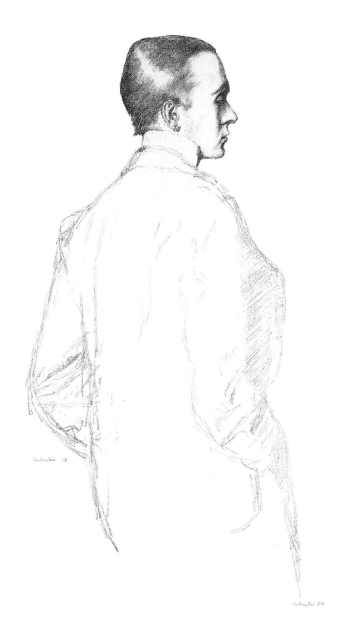

William Rothenstein (1872–1945),
Robert Ross, oil on canvas. Collection
of the late Sir John Rothenstein

Meeting Beardsley early in 1892,
Ross was one of the first to form a
significant collection of his
drawings. Ross, later Wilde's literary
executor, also remained an
extraordinarily kind and attentive
friend to the artist and his family. In
1909 he published one of the most
sympathetic accounts of Beardsley's
life and work.

be better known; hearing of 'poor Aubrey's death', Wilde wrote affectingly
to commiserate with Leonard Smithers, Beardsley's final publisher and per-
haps one of his truest friends: 'Superbly premature as the flowering of his
genius was, still he had immense development, and had not sounded his last
stop. There were great possibilities always in the cavern of his soul, and there
is something macabre and tragic in the fact that one who added another ter-
ror to life should have died at the age of a flower.'

As Wilde read it, 'his muse had moods of terrible laughter. Behind his
grotesques there seemed to lurk some curious philosophy.' Whether that
philosophy was essentially ironic or satirical, fantastic or simply mischie-
vous has always remained the great question. For Arthur Symons, the first to
write at length after Beardsley's death, the answer was clear, and Beardsley's

relationship with other key figures in the development of the modern sensibility easy enough to fix: 'Beardsley is the satirist of an age without convictions, and he can but paint hell as Baudelaire did, without pointing for contrast to any contemporary paradise.'

More recent writers have been anxious to find more complex patterns of thought in Beardsley's work, and much of the latest scholarship has placed what often seem to be specifically modern constructions on his original ideas and modes of expression when dealing with subjects such as costume, gender and sexual politics, satire or the representation of erotic scenes. Chris Snodgrass, for example, in his most recent study reverts to the question of irony: 'On one level' he writes,

Poster for Fisher Unwin, *'Girl and Bookshop'*, 1894. Colour lithograph. V&A E.1376-1931

Beardsley's sudden fame in 1894 led to several commissions for posters. This one for the publisher Fisher Unwin, actually depicts the bookshop of Lane and Mathews in Vigo Street. The design was later used as a book cover. In July 1894 Beardsley wrote a short, brilliant, part-facetious, part-serious essay on 'The Art of the Hoarding', suggesting that it was the quintessential modern art form, baffling to the old critics 'who can discover no brush-work to prate of'. The poster, he suggested, 'achieves publicity without a frame, and beauty without modelling'.

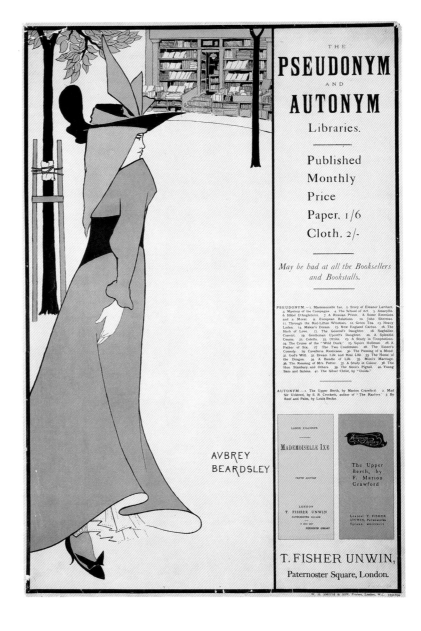

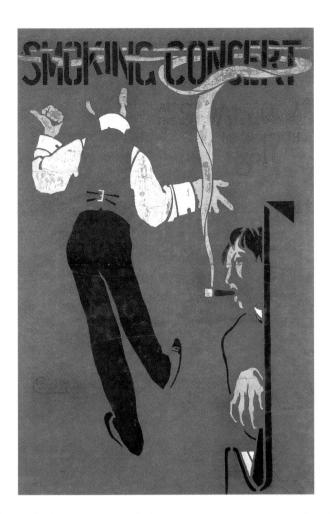

Beardsley's stylized irony recuperates the dislocations it reveals, serving to reinforce the anesthetizing effects of his harmonizing aesthetic techniques, adding another veneer of 'style' to distance and mitigate the dissonant metaphysical implications his works expose. On another level the metaphysical dissonance of that irony ever fractures the harmonizing elements of his style. Whichever voice seems dominant in the interpenetrating dialogical discourse of Beardsley's work, there is always the trace of that other oscillating feature of it, the 'obverse feature that gathers back ironic dissemination or scatters recuperative conservation, as the case may be. We recall that in any text the very act of demarcation (or writing, as Derridian grammatology puts it) involves an irremediable splitting or lack of equilibrium between what is set down and what it is possible for any reader to make of it. That is, there can never be a hermetically sealed 'voice' or universal 'Word'. Part of what Beardsley's art does is to accentuate this inescapable schism – in particular, turning the fetishistic fascination of Victorian bourgeois ideology against itself, ripping the culture's suturing, through a 'dis-placing' (and de-forming) deconstruction of its own conventions.

Illuminating as such an approach can be, I have in these pages generally preferred go back to the contemporary sources and to rely more closely upon the comments of writers who knew Beardsley personally, of those who

Burkan (fl.1895), Poster for a smoking concert at The Swallow, 1895. Lithograph (with stencilled colour?). V&A E.225-1938

This clever graphic *jeu d'esprit* – advertising a typical nineties, music-hall entertainment – by an otherwise unrecorded artist seems to epitomise those artistic virtues which Beardsley pronounced in his little article on the art of the poster.

William Rothenstein (1872–1945), *Charles Ricketts and Charles Shannon*, 1897. Lithograph. From the estate of Sir William Rothenstein.

Ricketts (below left) and his lifelong companion Shannon lived for a time in Whistler's house in the Vale, Chelsea, presiding over a fascinating circle of friends and a celebrated art collection. Beardsley went there occasionally, but he and Ricketts were ultimately rivals, competing for the favour of Wilde. Ricketts would later claimed that Beardsley's success had eclipsed his own efforts as an illustrator, and that this had directed him to other artistic endeavours.

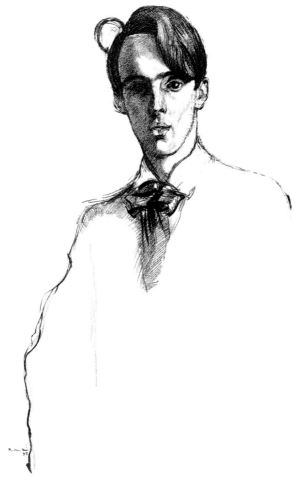

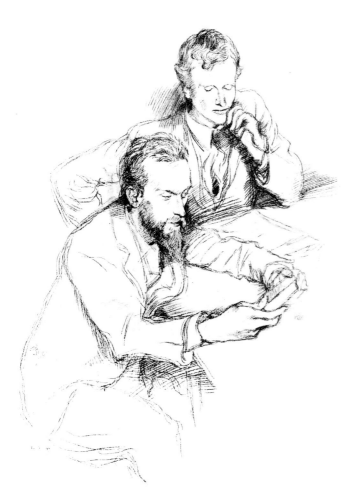

William Rothenstein (1872–1945), *W. B. Yeats*, 1898. Lithograph. From the estate of Sir William Rothenstein. V&A E.2146-1920

Yeats was the central figure of the 'Celtic Twilight', uniting the fashionable world of the London poets, such as Wilde, Ernest Dowson and Lionel Johnson, with the more mystic and decadent Symbolists and also with the Irish literary and nationalistic movements. He shared rooms with Arthur Symons, and was the prime mover of the Rhymers' Club; during 1896, the year of *The Savoy*, he became close to Beardsley. His memoirs of the 'Tragic Generation' form an essential basis of the nineties' mythology.

played a part in the brief life that is recounted here and who helped to shape the books and images that have come down to us from that extraordinary decade of intense artistic and literary activity. These observers viewed things from a point nearer in time and location to their subject; their milieu was his, and they walked the same few fashionable streets of London, Paris or Dieppe where this history is played out. It is the fate of those who die young to written about by the middle-aged, and of the creative to have their lives and works picked over by pedantic scholarship. So, quite deliberately, I have relied for this little study most of all upon Beardsley's own books and drawings, and upon what evidences of his art and his life he committed to paper in his letters. As a result, I have incurred a heavy debt, as must all who take an interest in Beardsley and his world, to the editors of those letters, Henry Maas, J. L. Duncan and the great collector, W. G. Good, and to the authors of the handful of truly indispensable works of reference about Beardsley: A. E. Gallatin, R. A. Walker, Brian Reade of the Victoria and Albert Museum, and, most recently, Mark Samuels Lasner.

The main facts of Beardsley's early existence can be easily and quickly rehearsed. Aubrey Vincent Beardsley was born in Brighton on 21 August 1872, in the same year as his friends the artists William Rothenstein and William Nicholson, and only days apart from that other quintessential figure of the nineties, Max Beerbohm. His only sister, Mabel, was almost exactly a year older, and the two, initially thrown very much together by circumstances, were from the first and always remained close and devoted. Their parents were not happy, or indeed always together. Aubrey's father, Vincent Beardsley, came from a background of industrious artisan jewellery-makers in Clerkenwell; he had inherited some property but none of the family abilities and motivation. Such property as he had was lost when, on his marriage, he was sued by another woman for breach of promise. Thereafter, he clung but tenuously to the rank and estate of gentleman, and had been obliged – from time to time – to seek intermittent periods of employment, mostly as a clerk in brewery firms in Brighton or London. He appears to have been a distant figure even when present, little inspiration to his children, and a source of constant disappointment to a wife who, forced to live in lodging houses and take employment as a governess or to give music lessons, considered herself justified in the idea that she had married beneath her.

Ellen Beardsley was the child of a well-to-do ex-Indian Army officer, Surgeon-Major Pitt, and had been accounted both bright and something of a beauty in her youth in Brighton. A notably slender figure, it was said she had been known, presumably behind her back, as 'the bottomless Pitt'. Her mother, it is recorded, had some talent as a maker of silhouettes in black and white, many of which hung in the Beardsley's rooms. Ellen was literary, an accomplished pianist and she managed to instil a genuine love of books and music in both her precocious children. She played to them every evening, a 'programme' of six pieces to improve their taste, and encouraged them to perform on the piano and to recite to such good effect, that as 'infant prodigies'

*Arthur Symons, c.*1907. Photograph. Princeton University Library

Symons was a poet of considerable skill and vitality; his 'modern', low-life subjects drawn from the music-halls and scenes of the streets, and his sexual frankness shocked the Victorian audience. He became the self-appointed 'Apostle' of French decadence and Symbolism in England. He brought Verlaine to lecture in London, and his wide literary sympathies shaped *The Savoy* magazine as the most avant-garde journal of its day.

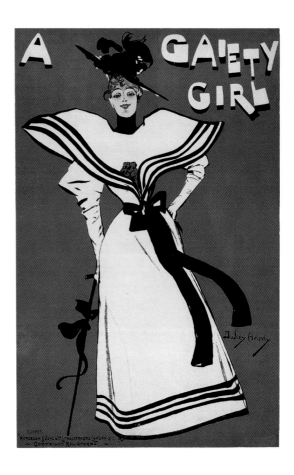

Dudley Hardy (1867–1922), Poster for *A Gaiety Girl*, 1894. Colour lithograph. V&A E.728-1959

Hardy, the only English poster artist to rival the exuberance of the French designers Chéret, Mucha and Toulouse-Lautrec, created three versions of his celebrated image. *A Gaiety Girl* was the first of Jimmy Davis's highly successful musicals on popular low-life themes staged at the Prince of Wales Theatre. The legendary stars of the piece, the Gaiety Girls, were much fêted, and several of the so-called 'Big Eight' attracted aristocratic admirers and eventually married well.

they were taken often to perform in the houses of her grander acquaintances. Music would remain one of Aubrey's greatest pleasures. He adored Chopin, and later in life developed a true passion for Wagner.

Throughout a long, and it must be said difficult and tragic life, Ellen Beardsley held tenaciously to three things: her respectability, her fierce pride in her clever children and the sense that she deserved better. It has been said that she was remarkably unshocked by her son and even the most *louche* of his friends, such as the scurrilous publisher Leonard Smithers; her objection to some, particularly Smithers, was based on her disapproval of the way she considered them to have treated Aubrey, rather than for any more conventional moralistic reason.

As a small child Aubrey drew with enthusiasm, though with no abnormal ability; he was, however, perhaps even more inclined to music than to drawing, and might well have followed that path had it not been for the fact that at the age of seven he was diagnosed as tubercular and sent away to an unmusical establishment, a small school at Hurstpierpoint in Sussex, to regain the strength of his weakened lungs. From there, in what would become the pattern of his later existence, he was moved to Epsom, which was thought to have a healthier climate. In 1883 employment took Vincent Beardsley to London, where Aubrey and Mabel gave drawing-room recitals,

earning some very welcome extra money. But in 1884 they were both sent for a year to live in the morgue-like house of their elderly Pitt great-aunt, a Miss Lamb, in Brighton. There they found their only solace in reading and in a new enthusiasm for religious life enlivened by picturesque High-Church ritual; they walked over a mile to a favourite Brighton church with Pre-Raphaelite stained glass, sometimes making the trip three times on a Sunday.

The next year, Aubrey was sent as a boarder to the boys' grammar school in Brighton, where he had the immense good fortune to attract the attention and ever-kindly help of A.W. King, his housemaster. King recognised the boy's talent for drawing and encouraged this and his deepening love of books by giving him free access to his own interesting library as well as the use of his sitting-room – that great privilege and luxury in a rowdy school environment, a quiet refuge in which to read or draw. Throughout his life Beardsley maintained his gratitude to King, who was among the first to realise his talents.

On leaving school at the end of 1888, at the age of a little over sixteen, Beardsley followed his family to London where they had rooms in Pimlico, the quarter of London which perhaps most reminded Ellen of the terraces of her Brighton home. Afterwards Aubrey would from time to time recall an odd aspect of Brighton's architecture in a drawing, or some other memory of that strange rococo-chinoiserie world: 'Weber's pianoforte pieces remind me', he once said, 'of the beautiful cut-glass chandeliers at the Brighton Pavilion.' But for the Beardsleys the raffish, Regency charm of Brighton was no more. On New Year's Day 1889 Aubrey started work. He began at first in the Clerkenwell District Suveyor's office as a stop-gap, until, later in the year, he secured a slightly better post at seventy pounds per annum in the Guardian Life and Fire Insurance Office in the City. His lot, it seemed for the moment, was to become an office clerk. Drawing would henceforth be an activity confined to his scant spare hours late in the evening.

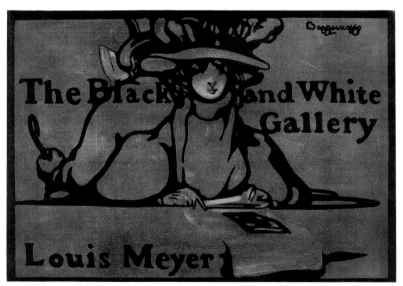

Beggarstaff Brothers, Poster for the Black and White Gallery, c.1896. Colour lithograph. V&A E.1027-1926

William Nicholson and his brother-in-law James Pryde (1866–1941) worked together as the Beggarstaff Brothers, achieving considerable recognition for their highly novel, stylised graphic designs for posters. This poster image reproduces their painted signboard for the Black and White Gallery, opened in the summer of 1897 by Louis Meyer at 153 Piccadilly, where collectors could buy original drawings by such artists as Phil May, Dudley Hardy, Cecil Aldin and, of course, Pryde and Nicholson themselves.

Chapter two
THE WELL-TRAVELLED PORTFOLIO

Self Portrait, 1892. From line-block. Private Collection

Beardsley drew this self portrait, which so curiously combines a tendency to self-glamorisation with a painfully sharp introspection, in 1892, at about the time he first met Robert Ross. He gave it to Ross, whose description of the artist's appearance seems to echo this haunting image.

With his characteristically light touch and half-facetious, half-serious tone, it was Max Beerbohm who first coined the phrase the 'Beardsley Period', and modestly declared that he himself belonged to it. Recognising an essential truth in a flippant, throwaway line, others took it up. A little later it was Bernard Muddiman, a creator and promoter of the myth of 'The Nineties', almost as influential in the development of the notion of a distinct *fin-de-siècle* culture as Holbrook Jackson or even W. B. Yeats, who first seriously proposed the idea that the whole period could properly be defined and accurately bounded by Aubrey Beardsley's five principal years of activity and fame. Prefiguring Osbert Burdett's more famous account of the phenomenon of the Beardsley Period by some five years, Muddiman, in his underrated little volume *The Men of the Nineties*, opened his argument with the key observation that, 'The day Beardsley left his stool and ledger in a London insurance office and betook himself seriously to. . .illustration. . .a new manifestation of English art blossomed'.

Whilst the various stages of Beardsley's career were telescoped into a remarkably short span, it is still nevertheless true that the decision to devote himself to an artistic career was not arrived at overnight. Prudently concealing any desires to become an artist from his mother and father, at first he discussed his plans only with his sister Mabel, for each was the other's confidante and ally.

For a young man in his position the leap was a momentous one to contemplate. At this date he was still very far from the highly cultivated dandy-aesthete of the nineties, still quite some way off even from realising the importance of perfecting the pose. But already he was surprisingly well-read and possessed of a noticeable intensity, which impressed all those who met him. Sophisticated beyond his years, certainly, and already quite distinctly a figure apart, driven by a curious inner compulsion, he perhaps resembled most the hero of one of H. G. Wells's tales of suburban clerks who dream of escaping from their confining little world of drudgery and finding a new and excitingly different milieu in the great city. Just like Wells's clever, middle-class lads, Beardsley was enthusiastic about everything he found in books, precocious in his tastes but largely self-educated in art and literature. He was excited by such vistas as he had glimpsed of a wider intellectual horizon than Brighton and respectably dowdy Pimlico could offer, but without connections and lacking the funds that would be needed to embark on a proper course of study, the possibility of a successful artistic career must have seemed at times very dim.

For a start there was the matter of training. In a period when those ardent souls who aspired to become 'serious' artists could expect to study for many years, and even those who hoped to succeed in the less rarefied worlds of wood engraving, book illustration and other branches of commercial art were often required to enter into long, formal studio apprenticeships, Beardsley had received, thus far, next to nothing in the way of proper art teaching. He and his school-friend G. F. Scotson-Clarke, who shared an interest in drawing, toyed with the idea of attempting to enrol at Hubert Herkomer's well-known private art school at Bushey, but nothing came of their rather half-hearted enthusiasm. Perhaps realistically Beardsley realised just how little prospect he had of escape from the need to bring home to Pimlico the modest weekly wage upon which his family were increasingly coming to rely.

His artistic efforts up until this time had been chiefly humorous: scratchy illustrations and caricatures, school-boy stuff intended for his own recreation or for the amusement of family, friends and fellow-pupils. The small sums which had come his way whilst still a child for some rather poor little Kate Greenaway-ish drawings sold as Christmas cards to an acquaintance of his mother's, and various menu cards and playbills for family entertainments hardly constituted any real promise of success. And now he had even less opportunity to draw. He could only indulge his desire to do so by setting up his things after nine o'clock in the evening and sitting up late into the night working in a small pool of candle-light in the darkened room; though

Scene from *The Double Dealer*, by William Congreve, 1888.
Pen and ink and wash. Simon Houfe, Esq.

This recently discovered and previously unpublished drawing is
dated 30 June 1888, and was made for presentation to
Beardsley's form master at Brighton Grammar School, H. A.
Payne. Beardsley enthusiastically collected and read the *Mermaid
Dramatists* series as they appeared, making drawings of scenes that
appealed to his imagination; the Congreve volume was first
reviewed in May 1888 and must have been acquired by Beardsley
immediately upon publication. He later gave his copy to William
Rothenstein, inscribing it 'from Aubrey Beardsley Admiringly'.

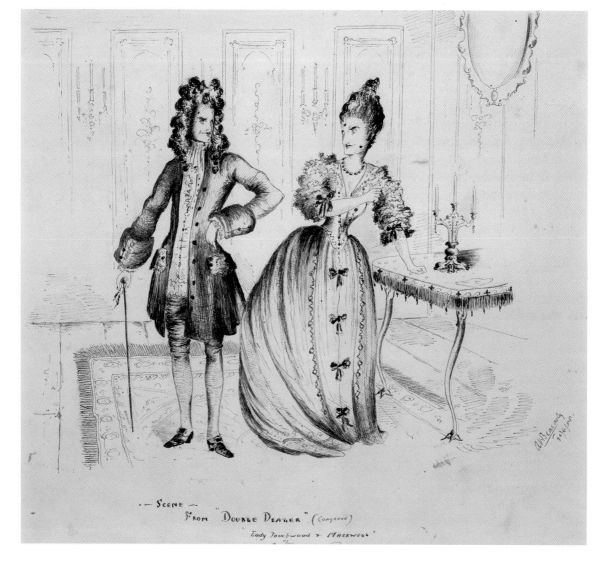

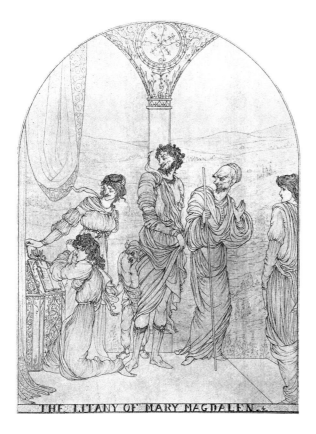

The Litany of Mary Magdalen, 1891.
From line-block.
National Art Library

Drawn shortly after his first visit to
Burne Jones, this complex drawing
reveals, in particular in the draperies
and postures, the extent to which
Beardsley was steeping himself in
the influence of Mantegna's prints.
Some of the types, in particular the
youthful figure on the right, are pure
Burne Jones, but other decorative
details perhaps also show the
influence of the work of the popular
early nineteenth-century German
illustrator Moritz Retzsch.

CIRCLE OPPOSITE
Adoramus Te, c.1889–90 From the
half-tone block in *Early Work*.
National Art Library

This, and a second, similar circular
design, *A Christmas Carol*, were
commissioned from Beardsley by
Father Alfred Gurney, who intended
to use them as Christmas cards.

initially tiring, this was the beginning of a pattern of work that would in
time become habitual with him.

Such drawings as he made were in the rather mongrel styles of the more
popular illustrators of the 1880s. Of those which he did in the year between
1889 and mid-1890, the best – and none of them is very good – were pre-
served by Ellen Beardsley in an album that she later gave to Robert Ross.
What is interesting about this group of twenty or so little line and wash illus-
trations is that almost all of them are figure subjects taken from literary
themes, and most from Restoration drama and French books ranging from
the plays of Molière and Racine and classic tales such as *Manon Lescaut* –
unlikely enthusiasms, it would seem, for a boy of seventeen – through to
the nineteenth-century novelists. All these texts he read with a keen critical
eye for detail, devouring them in the original; in a letter to his schoolmaster,
King, written in January 1890, Beardsley informed him, with only the slight-
est hint of showing off, 'I can read French now almost as easily as English'. In
particular at this stage he loved Balzac's encyclopaedic *Comédie humaine*, but
even as his tastes rapidly evolved throughout his short life, French literature
was always to remain of equal or even greater importance to him than any-
thing he read by English authors.

Then, at a crucial point, when he had been at full-time office work for
a while, Beardsley suffered the first serious return of haemorrhaging of the
lungs since his early childhood scares. With the threat of ill-health more
frighteningly revealed than ever before, he was forced to rest. For much of

this time he read feverishly, but for the best part of a year he ceased to draw at all.

With the return of something like better health in the early part of 1891 things began to look up. He had started to draw again with both renewed enthusiasm and growing facility and he began actively to explore a number of avenues that might advance his artistic career aspirations. He seems to have begun, too, at this moment consciously to assemble a portfolio of the drawings that he considered to be his best work, and in his letters began to refer to them by fixed titles, as though for the first time he considered each to be a distinct work of art. It is not known how or where he acquired his famous black, tooled marocco leather portfolio, but from this time on it became an almost essential adjunct of the young draughtsman's persona, carried everywhere with him, and proffered for inspection with a gradually growing confidence.

One or two extant designs from this period, such as *Francesca da Rimini*, *Dante in Exile* and *Annovale della Morte di Beatrice* show clearly in the choice of subject matter the influence of Rossetti in his later Aesthetic phase and of Simeon Solomon, whose dreamily sensual pencil and crayon drawings, so

Perseus and the Monstre, 1891. From half-tone block.
V&A, Gleeson White Collection, E. 432-1899

The rubbed pencil-work consciously imitates the softness of Burne Jones's style, whilst the actual figure almost parodies the older painter's predilection for attenuated and even effeminate male types. This drawing was bought from Beardsley by Aymer Vallance, who first reproduced it in his *Magazine of Art* obituary article in 1898.

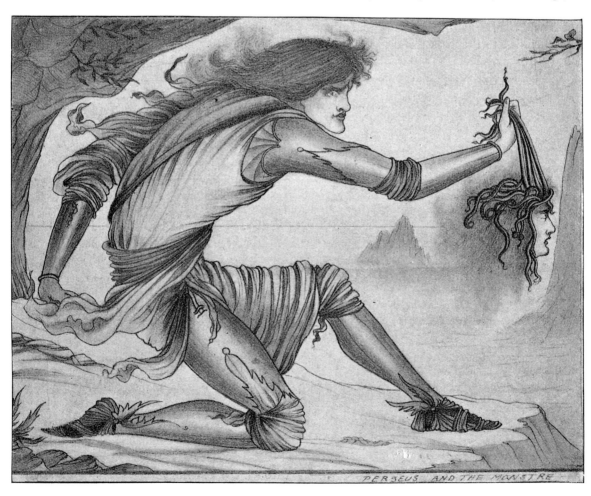

PERSEUS AND THE MONSTRE

avidly collected by Walter Pater and Oscar Wilde in the 1870s and 1880s, still remained something of a cult with the Aesthetes of the day. Other lost drawings of Beardsley's, known only from references in his letters to 'my latest productions', but bearing elaborate titles such as *Ladye Hero, Notre Dame de la Lune* and *Dante at the Court of Don Grande della Scala* and *Dante designing an Angel*, all proclaim a clear new allegiance to prevailing Aesthetic tastes in the selection of themes, and signal a major shift in Beardsley's drawing style towards the late Pre-Raphaelite ideal exemplified by Burne Jones.

Against this background, the steps that led Beardsley to throw up his job and to risk all, the speed and assurance with which he assimilated the variety of influences that came to bear on his artistic and intellectual ideals at this time, and the rapid technical and stylistic advances towards an entirely distinct and original manner of drawing that he made in only a few short months in 1891 and 1892 are all fascinating both in personal terms and for the light that they shed upon the nature of the artistic profession of the day. As Arthur Symons wrote in his much reprinted essay on Beardsley, echoing perhaps unconsciously but entirely appropriately the lapidary phrases of Pater's *Studies in the History of the Renaissance*, it was as though 'he had the fatal speed of those who are to die young; that disquieting completeness and extent of knowledge, that absorption of a lifetime in an hour, which we find in those who hasten to have done their work before noon, knowing that they will not see the evening'.

Equally intriguing is the phenomenal rapidity with which Beardsley found encouragement within a small, cliquey, artistic and bookish elite in London and then, so shortly after his first entrée into this glittering world, achieved such widespread recognition and notoriety for his idiosyncratic art with both the popular press and an often unsympathetic, but never less than curious public. Living in rooms in a lodging house in deeply unfashionable Charlwood Street in Pimlico and with the occasional invitation to tea or Sunday lunch from the kindly vicar of St Barnabas, Father Alfred Gurney, representing the pinnacle of his family's social aspirations, Beardsley's position looked anything but promising. But in his letters to Scotson-Clarke and those to A. W. King we can follow as the rapid sequence of events unfolds.

As it turned out, the family acquaintance with the Gurneys, which dated back to Brighton days, was to prove of considerable importance. Father Gurney was an intriguing character, a priest of a kind once common in the Anglican Church: well-educated and well-to-do, his faith combined the best elements of both muscular and aesthetic Christianity. Interested in church building and decoration as much as the care of souls, he took a serious and enlightened interest in the arts. He liked poetry and wrote a little, and in a modest way he collected art himself. At the vicarage Beardsley had the opportunity to look not only through photographs of celebrated Renaissance pictures, but also at some original drawings by Rossetti, bought by Gurney at the sale of the contents of the artist's house in 1882, and which Beardsley described enthusiastically as 'very capital . . . sketches'.

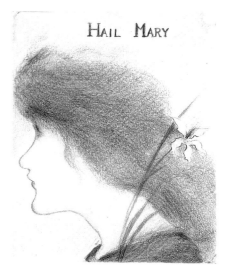

Hail Mary, 1891. Pencil. Princeton University Library

The rather feeble lost-profile of this head derives from Burne Jones. The drawing was given by Beardsley to Frederick Evans, and was among those that he showed to his publisher friend J. M. Dent, when the latter was seeking an illustrator for a projected edition of *Le Morte Darthur*.

By way of encouragement, Alfred Gurney from time to time gave books to Aubrey and Mabel, but also, more importantly still, he bought or commissioned a number of drawings from the young artist. Gurney was, according to Robert Ross, 'the earliest of his friends to realise that Beardsley possessed something more than cleverness or precocity'. He urged him to work in a manner which imitated Botticelli. Several early drawings once owned by Gurney are known; these include, in particular, two circular designs or *tondi* drawn as Christmas cards, *Adoramus Te* and *A Christmas Carol*, in which Beardsley dutifully shuffles the pack of Botticellian elements of lilies, angels with sweet profiles and musical instruments.

The sight of one or two real paintings by Botticelli, as well as others by (or rather *attributed to*) Giorgione, Memling, Luini and Leonardo, constituted one of the great excitements of Beardsley's life at this time, when he went with Mabel on a Sunday at the beginning of July 1891 to the house of the

Hamlet Patris Manem Sequitur, 1891. Lithographic facsimile of a drawing from *The Bee*, November 1891. Collection Anthony d'Offay.

Hamlet following the ghost of his father. *The Bee* was the journal of the Blackburn Technical Institute, run by Beardsley's old housemaster at Brighton, A. W. King. Redrawn on the stone by a professional lithographic artist, this exercise in the Burne Jones manner is, strictly, Beardsley's first 'published' design.

HAMLET PATRIS MANEM SEQUITUR.

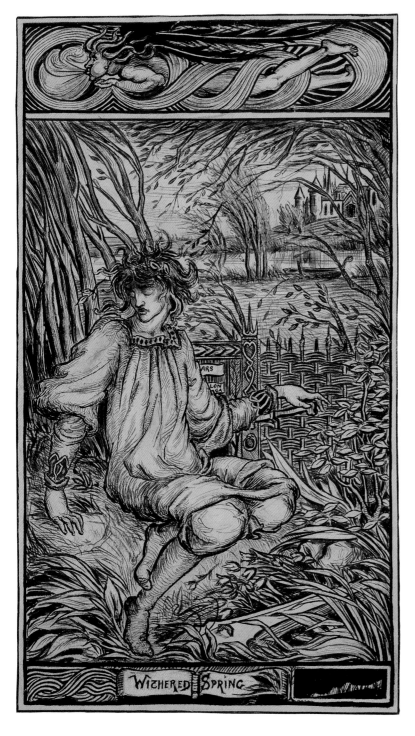

Withered Spring, c.1892. Pencil, ink
and wash. National Gallery of Art,
Washington, Rosenwald Collection.

This allegorical figure, and other
designs of this period, such as a
Perseus, play with the standard
Aesthetic format of compartments
for figures and title-panels perfected
by illustrators of the eighties such as
Walter Crane. The figure
personifying the *Vita Brevis* implied
by the inscription *Ars Longa* on the
gate seems highly influenced by the
vague and poetic allegorical figures of
Simeon Solomon, whose drawings
were so avidly collected by Walter
Pater, Oscar Wilde and others among
the Aesthetes (see illustration p.38).

millionaire collector Frederick Leyland, a modern Maecenas whose fortune
had been made in shipping and who, like other grandee aesthetes of the day,
generously allowed the public to view his collection at weekends out of the
Season. It was not, however, these Old Masters, impressive as they seemed,

Going thro' the rooms

Sketch of the artist and his sister visiting the Peacock Room at the house of Frederick Leyland, 1891. From *The Uncollected Work of Aubrey Beardsley*. National Art Library

Beardsley made this sketch and others of the art treasures collected by Leyland in two letters describing the expedition written in July 1891 to his old school friend G. F. Scotson-Clarke.

which most delighted the young visitors, for Leyland had also filled the palatial rooms of his Prince's Gate house with one of the most impressive arrays of contemporary pictures in London. He owned the finest single group of Rossetti's great late paintings of sensual *femmes fatales*, including *The Blessed Damozel, Veronica Veronese* and a version of *Proserpina*, as well as a dozen or so of the grand, dreamy visions of Burne Jones and memorable things by Millais, Ford Madox Brown and Watts. When Beardsley wrote to Scotson-Clarke to describe the scene, almost every item on his detailed list elicited an exclamation mark; 'His collection is GLORIOUS', he concluded.

Remarkable though these Pre-Raphaelite treasures were, Leyland's house was yet more famous for its dining-room, the Peacock Room, a room widely hailed as the finest and most avant-garde interior in London. It was the creation of James McNeill Whistler and celebrated equally as one of his greatest artistic triumphs and as the cause of one of his most amusingly vitriolic and convoluted disputes, second only in notoriety to his libel action against Ruskin. Leyland had at first consulted the mercurial painter about the colour he should paint the window shutters between the high banks of decorative wooden shelves which were the principal architectural feature of Thomas Jeckyll's original scheme of decoration. The story of how Whistler had, more or less without the knowledge of Leyland and on the pretext of creating a harmonious setting for his picture *La Princesse du pays de la porcelaine*, transformed the original sombre, Spanish-leather-lined room intended for the reception of his patron's collection of blue-and-white china, into a dazzling turquoise blue and gilded japonesque fantasy has often been told; what is interesting here is the extent to which, fifteen years later, the room had lost none of its original power to shock and excite.

Beardsley was entranced by Whistler's work, and in a second letter to Scotson-Clarke sketched elements of the scheme and even added an impres-

sion of Mabel and himself, scruffy and shambling, but with top hat and rather dandified cane in hand, being ushered around the house by an imperious flunkey. Although Beardsley, in admiration, made a small watercolour sketch of Whistler's picture and also at this date acquired one of his early *Thames Set* etchings, there can be no doubt that it was the incidental decorative elements of the room, the large blue and gold panel of fighting peacocks on the wall facing the chimney-piece, the areas of conventionalised Japanese flower-heads and the gilded shutters with their highly stylised feather motifs and oriental placing, which ultimately had the greatest effect on his imagination; but for the moment all these ideas Beardsley stored up in his mind.

Only a week later Aubrey and Mabel set off on a second, and yet more momentous artistic pilgrimage. Their aim was to travel as far as Fulham to see Edward Burne Jones's great studio in the garden of his old house, The Grange in North End Road, Fulham. This Beardsley believed it was possible to do if one simply rang at the door: 'I had heard', he wrote to A. W. King, 'that admittance might be gained to see the pictures by sending in one's visiting card.' If that had once been the case, it was so no more; they were politely turned away by the servant and 'left somewhat disconsolately'. Beardsley's own account of what happened next is almost breathless with excitement:

I had hardly turned the corner when I heard a quick step behind me, and a voice which said, 'Pray come back, I couldn't think of letting you go away without seeing the pictures, after a journey on a hot day like this.' The voice was that of Burne-Jones, who escorted us back to his house and took us into the studio, showing and explaining everything. His kindness was wonderful as we were perfect strangers, he not even knowing our names.

'By the merest chance,' he adds somewhat disingenuously, 'I happened to have some of my best drawings with me, and I asked him to look at them and

Sketch of Whistler's *La Princesse du pays de la porcelaine*, 1891. From *The Uncollected Work of Aubrey Beardsley*. National Art Library

Beardsley's quick rendering of the picture, the *raison d'être* of Leyland's Peacock Room, gives a remarkably good idea of the startling effect of the original, and records the young artist's enthusiasm for Whistler's memorable work.

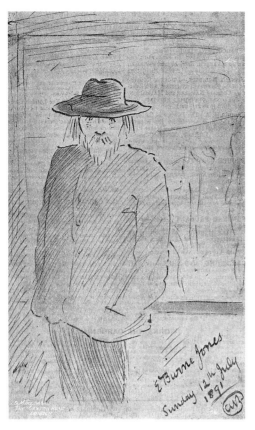

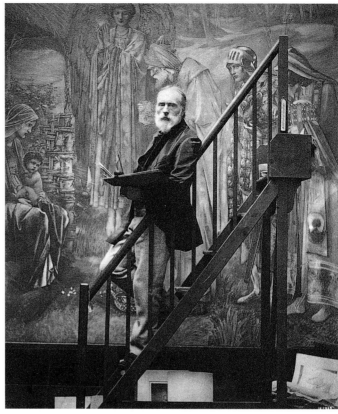

Edward Burne Jones, 12 July 1891.
From process print. V&A
(Unregistered)

Drawn by Beardsley as a recollection
of Burne Jones, and perhaps sent to
Scotson-Clarke in exchange for a
sketch of the same subject by the
latter. Later this sheet came into the
hands of Tregaskis, the book-dealer,
who made a limited edition of eight
prints, and also published the image
in his catalogue, from which this
cutting comes.

give me his opinion.' Burne Jones was favourably impressed by what he saw,
and his remarks, as reported by Beardsley, have a certain ring of authenticity,
revealing the older painter's famous warmth, generosity and charm: 'There is
no doubt about your gift, one day you will most assuredly paint very great
and beautiful pictures. . . All [these drawings] are full of thought, poetry and
imagination. Nature has given you every gift which is necessary to become
a great artist. I seldom or never advise anyone to take up art as a profession,
but in your case I can do nothing else.'

Burne Jones went on to offer to find out about suitable art training, sug-
gesting that two hours study a day would suffice in Beardsley's case. There
was anyway, he said, plenty of time; he himself, after all, had not begun to
study art until the age of twenty-three, when he went down from Oxford
and fell under the spell of Rossetti in London and determined to be a painter.
In a sense, with Beardsley's introduction to Burne Jones history repeated
itself.

This highly encouraging encounter with 'the greatest living painter in
Europe' concluded with tea on the lawn, where the other guests that after-
noon included, by extraordinary and prophetic chance, Oscar Wilde and
his family. The Wildes – 'charming people' – took Aubrey and Mabel home
in their carriage. Beardsley had taken a great step, and from this point he
realised that art was to be his vocation. From now on he wanted only the

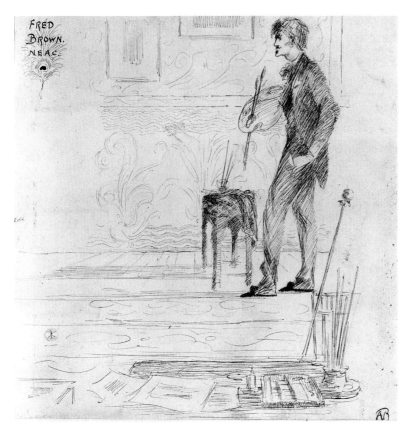

Fred Brown N.E.A.C., 1892.
Pen and ink. Tate Gallery, London

Following Burne Jones's advice, for a few months in 1891–2 Beardsley attended, in a rather desultory fashion, evening classes at the Westminster School of Art. These were presided over by Fred Brown, a member of the avant-garde New English Art Club, the initials of which Aubrey added to the painter's name in the inscription. The style of the sketch is presumably a vague attempt to copy that of Whistler's etchings.

OPPOSITE RIGHT
[Frederick Hollyer],
Burne Jones in his studio, c.1890.
Photograph. V&A Ph.11-1939

This portrait of Burne Jones in his garden studio was taken just a year before Beardsley's first visit. The original photograph was taken for a series of portraits of artists in their studios by a young woman named by Lady Burne Jones as Barbara Leighton. High quality platinum prints were made from her large glass negative by Frederick Hollyer, Burne Jones's 'official' photographer.

opportunity. At first he and Burne Jones had an instinctive sympathy; taking Burne Jones's curiously wan Pre-Raphaelite style as his highest model, but also looking at some of Burne Jones's own influences and sources, including the drawings of Botticelli and the steely-lined, but fantastic engravings of Mantegna, Beardsley began to draw in ever-greater earnest.

'My latest productions show a great improvement', he told Scotson-Clarke, listing new subjects taken from Chaucer and, less predictably, Aeschylus' Oresteian tragedies, and announcing the intention to treat the theme of Merlin, another curious instance of prophetic coincidence, as things would turn out. In addition to searching for good subjects, Beardsley was also devouring new influences. He looked at books of Old Master paintings and every kind of print on the bookstalls; every detail was absorbed and reworked. Just as it had been Ruskin who first showed to Burne Jones *Melancholia, Knight, Death and the Devil* and other prints by Dürer, so in turn it was probably Burne Jones who was responsible for introducing *his* protégé to these engravings, many of which hung framed on the walls at The Grange. When, a little later, Beardsley presented Burne Jones with the largest and most intricately worked of his early pen drawings, the highly complex *Siegfried*, an imaginatively rendered illustration of Act II of Wagner's opera, he was flattered when Burne Jones hung it alongside his Dürers and other fine prints and drawings in his colourful drawing-room.

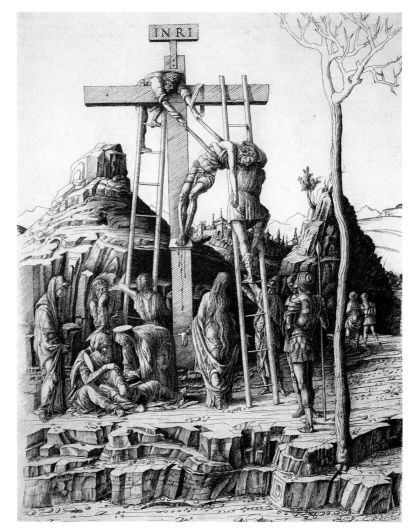

Andrea Mantegna (1431–1506), *The Entombment.* Facsimile of the original engraving, issued by Lippmann of Berlin, 1890–95. V&A E.2608-1934

One of the key influences upon his art, Beardsley kept a collection of facsimiles of Mantegna's engravings by him throughout his short career as an artist. They were pinned to the wall of the hotel room in which he died (see illustration p.201).

Siegfried, Act II, 1892–3. Pen, ink and wash. V&A E.578–1932

Full of reminiscences of the prints of Mantegna and details from other Renaissance pictures seen in the National Gallery, overlaid with a deliberately stylised and decorative treatment, this drawing, with its profusion of 'hairline' calligraphic flourishes, is the greatest achievement of Beardsley's early period. He presented the drawing to Burne Jones.

Keeping in close touch with Burne Jones, Beardsley returned with his increasingly well-stocked portfolio, just as his self-appointed mentor requested, and for six months or so basked in the praise that came his way both in person and by letter. His tastes, guided by Burne Jones and perhaps, too, by the Gurneys, to whom he continued to show his work, were maturing as rapidly as his drawing style. In September he told Scotson-Clarke, 'I am just now enthused to the highest degree about pictures, and am studying the life and works of Mantegna, who, as you know, has inspired Burne-Jones all along. . .' He proposed a trip to Hampton Court to look at the paintings. At that time the palace offered one of the choicest series of Old Masters available to the public: Beardsley knew the collection at least as well as that of the National Gallery, to which he was perhaps a more frequent visitor. In particular among the Hampton Court treasures, he singles out that romantic and noble vestige of Charles I's once superb collection, 'Mantegna's tremendous Triumphs of Caesar. . .', which he describes as 'an art-training in

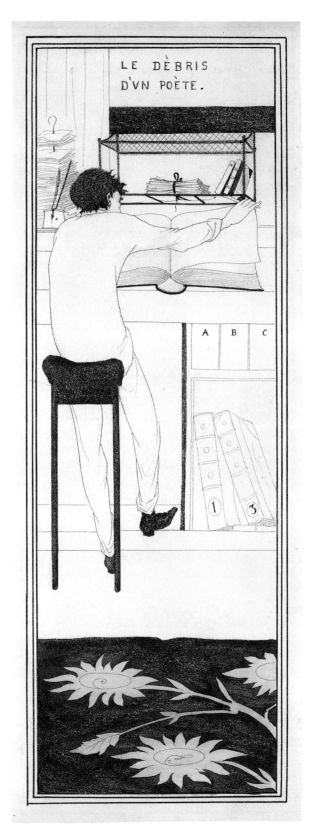

Le Dèbris d'un Poète, c.1892.
Pen, ink and wash. V&A, Given by
Canon John Gray in memory of
André Raffalovich, E.1965–1934

One of the first drawings that
manifests hints of Beardsley's
idiosyncratic japonesque style, its
subject alludes to the artist's own
period of drudgery as a clerk in the
City. For the young poets of the
nineties – Yeats's 'Tragic Generation'
– the notions of failure, and of
exquisite sensibility crushed by the
realities of quotidian existence, had a
peculiar resonance.

themselves.' Throughout his life this hauntingly magisterial cycle of canvases would exert a peculiar fascination over his imagination; this suggests a rare degree of perception in one so young, for, as it has been observed, their truly ruinous state of preservation at that date must have made it very difficult indeed to appreciate their finer qualities.

Another call that Beardsley made around this time was on the eminent but venerable G. F. Watts. Watts's work was probably much less to his taste than that of Burne Jones, and the visit clearly was less of a success. Beardsley described Watts in a laconic note to King as 'a disagreeable old man, however very nice to me'. He listened, none the less, to the old man's advice, which was in essence to avoid the Government Art School at South Kensington, and to rely more on 'self-culture'. In spite of the obvious pertinence of this remark to his own situation, Beardsley seems not to have gone again to see Watts, nor ever to have mentioned his name again.

In a way, Burne Jones had fundamentally misunderstood Beardsley's ambitions to be a *graphic* artist when he made what was, at that time, and to him at least, the natural assumption that the young man's portfolio of drawings represented ideas for paintings rather than finished works of art. To Burne Jones it must have seemed obvious that he would in due course want to train as a painter: 'Every one of the drawings you have shown me', he judged encouragingly, 'would make beautiful paintings.' Beardsley nonetheless conscientiously heeded the suggestion Burne Jones proffered concerning the best plan for his art education. He enrolled with Professor Fred Brown, a pillar of the influential New English Art Club and the head of the Westminster School of Art. Taking Burne Jones's advice to the letter, he proposed to take classes only for a couple of hours in the evenings, that is after his day's work; but in the event, his attendance at the school – the only real art training he ever undertook – was to be highly sporadic. Later claiming that he never attended more than a dozen or so classes, the most tangible reminder of the few weeks or months that he completed there was a spirited pen drawing – rather in the style of a Whistler etching, depicting Brown in the pose of a bohemian pedagogue at his big studio easel.

Then, at the very end of this remarkable year, during the Christmas holidays of 1891, another of the crucial figures in Beardsley's life made an unexpected entrance upon the scene. Aymer Vallance was an old-fashioned High-Church, Aesthetic bachelor. He had a particular interest in church furnishings and in old needlework, subjects which had brought him at some point into contact with William Morris, about whom he would later write one of the first important monographs. The circles in which Vallance moved had, not unnaturally made him acquainted with Alfred Gurney and his artistically minded curates, but he had come specifically to look up Beardsley at the urging of another of the Brighton clergy, his friend the Reverend C. G. Thornton, once a school-fellow of Beardsley's. Examining the artist and his cache of designs, Vallance was astonished by both in about equal measure. Immediately, he determined to display the boy and the portfolio to his very particular set of friends.

Although Burne Jones's praise and encouragement were so important to the young artist, it is probably true to say that it was Vallance's untiring efforts, showing off his work and effecting useful introductions, which really catapulted Beardsley, still not twenty years of age, into an entirely new sphere during the first months of 1892. Among Vallance's intimates he found himself an object of curiosity to a group who were connoisseurs of the curious. Here for the first time he encountered a circle of young men for whom collecting drawings and other objects, and the arrangement of rooms was a serious matter. It was in Vallance's precisely ordered chambers, rooms filled with delicate and dainty things, on St Valentine's Day, 14 February 1892,

Simeon Solomon (1840–1905), *The Singing of Love*, 1870. Pencil and wash. Birmingham City Art Gallery

In his long years of dissolute decline, Solomon was something of an admired figure among the members of the Cénacle, as much for his picaresque existence and flagrant homosexuality, as for his dreamlike images of allegorical figures. Beardsley may have been influenced to some degree both by his types and subject matter and by the curious, appealing *morbidezza* of his drawing style.

that Beardsley first met Robert Ross and More Adey, two of the key figures in the so-called Cénacle, a loose group of witty, literary, dandified young men-about-town who circulated around the, in every way, imposing figure of Oscar Wilde.

It was Robbie Ross, most loyal of all Wilde's friends and ultimately his literary executor, who seems to have acted as an urbane and knowledgable Virgil to Oscar's Dante, guiding his descent into many of the more interesting lower circles of the homosexual underworld of Victorian London. Ross was amusing and knew everyone, but he was also accounted a good judge of books and pictures, and this made his evident admiration of the designs which Beardsley produced from the 'well-travelled portfolio' all the more gratifying. 'Though prepared for an extraordinary personality,' Ross recalled, 'I never expected the youthful apparition which glided into the room.' The 'marvellous drawings' were for Ross at first all but 'overshadowed by the strange and fascinating originality of their author'. Sketching Beardsley's appearance, Ross wrote that 'his rather long brown hair . . . was brushed smoothly and flatly on his head and over part of his immensely high and narrow brow. His face even then was terribly drawn and emaciated.' It is a description which is echoed all too accurately in Beardsley's own merciless description of himself in a letter to King in which he wrote, 'I am eighteen

years old, with a vile constitution, a sallow face and sunken eyes, long red hair, a shuffling gait and a stoop'.

At first, Ross continued, Beardsley was 'shy, nervous and self-conscious, without any of the intellectual assurance and ease so characteristic of him eighteen months later when his success was unquestioned'. Though somewhat abashed by the, no doubt, alarming sophistication of the assembled company, but rapidly warmed by praise and discovering a sympathetic audience, Beardsley began to thaw and then to sparkle. More Adey, described by Ross as an authority on Balzac, was reported to have been astonished at Beardsley's close knowledge of the novels, and of French literature in general.

Ross was impressed, as well, by the way in which 'he spoke of the National Gallery and the British Museum, both of which he knew with extraordinary thoroughness'.

From the start, Ross, Adey and Vallance too, were all keen to purchase drawings. The particular examples which each selected are, of course, indicative of their own tastes, but also revealing of the still highly eclectic mix of styles in which Beardsley was working. Vallance naturally chose medievalising subjects in Beardsley's most Burne Jones vein, such as the softly shaded *Perseus and the Monstre,* and an idealised portrait of Botticelli which Beardsley had drawn in an attempt to extrapolate the image of the artist from the facial types favoured in his works. More Adey also preferred designs which reflected Beardsley's enthusiasm for Renaissance models, and so bought a number of single heads, such as one of *Francesca da Rimini.* Ross set his heart upon acquiring the most ambitious composition in Beardsley's portfolio a long, frieze-like pencil drawing, clearly inspired by Mantegna's *Triumphs,* but based on the theme of Joan of Arc. Beardsley was reluctant to part with a sheet that he considered to be one of his two or three best-ever performances and instead proposed to Ross that he make a replica or second version. This second, even more elaborate drawing – this time in pen and ink – delighted Ross, who gladly gave Beardsley a cheque in payment when the drawing was delivered shortly afterwards. Beardsley must have been overjoyed to be actually earning some money from his drawings.

Less successful was the meeting that Vallance engineered early in 1892 between his new discovery and his great hero, the old warrior bard William

The Procession of Jeanne d'Arc, 1892. From line-block. V&A E.340-1972

Robert Ross wanted to purchase the original version of this design, so redolent of Mantegna's procession pictures, but Beardsley refused to part with it, claiming it to be the best thing he had done so far, and offering instead to create a 'replica'. Reproduced as a small illustration in the first number of *The Studio,* this large plate was issued as a folded supplement to copies of the second, May 1893, issue.

Morris. Morris, at that time deeply involved in his last great enthusiasm and enterprise, the creation of his Kelmscott Press books, had confided in his disciple Vallance his anxieties about finding suitable illustrations to grace the stately pages of the sumptuously archaising editions of his favourite authors, books which he proposed to hand-print and publish in limited editions of two or three hundred. At this stage he had still completed very few of his intended titles, and was still experimenting with page layouts and lettering forms inspired by the choice examples of medieval manuscripts and Renaissance printed books in his own superb collection in the library at Kelmscott House on Hammersmith Mall. Most of the artists he had tried to commission, including Walter Crane, perhaps the most admired illustrator of his day, had proved a distinct disappointment. So far, only Burne Jones had really met Morris's ever-fastidious requirements, but he was unable to devote enough time to the laborious process of preparing precise drawings for the wood-cutting process.

Vallance saw here the chance of both pleasing Morris and giving the young Beardsley his great chance and some important guidance: he was, Vallance later wrote, 'at the very outset of his career, while as yet the course which his genius might take was undetermined . . . fearful lest [he] should fall under unworthy influences I endeavoured to bring him within the sphere of William Morris . . .' Knowing that, in particular, Morris wished to print an edition of Wilhelm Meinhold's legend *Sidonia the Sorceress*, a text translated by Oscar Wilde's mother Speranza, and a great favourite with all the Pre-Raphaelites, Vallance easily persuaded Beardsley to make a trial design for a frontispiece and to take it to show the great man. What that drawing looked like we shall never know; presumably in the Burne Jones manner, it may have betrayed touches of that subtle, subversive anachronism that the young artist already delighted in introducing into otherwise 'serious' subjects. And did it perhaps reveal, too, some slight elements of the caricature that invades Beardsley's drawings of this critical period, half-suggested hints of cynicism about his preferred models?

Arriving in Hammersmith, Beardsley proffered his drawing and, perhaps not unreasonably expecting a reception similar to that which he had received from Morris's dearest friend, Burne Jones, was dashed when Morris was cool almost to the point of rudeness. Morris complained that the figure of Sidonia was 'not pretty enough', and then added somewhat dismissively, 'I see you have a feeling for draperies, and I should advise you to cultivate it'. Hurt, Beardsley took away his drawing and attempted to improve it, scraping out the face and re-drawing the hair. Spoilt beyond repair, he angrily destroyed the design and refused to countenance the idea of ever approaching Morris again. Even when, a few months later, Vallance wanted to 'make one more effort', Beardsley would not go to Hammersmith with him. For Beardsley, standing on the very threshold of a new and exciting career it was just one small set-back; but in the light of the way in which his big break was to come, it was one laden with a quite delicious irony.

Chapter three
FIRST COMMISSIONS AND
EARLY FAME

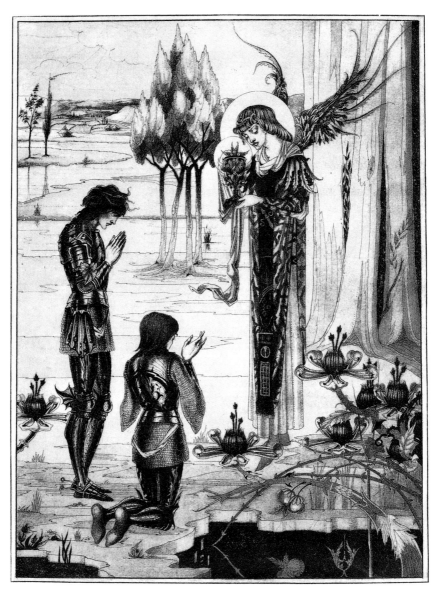

The Achieving of the Sangreal; frontispiece to Vol. II of *Le Morte Darthur,* 1892.
From the half-tone block. Collection Anthony d'Offay.

This was the sample drawing made in autumn 1892 to show to Dent, which secured for the
twenty-year-old Beardsley the major commission to illustrate *Le Morte Darthur.*

Cover for *Le Morte Darthur*
by Sir Thomas Malory
(J.M.Dent, 1893–4).
Collection Anthony d'Offay

The bizarre, stylised Art Nouveau
lilies with their arrow-headed leaves
are a complete invention; the design
is echoed by a pattern of similar
leaves on the spines of the books.

Aubrey Beardsley's whole world lay in books, and not merely in the narrow
sense that, for all his few and precious years of maturity, his work was dic-
tated by the texts for which he was commissioned to make drawings. His
short life was, rather, one entirely measured out in books. From his earliest
days he had lived vicariously in the imaginative world of authors. What he
knew of life, perhaps all that he would ever come to know of love, and, curi-
ously, much that he had learned about the painting and drawing of the past
and absorbed into his own art, all came to him through the printed word
and the picture on the page.

Already steeped in surprisingly adult and demanding reading as a young
child, Beardsley's great love of books had been instantly discovered and
assiduously cultivated by his kindly and imaginative Brighton schoolmas-

ter, A. W. King. By the time he left school Aubrey already had a precociously sophisticated taste in literature. Once in London, with the few shillings in his pockets that he did not hand over from his weekly wages as a clerk, he had rapidly come to know all the old bookshops and secondhand book-stalls that lay within lunchtime reach of the city.

First and foremost among his haunts was that extraordinary and rather ill-omened thoroughfare Holywell Street, a slum area behind St-Mary-le-Strand, lined by day with the stalls of honest booksellers in a small way of business and with the dark and mysterious premises of several of the more notorious of the city's publishers of *curiosa* and pornography hidden behind discreet doors in the shades of the gas-lamps. According to taste, a half-hour's browsing along the barrows or inside the narrow, high-shelved rooms that lay beyond might at that date have yielded to the sharp-eyed collector anything from a well-used early quarto of an Elizabethan play, or an uncon-sidered first edition of the poems of Keats for sixpence (such had been

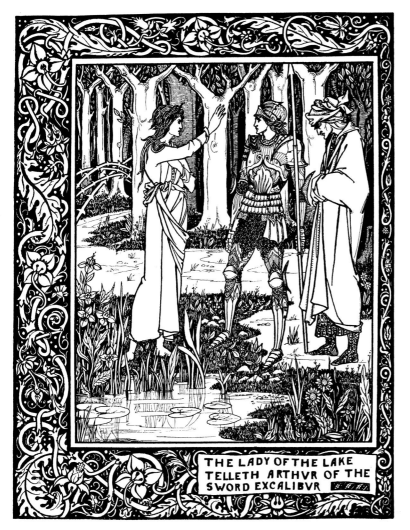

The Lady of the Lake telleth Arthur of the Sword Excalibur, c.1893. From line-block. Gleeson White Collection, V&A E.406-1899
This design, one of the most care-fully worked in a 'pure' Burne Jones manner, is the one taken by Aymer Vallance to show to William Morris. His reaction was violent.

THE LADY OF THE LAKE
TELLETH ARTHVR OF THE
SWORD EXCALIBVR

Holman Hunt's luck some years before) to the latest salacious French novel with unusual illustrations. Much loved and lamented by many of the writers of the nineties, such as Arthur Machen, whose weird novels are often partly set in the dubious quarters of old London, Holywell Street was, perhaps not altogether surprisingly, viewed with suspicion by the authorities. One of Beardsley's earliest wash drawings, and a rare example of him taking any interest in the recording of an actual scene, was an impression of Holywell Street, dashed down some time shortly before the whole area was cleared for redevelopment and its tradition of open-air and fly-by-night bookselling, which dated back to the seventeenth century, was lost for ever.

Of all the bookshops frequented by the young Aubrey, however, none was to prove more important than that of Jones and Evans in Queen Street,

How King Arthur saw the Questing Beast; frontispiece for Vol. I of *Le Morte Darthur,* 8 March 1893.
Pen, ink and wash.
V&A, Harari Collection, E.289-1972

Similar in style and handling to the *Siegfried* drawing, this design had to be reproduced by half-tone photogravure in order to catch all its minute detail. Many elements are borrowings from Mantegna, Pollaiuolo, Uccello, Crivelli and other early painters, but the opulently scaly dragon was certainly inspired by the Regency chinoiserie light fixtures of the Brighton Pavilion which had so impressed Beardsley in his childhood years.

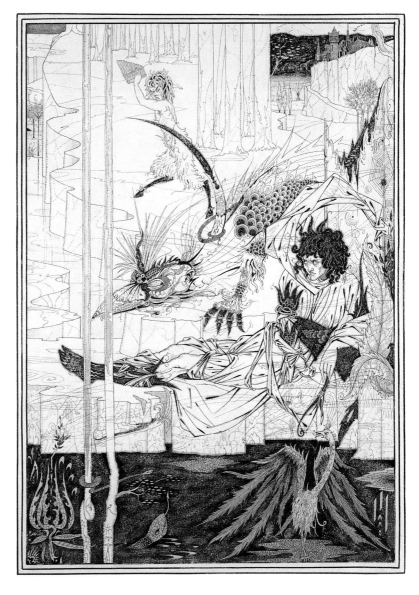

off Cheapside, where the genial Frederick Evans presided over a large stock of reasonably priced secondhand editions of English and French literature. Evans was that old-fashioned character, a bookseller who loved and knew a great deal about books and writers. George Bernard Shaw would later describe Evans as 'an odd little man', adding that he was also 'a wild enthusiast about music and acting . . . and the best amateur photographer in London'. His shop had become a meeting-place for bookmen, its atmosphere club-like and welcoming. Evans tended, in the way of the old booksellers of genius, to befriend his customers, and certainly encouraged the shy, tall and stooping youth who combed his shelves so assiduously in search of unfashionable eighteenth-century tales of gallantry, of Congreve and the Restoration wits, and copies of the Mermaid reprints of the early English dramatists, which formed his chief literary passion of the moment.

With this shared love of obscure volumes, Beardsley and Evans became firm friends, and whether out of kindness to an enthusiastic, but penurious young collector, or as acts of perceptive and enlightened patronage, the bookseller would often allow the would-be artist to borrow books that he could not afford to buy, and from time to time to have the odd volume in exchange for a drawing. In this way Evans became the owner of one of the first collections of Beardsley drawings, numbering among his acquisitions several of Beardsley's early and most Burne Jones-like performances, such as the subtle, *sfumato*, lost-profile head of the Virgin, *Hail Mary*, and also in due course the original version of the *Jeanne d'Arc* frieze that the artist had refused to part with to his more recent acquaintance Robert Ross.

As a keen and highly talented photographer, Evans also took a considerable interest in the attempt to produce high-quality facsimiles of Beardsley's drawings. In a letter to Scotson-Clarke Beardsley had mentioned, with all the excitement of one seeing his drawings reproduced for the first time, that he hoped soon to have some of these copies to send. Carried out in the relatively expensive platinotype process, several of Evans's prints are of surpassing quality and very true to the originals. His other, more imaginative camera studies of architectural subjects and portraits also reveal a sensitive artistic temperament at work.

A close friend of Evans, and another frequenter of the Queen Street shop was the publisher J. M. Dent, the proprietor of the successful Everyman Library, and a staunch believer in the principle of good, well-produced, but relatively cheap books for all. With the initial artistic success of William Morris's Kelmscott Press experiments, the first of which had begun to appear only the previous year (1891), still very much uppermost in his mind, Dent had conceived the idea of creating books with a similar degree of ornamental and illustrative embellishment, but of making use of the new, photo-mechanical line-block process for reproduction, in place of Morris's expensive woodcut technique, and of printing and binding by ordinary commercial means, thus producing good-looking volumes at competitive trade prices. A cherished project was to print the text of Thomas Malory's chivalric romance so beloved of the Pre-Raphaelites, the *Morte Darthur*.

Dragon chandelier in the dining-room of the Brighton Pavilion. Brighton Museums.

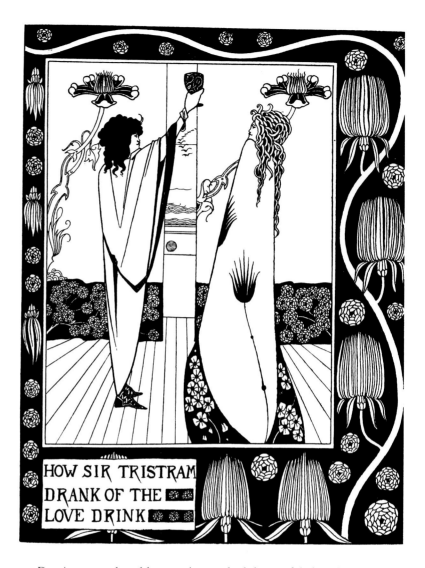

How Sir Tristram drank of the Love Drink, c.1893; illustration from *Le Morte Darthur.* From line-block. Collection Anthony d'Offay

Many of the finest *Morte Darthur* illustrations, such as this full-page image, show Beardsley's ability to juggle with several influences at once, blending and balancing the original inspiration of Morris and Burne Jones's medievalism with elements derived from his growing interest in Japanese prints.

Dent's principal problem, and one which he confided to Evans, was to find an illustrator imaginative and capable enough to carry out the very large number of designs that would be required, but not so grand and established a figure in the art world as to command too large a fee for the necessarily demanding task. Evans immediately suggested his young protégé, Beardsley, and offered to try to borrow the artist's portfolio in order to show Dent what he could do. This was easily arranged, but in the event, just as Dent was looking through the varied collection of pen-and-ink and pencil drawings in the morocco case Beardsley came into the shop. 'There', said Evans, 'is your artist.'

Dent recalled the event vividly in the memoirs which were published two years after his death in 1926:

Evans asked me to call at the shop to look at some drawings by a young man whom he thought might be good enough for the Morte d'Arthur [sic]. As he could only keep them for a day I went at once, and although I could not immediately assess the potentialities of

the work, yet I instinctively felt that here was a new breath of life in English black-and-white drawing. Its chief feature was a wonderful balance in black and white, giving force and concentration as well as a sense of colour. Its value as decorative art was at once apparent. The young artist, Aubrey Beardsley, was then barely nineteen years of age, and when I saw him I was shocked at his emaciated appearance. Alas! even at that time it was evident that without great care he could not be long for this world. He was a strange boy, 'weird' is the right description. He had steeped himself in early nineteenth-century French literature, especially Balzac, and had studied the Comédie Humaine, and life had already in a way become blasé. Still, he was keen about his art and about the commission to decorate Malory's book.

Dent was evidently impressed enough by what he saw to tell the astonished boy on the spot that, subject to the preparation and acceptance of a specimen illustration, this major commission was his. 'It's too good a chance,' Beardsley was heard to mutter as he was leaving the shop, somewhat dazed by what had occurred, 'I'm sure I shan't be equal to it.' Fortunately, the drawing which he made as his sample, and which represented one of the climactic moments of the tale, *The Achieving of the Sangreal*, more than satisfied the publisher, whose own holy grail of publishing was the achieving of the look of Burne Jones on a tight budget. In the event, the highly finished, delicately shaded and minutely elaborated technique which Beardsley employed made

How Queen Guenevere rode on Maying, c.1893; illustration for *Le Morte Darthur*. Pen, ink and wash. V&A, Harari Collection, E.290,291–1972

Many of the later large illustrations, especially those towards the end of the project, were arranged as double-page spreads; this allowed Beardsley to save work by repeating or simply reversing border designs.

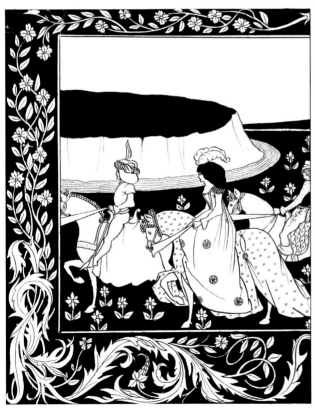

it quite impossible to reproduce the design as a line-block, as Dent had intended; ultimately, a rather more expensive half-tone block had to be made in order to allow the drawing to serve as the frontispiece to the second of the two volumes of the edition.

For the many hundreds of small chapter heads, head- and tail-pieces and the principal series of full-page illustrations, each with its elaborate decorative border that would be required, Dent offered a contract to the young illustrator proposing payment, over an estimated period of more than a year, of two hundred pounds; this sum eventually being increased to £250 as the scale of the undertaking became more fully apparent. Though hardly an over-generous rate when the number of designs to be made each week was taken into consideration, it still must be judged as a bold commission to offer to an, as yet, untried young artist. The figure also represented, it should be remembered, something in the region of three times Beardsley's annual salary at the Guardian insurance office.

Dent's intention was to publish in regular, monthly parts at half-a-crown, in the manner of many of the larger-scale illustrated books of the day; these parts would, if subscribers returned their copies to the publisher, in due course be bound up for a small extra fee in specially blocked cloth covers, also to a design by Beardsley. Later, Dent proposed that complete bound sets would also be put on sale, but the edition was from the outset intended to be limited, not, of course, to the usual couple of hundred or so copies of the intensely hand-crafted Kelmscott books, but to 1,500 ordinary, and a much smaller number of de luxe copies. These last, to be printed (with the initial letters in red) on better, thicker paper, would bind up into three volumes and were to have appropriately more sumptuous vellum covers.

For Beardsley, the arrangement seemed – initially at least – an ideal one. Here, at last, was the prospect of considerable and worthwhile artistic employment for a good length of time, and at a rate far beyond his wage as a clerk. For some months Aymer Vallance, echoing Burne Jones's advice, had been counselling Beardsley to take the great leap: 'You must live by it – you are an artist'. Beardsley had merely quipped in reply, 'What! And give up making out insurance policies in Lombard Street? Impossible!' Now it appeared he could 'live by it'. So, in the autumn of 1892 Beardsley walked away from the City for ever. He was just twenty; he was henceforth an artist.

At first he worked hard and with enthusiasm on the *Morte*, drawing after drawing pouring out in a fertile rush of invention. R. A. Walker, the celebrated Beardsley scholar who prepared the third, enlarged edition of the book for Dent in 1927, calculated that for the entire project Beardsley made some 362 drawings, counting all the designs for full- and double-page illustrations, individual borders and the multitude of smaller chapter headings and numbers; however, many of these latter ornaments were repeated, sometimes in different sizes, to make a grand total of no less than 1,095 decorations in the volumes.

Since the illustrations and other decorative designs in the book were not laid out in the sequence in which they were drawn it is not a simple matter to

Chapter head of a young knight for *Le Morte Darthur*, c.1893. Pen, ink and wash. V&A, Harari Collection, E.310-1972

chart the evolution of the artist's drawing style. Had they been thus printed, in order, it would have all too clearly chronicled the extent to which Beardsley's rapidly developing artistic enthusiasms quickly outgrew the straightjacket imposed upon him by the strict formula of serial publication. More crucially it would reveal, too, just how quickly he grew tired of the subject matter and began to indulge in what would become his invariable habit of distancing his illustrations from the text in hand by means of the introduction of caricature elements, slyly ironic details and references, and deliberate anachronisms of costume, of setting and in the facial and physical types which he chose to portray.

Both to please Dent and as a natural expression of his own tastes, all the earliest designs for the book are in a distinctly Burne Jones vein, but even in some of these very first drawings it is possible to discern the seeds of much of Beardsley's later development as a draughtsman. From the outset, his figure types became more and more extraordinary: attenuated and mannered to a degree that seems almost intentionally to parody Burne Jones, the bold knights of Arthur's court increasingly tend towards the obviously effeminate, whilst other figures, such as pages and various fauns, wood nymphs and other grotesque characters – all quite unmentioned in the text – display an even more deliberate and at times startling sexual ambiguity.

Although, as Brian Reade observed, the delicacy, precision and sheer joyful inventiveness with which many of the details of Beardsley's illustrations are drawn proclaim that he was, in the early days of the project at least, still to some degree entranced by Malory's powers as a story-teller, quite rapidly, however, he came to affect a cynical attitude to the work. This stance, perhaps even more than the element of parody in his designs, seems to have driven a wedge between him and Burne Jones, for whom – along with his lifelong friend Morris – the *Morte D'Arthur* was little short of a sacred book. There was, as a result, a gradual but distinct cooling of the friendship which had, at first, meant so much to the younger man, and in later years the normally sweet-tempered Burne Jones would reflect bitterly and even with uncharacteristic outspoken anger at what he considered to be the ungrateful way in which Beardsley had, as his career developed, turned away from him and all his most cherished Pre-Raphaelite ideals.

Headpiece for *Le Morte Darthur*, c.1893. Pen and ink and wash. V&A D.1823-1904

Intemperate anger was, too, William Morris's reaction when he first saw what Beardsley had made of *Le Morte Darthur*. Remembering the poor reception that Morris had given Beardsley's *Sidonia* drawing, but still anxious to bring the two together, Aymer Vallance had tried with predictably little success to coerce Beardsley into making the trip out to Hammersmith Mall again. Instead, towards the end of the year, Vallance had gone alone, bearing some early proofs of pages from the book, including the splendid full-page design, *The Lady of the Lake telleth Arthur of the Sword Excalibur*. This is one of Beardsley's purer exercises in the Pre-Raphaelite chivalric manner, finely drawn and in a style very close to, but perhaps rather more sharp and expressive in its line and incisive in its characterisation than the Kelmscott wood-

Edward Burne Jones (1833–1898) and William Morris (1834–1896), Trial print of the opening page of the Kelmscott *Chaucer*, 1896. V&A E.1255-1912

It is said that Beardsley had to ask Evans to show him an example of a Kelmscott book when the *Morte* commission was first discussed. Morris had not printed many titles at that stage. The *Chaucer* was the culmination of all his and Burne Jones's efforts to fashion 'the book beautiful'.

cuts after Burne Jones or Walter Crane; as a book illustration it is more vivid, and, it must be said, quite simply better than most of the Kelmscott blocks, which all too often have a somewhat dead quality as a result of being copied, transferred to the woodblock and cut by hands other than those of the artists. Morris, for whom the Kelmscott books in many ways represented the culmination of his ideals after long struggles, immediately upon seeing the sheet proffered by Vallance, grew incandescent at 'this act of usurpation': 'Dammit,' he spluttered with a curiously proprietorial rage, 'a fellow should do his own work!'

Vallance made no further attempts to reconcile the great man and the young artist, and henceforth concentrated his efforts on introducing his protégé only to those who were more receptive to the new, and were likely to embrace what was coming to be regarded as the dangerous but exciting modernity of Beardsley's style. Robert Ross, who must have heard of all this at first hand from his friend Vallance as well as from Beardsley himself, later accounted for Morris's petulant reaction rather bluntly when he came to write his 'Eulogy', one of the first essays on Beardsley's life and art, published shortly after his death in Smithers's posthumous edition of *Volpone*: 'That Morris was annoyed by the sincerest form of flattery', Ross suggested, 'can only be explained by Beardsley's superiority at figure drawing and the versatility he showed on every border, while his decoration of the page was more plausible than any Hammersmith effort.'

For those who consider that Morris as a pattern designer is unassailable, and that the stately, but often rather sombre and worthy Kelmscott volumes represent the high water mark of the development of 'the book beautiful', Ross's words will always sound like special pleading. But even if it be agreed that, for example, the more direct heirs of the Kelmscott books – such as Charles Ricketts's Vale Press volumes – often have a lighter and more lively grace than their progenitors, most critics of the nineteenth-century book have inclined to see Beardsley's contribution, as first signalled in the *Morte Darthur* and realised in his later books, as of at least equal and possibly greater significance for the development of modern book design and illustration than Morris's at times ponderous and always more obviously archaising example. Beardsley, it was clear to many, presented an innovative approach to book design, and, above all, proposed – as even the conventionally minded Dent had perceived – an entirely new style of illustration.

A serious question began to be voiced: just what was this new style that the young artist had created? What elements had he drawn together to create a book which, from its ostensible get-up as an imitation of Morris and Burne Jones, in fact, and when examined closely, proved to be so very radical and different from its supposed models? The answer to this lay in the fact that with remarkable rapidity Beardsley was assimilating an extraordinary variety of influences, taking and making his own only as much as he needed of the ideas, stylistic effects and pictorial details from the work of a wide range of English and European artists both old and new, and also elements from several other cultures. As Joseph Pennell would put it, 'Mr Beardsley has

 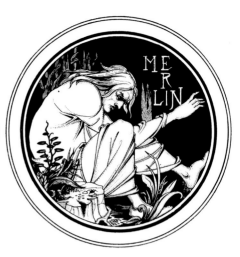

Interior of a kylix in the British Museum depicting a boy and a hare. Plate XVI from *Greek Vase Painting,* by J. E. Harrison and D. S. MacColl, (Fisher Unwin, 1894). National Art Library

The illustrations of this book render the Greek originals with a simplified graphic clarity. This circular design comes from a famous kylix of the best Attic period, inscribed 'the boy is beautiful'; a vessel much admired by the Aesthetes.

Merlin, c.1893; roundel design from Vol. I of *Le Morte Darthur.* Platinotype photo-facsimile by Frederick Evans of the original drawing. V&A 29v-1972

In spite of its medieval subject, the inspiration for this unusual composition seems clearly to be an illustration of a Greek vase painting. Beardsley would have seen his friend D. S. MacColl's book in the press at this time; he appears to have lifted both the position of the figure, and in particular the placing of the foot and outstretched fingers of the hand, as well as the general idea of silhouetting the design against a solid dark background

drawn his motives [*sic*] from every age, and founded his styles – for it is quite impossible to say what his style may be – on all schools.' As a sort of visual butterfly, he alighted upon images as diverse as early Italian pictures, sixteenth-century book illustrations, French eighteenth-century engravings, Greek vase paintings and the works of the Japanese printmakers, taking from each some essence of their draughtsmanship that would inform his own rapidly improving technique and drawing style.

Many of these novel visual resources we must presume he discovered during his frequent visits to the National Gallery, his knowledge of which had so impressed Robert Ross; during hours spent at the British Museum, where Greek vases, for example, figured prominently in the late nineteenth-century displays devoted to the archaeology of the classical world; and perhaps also in the library, print room and galleries of the South Kensington Museum (known later as the Victoria and Albert Museum), where, at any time after the late 1880s, along with a wide range of objects of decorative art, some of the finest examples of Japanese prints could be seen.

In addition to these possibilities for widening his visual repertoire at first hand, the strongest supposition must remain that Beardsley's most natural and habitual mode of discovery lay through the exploration of books. Lewis Hind, who first met him late in 1892 and came to know him well in the next year or so, suggests as much in one of his perceptive remarks about the young artist of these years: 'But this matter of influences is rather idle talk,' opined Hind, 'Beardsley was mentally so quick, his artistic antennae so supersensitive, that he could perhaps get all he needed from an artist by browsing in his luncheon hour among the rarer books in the establishment of Messrs. Jones and Evans of Queen Street, Cheapside.'

An example from this phase of his career (and others will be touched upon later) will serve to underline the truth of this assertion. Much has been made of the idea that the Greek vase painters of the Attic red and black figure periods influenced his drawing style greatly, in particular through their ability to use a strong, unbroken and lively line and the potential of silhouette to express not only form but also character without any need of shading. A

curious parallel may be made between more than one of Beardsley's illustra-
tions and the line-block reproductions of various masterpieces of Greek vase
painting contained in a large folio volume on the subject written by the cel-
ebrated classics scholar Jane Harrison, assisted by Beardsley's friend, the art
critic D. S. MacColl. Appearing in the year after the *Morte Darthur*, this was
issued by Fisher Unwin, a publisher for whom Beardsley was already begin-
ning to do some work during the middle phase of the *Morte* project, at the
very moment when *Greek Vase Painting* would have been going through the
press. Ross alludes obliquely to its influence on Aubrey at this stage.

In that book, Plate XVI, illustrating the roundel from the interior of a
famous kylix in the British Museum inscribed 'the boy is beautiful', would
seem, both in the arrangement and linear style of the figure and in the con-
trast of the bold white subject against a solid black background, to be a clear
and quite precise source for Beardsley's roundel design of *Merlin*, an illustra-
tion which, although placed near the beginning of Volume I of the *Morte
Darthur* in its final book form, belongs in fact with the preliminary pages for
the volume, which were actually prepared rather later in the sequence of the
part issues.

Other influences that are to be discerned in the pages of the *Morte Darthur*
include the continuing shade of Mantegna, whose dry, rigorously linear
engraving style and pictorial inventiveness never ceased to fascinate
Beardsley. Examination, too, of the details in designs such as the important
frontispiece for the first volume, *How King Arthur saw the Questing Beast*, a draw-
ing made in March 1893 but very similar stylistically to the *Siegfried* pre-
sented some six months earlier to Burne Jones, reveals many Mantegnesque
touches in the rocky landscape and curious, thin Italianate tree-trunks
etched with minute patterns. Never in a position to buy examples of the
original engravings, even at that time highly regarded by connoisseurs and
reaching relatively high prices for prints, Beardsley nevertheless became an
avid collector of the high quality, full-size facsimile reproductions published

Old man and embryo, illustration for
Bon Mots of Smith and Sheridan (J. M.
Dent, 1893). Pen and ink. V&A,
Harari Collection, E.314-1972

One of the finest 'grotesques' from
the series. Beardsley's obsessive
depiction of embryo motifs around
this time has fuelled endless, but
ultimately inconclusive speculation
concerning the possibility of the
traumatic involvement of either
Aubrey or his sister (or, it has also
been suggested, of both) in an
abortion. The sight of either an
actual embryo, or more likely an
illustration of one clearly created an
indelible impression upon the artist's
imagination.

Vignette, known as *'Waiting'*, from
p.171 of *Bon Mots of Foote and Hooke*
(J. M. Dent, 1894). V&A, Harari
Collection, E.337-1972

This design of a woman at a café
table was identified by Brian Reade
as one of the last *Bon Mots*
illustrations; no longer strictly a
'grotesque' at all, it was drawn after
Beardsley's visit to Paris, and shows
the influence of recent French
graphic art, such as the posters of
Toulouse-Lautrec, in both style and
in its 'modern' subject matter; in
both these respects it looks forward
to Beardsley's illustrations of the
Yellow Book period.

in these years by the Berlin editor Lippmann. Throughout his life Beardsley
kept these images constantly by him, framed or simply pinned to the wall
wherever he found himself; towards the very end, as we shall see, when
almost all his other possessions had been sold and barely a few of his pre-
cious books remained, his Mantegna prints formed the sole artistic decora-
tive element in the room in which he died, just as they had always played a
vital role in his visual sensibility during his life.

The other significant element in the stylistic development of the designs
and decorations of the *Morte Darthur*, and indeed probably the crucial factor
which led to Beardsley's gradual disillusion and ultimately frantic impatience
to be done with the project, was his growing fascination with Japanese art,
and in particular with the formal abstraction and sheer graphic excitement
offered by his growing awareness of the work of the Japanese woodblock
printmakers of the late eighteenth and early nineteenth centuries. Of course
the discovery of this startling visual world by European artists had already
begun some years before, and Rossetti and Whistler in England and many of
their French contemporaries had already begun to tap this exciting source of
alien pictorial inspiration.

Beardsley had already imbibed one particular aspect of *japonisme* distilled
with such brilliance and finesse by Whistler in his decorations of the
Peacock Room in Frederick Leyland's house, but his own distinct, mature
and entirely personal japonesque style lay still, for the moment, a little way
off. At this stage the simpler formal tricks of the Japanese graphic artists
began to invade unlikely corners of his medieval Arthurian world.

By far the most successful of all the Japanese elements in this first phase
of assimilation are the stunning front covers and spines created by Beardsley
for the bound volumes of the *Morte Darthur*. Always rightly regarded as one
of the most original of all designs for books in a century which made an art
form of bookbinding, the main cover design – of monstrous, overtly sexual
flowers arranged in conventionalised repeating patterns on savage stems and
amid menacingly arrow-like leaves – remains one of the crucial icons of the
Art Nouveau impulse in English design in the nineties. The perfect contrast
of an almost bland, cream cloth and the steely, tensile leaf forms, developed
from an original motif in the Burne Jones *Siegfried* drawing, blocked in flat
expanses of gold, and the quirky hand-drawn lettering, make this, perhaps of
all his essays in the art, Beardsley's own masterpiece of perfectly judged,
intense and utterly distinctive design for the cover of a book.

As the *Morte Darthur* creaked on in its monthly parts, Dent became
increasingly worried that Beardsley's drawings were becoming more and
more perfunctory and exhibiting ever more capricious stylistic elements and
erotic grotesqueries. This is especially true of the small chapter headings,
many of which reveal Beardsley taking the liberty of ignoring the text
entirely, of freely introducing characters and inventing scenes without rele-
vance to Malory's tale, and of generally, in the phrase Rossetti had once used
of his own illustrations, 'allegorising on one's own hook'. It is nevertheless
true that some of the later large illustrations, such as *How Sir Tristram drank of*

the Love Drink, a design which belongs to this very final phase, in which medieval and japonesque elements seem to exist side-by-side in almost perfect balance, are in fact some of the finest, most psychologically incisive and visually memorable pages in the entire book.

Of even greater worry to Dent than Beardsley's stylistic vagaries was the very real possibility that he might throw up the entire scheme and leave the book unfinished. One day, particularly anxious about the week's batch of designs, he had called at the Beardsleys' house in Charlwood Street, where he met only Ellen Beardsley, who was forced to admit that Aubrey, who habitually worked late into the night, was still in bed. When she went upstairs to remonstrate, Beardsley is supposed to have come up with this extempore limerick:

There was a young man with a salary,
 Who had to do drawings for Malory:
When they asked him for more,
 He replied 'Why?, Sure
You've enough as it is for a gallery'.

Rightly sensing that boredom was the most critical factor, Dent hit upon the clever tactical idea of commissioning another group of illustrations, this time for a series of little pocket editions of the sayings and writings of the English wits from Sheridan and Sydney Smith to Lamb and Jerrold. These *Bon Mots* volumes were to be decorated rather than illustrated, and Beardsley was encouraged to give the freest rein to his imagination, creating hundreds of tiny, bizarre images or grotesques. With endless, and at times almost frightening invention, Beardsley conjured a novel stage peopled with fashionably elegant, strange and ugly, sinister or deformed characters, an entire nightmare world of recognisable animals, nameless creatures, foetuses, homunculi and various other merely calligraphic excesses. Dent's ruse, and the combined threats and attempts to exert moral and other pressure exercised by him as well as Mrs Beardsley and her ally in this situation, the everwatchful and kindly Robert Ross, prevailed and Beardsley saw both the *Morte Darthur* and *Bon Mots* commissions through to their conclusions.

However, by the middle of 1893, when these books were actually completed and published, a dramatic turn of events had made Beardsley the most talked-of young artist in England and his now frighteningly rapidly evolving drawing style the most avidly watched of all the remarkable developments in the European graphic arts in the 1890s.

Woman and cat, vignette from p.76 of *Bon Mots of Smith and Sheridan* (J. M. Dent, 1893). From line-block. V&A, Gleeson White Collection, E.540-1899

The *Bon Mots* illustrations gave Beardsley free rein to combine 'grotesqueries' in the 17th-century manner with calligraphic decorations and details derived from the Japanese illustrative tradition. Here the influence of book artists such as Haronubu, whose prints Beardsley collected, seems to be uppermost.

Chapter four
'SOMETHING SUGGESTIVE OF JAPAN'

Cover of *The Studio*, Vol.1, No.1, April 1893. Stephen Calloway

Cover of *The Studio*, Vol.1, No.1, April 1893. Stephen Calloway

The first design for the cover was rejected by Hind and Holme because they considered that the crouching faun-like figure of Pan that Beardsley had introduced was too lascivious in appearance. This expurgated version, similar in feel to the covers for the part issues of the *Morte Darthur*, also served as the basis for the prospectus and as a poster.

In April 1893 the 'Beardsley Boom' began in earnest: 'After the publication of the first number of *The Studio*', wrote D.S.MacColl, 'a youth who was known to a few dozen became quickly famous in two continents . . .' The youth was of course Beardsley, whose work was featured in the new magazine's sensational keynote article. But, paradoxically, whilst this short piece – and the handful of reproductions of Beardsley's work that illustrated it – made the artist's reputation more or less overnight, it also did much to establish *The Studio* (originally planned on a modest scale as a periodical for art students) as the leading artistic journal of the day. The way in which this came about reveals a great deal about the extent to which the London art scene in the 1890s was still a small and, though vital, nevertheless extraordinarily close-knit world of interlocking friendships and acquaintances.

The birth of *The Studio* had been rapid. Towards the end of 1892 Lewis Hind, a bright and ambitious sub-editor on the old, staid *Art Journal*, and would-be literary man-about-town, began to talk of creating a new magazine more in touch with current trends in the fine and applied arts. Hearing of this, John Lane, the single most influential publisher of the decade, told Hind, 'That's odd . . . my friend, Charles Holme, is also planning one. He has money. I'll bring you together.' The two men easily agreed to collaborate in a joint venture as editor and proprietor, and began to gather material for an opening issue early in the new year. Having secured as contributors a number of good establishment names, including those of Frederic Leighton, then basking in the Olympian grandeur of his final years, Arthur Lasenby Liberty (who would write as an expert on craft subjects such as old Spitalfields silks) and younger stars such as Frank Brangwyn, both realised that what they crucially needed was something fresh and newsworthy, or as Hind journalistically put it, 'a sensational send-off article for the first number'.

Years later Hind described how 'the luck of the Nineties' touched him when, one Sunday afternoon, as was his habit, he had gone to call upon 'that dear woman and rare poet, Alice Meynell', who with her husband Wilfred held court at their house in Palace Gate to many of the leading poets, intellectuals and painters of the day. Evoking a quintessential vignette of the period, Hind recalled,

Vernon Blackburn was singing our hostess's 'Love of Narcissus' sonnet, which he had recently set to music. When he reached the last line, 'His weary tears that touch him with the rain', and we had stirred, after a pause, back to life, Aymer Vallance, who was among the guests, came towards me, saying, 'I've brought a young artist here, Aubrey Beardsley. I wish you would look at his drawings: they're remarkable'.

Siegfried, Act II. Published in *The Studio*, April 1893. From line-block. V&A, Gleeson White Collection E.455-1899

Joseph Pennell made particular mention in his article on Beardsley in the first number of *The Studio* of the quality of the process line-block reproductions after his drawings; it should always be remembered that it was upon these alone that Beardsley's work was customarily judged by the wider artistic audience of the nineties.

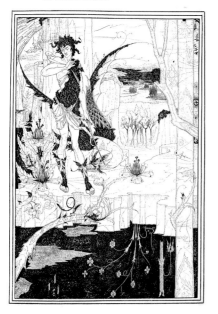

Hind was immediately and deeply impressed both by the young artist's appearance as well as by the work he proffered for inspection: 'It seems incredible,' he continued, 'but Beardsley was then only twenty years of age; he stood behind Aymer Vallance, slim, self-possessed, a portfolio under his arm. He handed it to me. I looked through the drawings, and said to myself, "Either I'm crazy, or this is genius."... Here was the "sensational send-off" that we wanted. What better than the discovery of a new genius by a new journal...'

The following day, Beardsley arrived as bidden at the offices of *The Studio* in Henrietta Street, near the heart of the old Covent Garden market; Holme was as excited as Hind, and immediately made the agreeable suggestion that *The Studio* should buy outright one or two designs from the young artist and illustrate several others, including examples from the group in preparation for Dent. According to Hind's perhaps imperfect recollection – and he was, after all, writing a quarter of a century after the event, and may simply have looked at the contents of *The Studio* in order to refresh his memory – the 'well travelled portfolio' contained on that important day not only some early designs for the *Morte Darthur*, but also the *Siegfried* (borrowed back from Burne Jones for the occasion, possibly) and two recent performances, *The Birthday of Madame Cigale* and *Les Revenants de Musique*, these last being examples of what Beardsley had already begun to refer to as 'my new Jap manner'.

These, in any event, were the designs that Hind chose to reproduce, adding also a startlingly original design, finished just in time to be included, illustrating the climax of Oscar Wilde's new play *Salomé*, which signalled a novel, very continental, and dangerously decadent, symbolist line in English art. To accompany the pictures, Hind commissioned a short but well-considered accompanying article entitled 'A New Illustrator: Aubrey Beardsley' from Whistler's great friend, the American journalist, critic and authority on the decoration of books, Joseph Pennell. Pennell wrote with great enthusiasm and considerable perception about Beardsley's drawings, rightly identifying the crucial fact that the young artist, unlike many illustrators of the day, took no interest in what he considered the bogus mystique of wood engraving and preferred to draw for reproduction by the new photo-mechanical line-block process, lately perfected by master-technicians such as Carl Hentschel. As Pennell put it, 'he has not been carried back into the fifteenth century, or succumbed to the limitations of Japan; he has realised that he is living in the last decade of the nineteenth century, and he has availed himself of mechanical reproduction for the publication of his drawings, which the Germans and the Japs would have accepted with delight had they but known of it.'

'The reproduction of the *Morte Darthur* drawing... is one of the most marvellous pieces of mechanical engraving, if not the most marvellous, that I have ever seen', he enthused, 'simply for this reason: it gives Mr Beardsley's actual handiwork, and not the interpretation of it by some one else.' Beardsley's drawings revealed, he continued, 'the presence among us of an artist... whose work is quite as remarkable in its execution as in its invention: a very rare combination.' But, 'most interesting of all', Pennell

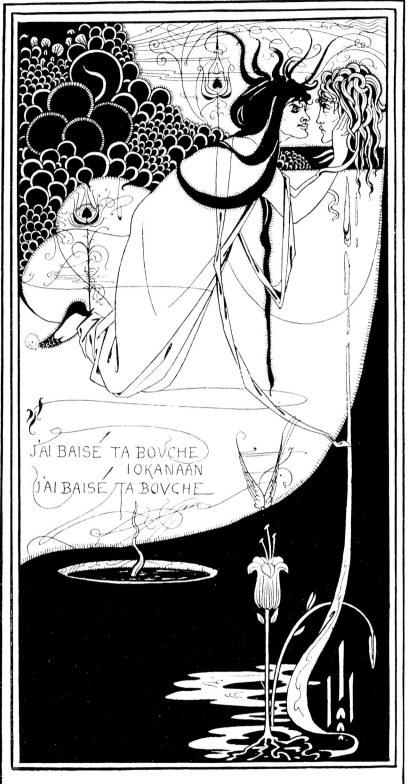

J'ai baisé ta bouche Iokanaan, illustration
to *Salome* by Oscar Wilde, published
in *The Studio,* Vol. I, No. 1, 1893.
From line-block. V&A, Gleeson
White Collection, E.456-1899

Almost the last of his drawings in the
fantastic, 'hairline' style, Beardsley
took his subject from Wilde's play,
published in French in 1893. The
drawing attracted the attention of
Wilde and of John Lane, who agreed
to publish an English version with
illustrations by Beardsley. This
scene, 'The Climax' was redrawn in a
clearer, simplified version for the
book. Some time after 1893
Beardsley added watercolour washes
to his original drawing in green, the
colour that for Wilde and the
Cénacle denoted decadence.

THE BIRTHDAY OF
MADAME CIGALE

The Birthday of Madame Cigale;
published in *The Studio*, Vol. 1, No. 1,
1893. From line-block. V&A,
Gleeson White Collection,
E.450-1899

One of the key drawings of
Beardsley's japonesque phase,
Madame Cigale (which means cricket
or *cicada*) recapitulates many of the
themes of his earlier work, and even
reuses a number of figures, such as
the boy offering a pair of oriental
shoes, from the *Bon Mots*
illustrations. The extreme stylisation
or abstraction of the picture plane,
the fantastical costumes and the
frieze-like decorative panel along
the lower edge look forward to the
pictures of the *Salome* group.

concluded, seizing upon the two key factors to which all subsequent com-
mentators on Beardsley's draughtsmanship have inevitably and endlessly
returned, 'is his use of the single line... leading, but not forcing you, properly
to regard the concentration of his motive [*sic*]. In his blacks, too, he has
obtained a singularly interesting quality, and always disposes them so as to
make a very perfect arabesque.'

The publication of *The Studio* had a considerable impact on the London
art world, bringing Beardsley, as D.S. MacColl observed, to the instant
notice of a wide public. Not everyone, however, was as enthusiastic about
his work as Pennell or the inner circle of the Vallance–Ross–Wilde Cénacle,
and in certain quarters his work was viewed with not a little suspicion; it was
suggested, by no means for the last time, that there might be something
unhealthy or even indecent revealed in the details of his drawings. Indeed,
even Holme and Hind had entertained some misgivings about the design
which Beardsley had originally submitted to them for the cover of the first
number. Conceived very much in the same vein as his wrapper design for the
part issues of the *Morte Darthur*, it featured a seated faun, which creature
exuded, they felt, too lascivious an air for a journal that aspired to be avant-
garde but aimed also to keep well within the wholesome ethos of the English
Arts and Crafts Movement. As would so often be the case in the years to
follow, Beardsley was required to excise the offending detail from his design,
which duly appeared expurgated and blameless, if a little bland, printed on
a suitably earnest and artistic dull-green paper.

Shortly before *The Studio* had hit the bookstands, Beardsley had found time, amid all the excitements and the real pressure of work on the *Morte Darthur* and the *Bon Mots* series, not only to execute a few other designs for different publishers, but also, presumably at the suggestion of Fred Brown, to send in a group of drawings to the exhibition of the New English Art Club. Increasingly the 'new illustrator' was becoming a figure to watch. Vallance introduced him to John Lane and also around this time, through Ross, he renewed the acquaintance with Oscar Wilde, first made during the summer of 1891 on Burne Jones's lawn. As the nineties began to take on their distinctive character, Beardsley found himself very much at the centre of things.

The Kiss of Judas, published in *The Pall Mall Magazine*, July 1893. Pen, ink and wash. V&A, Harari Collection, E.292–1972

Through the influence of Lewis Hind, who had left *The Studio*, Beardsley made a number of drawings for the *Pall Mall Magazine*, including this full-page design, the first in the fully developed style of the *Salome* pictures. It illustrates a short story by 'X.L.', 'a Moldavian legend':

'"They say that children of Judas, lineal descendants of the arch-traitor, are prowling about the world, seeking to do harm, and that they will kill you with a kiss." "Oh, how delightful!" murmured the Dowager Duchess . . .'

THE·KISS OF JVDAS

Frontispiece for *The Wonderful History of Virgilius, the Sorcerer of Rome*
(David Nutt, 1894). From-line block. V&A, Gleeson White
Collection, E.434-1899

One of Beardsley's first drawings to reveal the more specific influence
of Japanese prints, which encouraged his move away from the
more generalised japonesque orientalism of the Aesthetic Movement
towards an increasing graphic purity.

Around the middle of February 1893 he had at last found a moment to write a long letter to his old school-friend Scotson-Clarke, now seeking his fortune as an artist in America. This breathless and rather boastful budget of news deserves to be quoted at considerable length, not only for the light it sheds on Beardsley's hectic activity, but also because it reveals so clearly the extraordinary growth in his self-confidence and sophistication during these few months, and his rapidly developing awareness of the importance in the artistic circles of the day of striking a memorable pose. In a relatively short space of time, he had become a character to be reckoned with. 'Behold me', he wrote,

the coming man, the rage of artistic London, the admired of all schools, the besought of publishers, the subject of articles! Last summer I struck for myself an entirely new method of drawing and composition, something suggestive of Japan, but not really japonesque. Words fail to describe the quality of the workmanship. The subjects were quite mad and a little indecent. Strange hermaphroditic creatures wandering about in Pierrot costumes or modern dress; quite a new world of my own creation. I took them over to Paris with me and got great encouragement from Puvis de Chavannes, who introduced me to a brother painter as 'un jeune artiste anglais qui a fait des choses etonnantes.' I was not a little pleased, I can tell you, with my success.

On returning to England, I continued working in the same method, only making developments. The style culminated in a large picture of Siegfried (which today hangs in Burne Jones's drawing room.)

My next step was to besiege the publishers, all of whom opened their great stupid eyes pretty wide. They were frightened, however, of anything so new and so daringly original. One of them (Dent – lucky dog!) saw his chance and put me on to a large edition de luxe of Malory's Morte Darthur. The drawings were to be done in medieval manner and there were to be many of them. The work I have already done for Dent has simply made my name. Subscribers crowd from all parts. William Morris has sworn a terrible oath against me for daring to bring out a book in his manner. The truth is that, while his work is a mere imitation of the old stuff, mine is fresh and original. Anyhow all the good critics are on my side, but I expect there will be more rows when the book appears (in June).

Better than the Morte Darthur is the book that Lawrence and Bullen have given me, the Vera Historia of Lucian. I am illustrating this entirely in my new manner, or, rather, a development of it. The drawings are most certainly the most extraordinary things that have ever appeared in a book both in respect to technique and conception. They are also the most indecent. I have thirty little drawings to do for it 6 inches by 4. L and B give me £100 for the work. Dent is giving me £250 for the Morte.

Joseph Pennell has just written a grand article on me in the forthcoming number of The Studio, the new art magazine which has by the way a grand cover by me. I should blush to quote the article! but will so far overcome my modesty as to send you a copy on publication. It will be profusely illustrated with my work. My weekly work in the Pall Mall Budget has created some astonishment as nobody gave me credit for caricature and wash-work, but I have blossomed out into both styles and already far distanced the old men at that sort of thing. Of course the wash drawings are most impressionist, and the caricatures in wiry outline. This last week I did the new Lyceum performance, Becket.

Katsukawa Shunsen, *A Courtesan*, c.1820. *Kakemono-e* (pillar-print, mounted as hanging panel) colour print from woodblocks. V&A E.12564-1886

Beardsley learned a great deal about the disposition of broad masses of drapery from his study of the Japanese printmakers, and in particular absorbed the lesson of how to represent the play of flat pattern across folded cloth in a stylised, decorative manner.

My portrait of Irving made the old black-and-white duffers sit up; and my portrait of Verdi, this week, will make them sit up even more. I get about £10 a week from the Pall Mall and can get off all the work they require on Sunday. Clark, my dear boy, I have fortune at my foot. Daily I wax greater in facility of execution. I have seven distinct styles and have won success in all of them...

Shortly afterwards, writing to A. W. King, Beardsley announced, with perhaps the last hint of naïve schoolboy enthusiasm and bravado breaking through the new suaveness of manner which he was rapidly mastering, 'I'm off to Paris soon with Oscar Wilde'. Henceforth he would affect, with considerable assurance, that pose of world-weary hedonism and dandified insouciance that was the currency of the Cénacle. He adopted their self-consciously 'brilliant' tone, and learning the value of the well-judged *mot*, easily succeeded in gaining a reputation for his manner that matched the one he was winning for his art. 'I caught cold', he was heard to say, in a line worthy of Beau Brummell, 'by going out without the tassel on my walking stick.'

Just what Beardsley meant exactly by his 'seven distinct styles' is far from clear. Indeed he, too, may well have been a little vague about the precise meaning of the boast; for, when writing to the editor of the *Pall Mall Magazine*, T. Dove Keighley, begging the return of *La Femme incomprise*, which he wanted for the sending in day of the NEAC show, he somewhat confusingly described the drawing as being 'worked in semi-Japonesque style'; meanwhile to King he wrote that he had 'struck out [in] a new style and method of work which was founded on Japanese art, but quite original in the main... something suggestive of Japan, but not really Japonesque...' What is certain is that at this stage, as the monthly parts of the *Morte* continued to appear, he was more than anxious to put the Burne Jones–Morris medieval style behind him, eschew ordinary, journalistic drawing in the style of 'the old black-and-white duffers', and concentrate on illustrations with the kind of subject matter and in the 'Jap' style that appeared fresher and more unusual.

It was clear that his 'new Jap manner' was the one amongst all his ways of drawing that both he and those who were watching his work evolve found the most exciting and the most full of potential. Rapidly, and with an increasingly sure sense of what reproduced well by line-block and looked good on a printed page, he pared away the less successful stylistic elements of his earlier manner, such as the 'nightmare profusion' and sometimes meaningless mesh of fine, spidery, calligraphic lines and ornaments that had previously threatened to overwhelm such drawings as *How King Arthur saw the Questing Beast* and certain others of this phase including *A Snare of Vintage* from the Lucian series. Abandoning what Haldane MacFall, a writer, art amateur and early collector of Beardsleyana, aptly termed his 'hairy line' grotesqueries, henceforth his work would exhibit the essential economy of the Japanese woodblock artists, whilst his talk would be much about the importance of *line* in the creation not just of illustrative drawings, but in all works

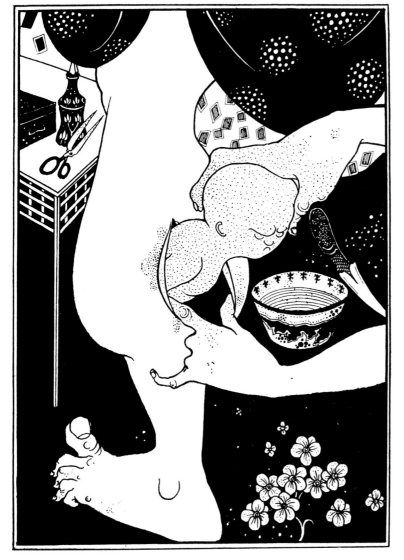

Birth from the Calf of the Leg;
illustration intended for *Lucian's*
True Histories, 1894, but not used.
From line-block. V&A E.687-1945

One of several designs omitted from
the published version of *Lucian's True*
Histories, this design, one of the most
strongly influenced by the study of
Japanese prints, was identified by
Brian Reade as another instance of
Beardsley's obsession at this time
with foetuses and with the subject of
'irregular births'. The design was not
printed until 1906, when it appeared
in Smithers's portfolio *An Issue of Five*
Drawings Illustrative of Juvenal and
Lucian.

of art. So great was his interest in this particular theme that he even con-
templated writing some sort of article. To King, in whose school magazine
The Bee his first published illustration had appeared, Beardsley mentioned
that 'I am anxious to say something, somewhere, on the subject of lines and
line drawing', adding 'How little the importance of outline is understood even
by some of the best painters.' In the event, Beardsley discovered that Walter
Crane had also written something about the importance of lines, and so the
idea was dropped.

That Whistler was, at first, so relatively hostile to him, and seems to have
gone out of his way to be both discouraging and rude, may in part be the
result of Beardsley's obvious attempts to ally himself with the Cénacle, and
in particular with Wilde, with whom the ever-irascible Jimmy had skir-
mished, for the most part light-heartedly for many years, but with whom

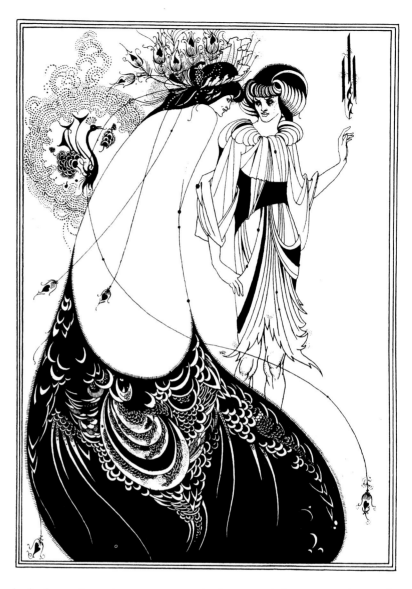

The Peacock Skirt, from *Salome*, 1894.
From line-block.
Plate IV in portfolio edition, 1906.
V&A E.426-1972

Whilst retaining some slight
reminiscences and mannerisms of
Beardsley's Mantegnesque style,
The Peacock Skirt, of all the *Salome*
pictures, most clearly reveals his
great debt to Whistler's painted
decorations in the house of
Frederick Leyland.

he had, too, from time to time, reached a state of almost outright war. It
must also, however, have been due to a degree of jealousy on the part of the
older painter, who was irritated by the equally blatant way in which
Beardsley had profited from the study of his pictures, his prints and, espe-
cially, the decorations of the Peacock Room. For whilst Beardsley's earliest
japonesque style clearly revealed some degree of first-hand knowledge of
the work of Japanese artists, and in particular of the stylised graphic modes
of the *Ukiyo-e*, the prints of the artists of the 'Floating World', it relied even
more heavily, perhaps, upon lessons that he had learned from 'the Master's'
own, idiosyncratic use of oriental motifs and conventions.

This debt is most readily apparent when a comparison is made between
details such as the intricate pattern of peacocks which seems to be a repre-
sentation of the decorative border of a carpet in Beardsley's drawing *Madame*

Cigale, and the highly stylised and exquisitely judged painted designs with which Whistler adorned the shutters of Leyland's dining-room and composed his celebrated large panel of fighting peacocks. It was a debt that would become even more clearly revealed when Beardsley's first drawings for Wilde's *Salome* began to be seen. *Japonisme*, however, was by the nineties a taste that had been growing for some considerable time.

In England, as in France, artists had been the first to make discoveries in this unfamiliar area; as early as the 1860s Rossetti and Whistler had vied with each other to find the choicest specimens of blue-and-white china and picked up unconsidered Japanese prints in the sailors' pawnshops of Wapping and Limehouse and the curiosity dealers' emporia of old Chelsea. As a result, the collecting of Japanese prints had become something of an obsession among the artists and Aesthetes of the 1870s and 1880s, for whom all kinds of oriental china and enamel-wares, painted fans and other oriental gewgaws had held a similar numinous charm. In his Oxford days Oscar Wilde had been a devotee, and had helped, with his high aesthetic profile, further to disseminate a rather less rigorous love of the quaint and colourful.

James McNeill Whistler (1834–1903), Detail of the decoration of the Peacock Room from the house of Frederick Leyland, 1876–7. Freer Art Gall, Smithsonian Institution, Washington.

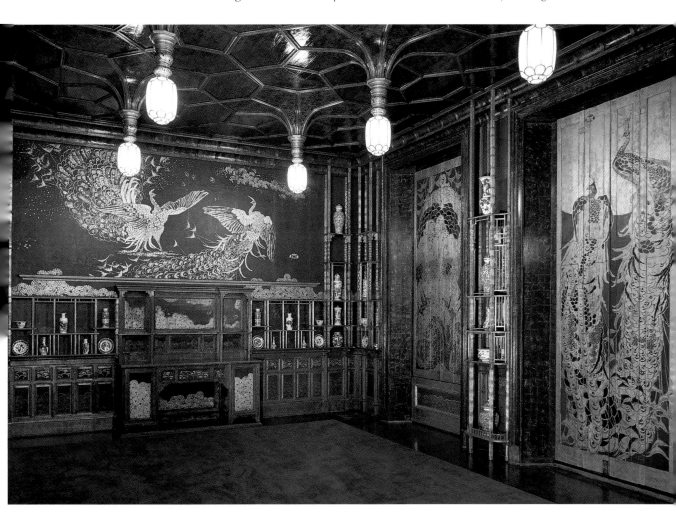

Shunkosai Hokuyei
(fl. early 19th century), *Portrait of an Actor*, c.1830. Colour print from woodblocks. V&A E.5130-1886

The acquisition of a major collection of Japanese prints by the South Kensington Museum in 1886 for the first time made a large body of these influential images available to artists and a wider public. The bold graphic stylisation and abstraction of form practised by the Japanese artists of the late eighteenth and early nineteenth centuries, such as Utamaro and Hokuyei, was of crucial importance to Beardsley.

By the nineties, however, the appreciation of the Japanese print had reached a new stage of connoisseurship. Whistler himself had developed a good eye for the best specimens and framed and hung them with his usual consummate taste. Charles Ricketts and Charles Shannon (Wilde's great friends, and to some degree Beardsley's rivals for his esteem), meanwhile, were in the throes of forming a highly important collection; at just this moment one of their greatest artistic *coups* was the acquisition (after frantic borrowing of money from all their friends in the saleroom) of six superb volumes of the drawings of Hokusai.

Beardsley's own attitude to oriental art in general, and to Japanese prints in particular, seems to have been similar to his approach to most other passing influences. He had, it would appear, no overwhelmingly compelling desire to collect these things himself, but rather simply to scrutinise and extract from them some essence that would spark his imagination, inform his technique and enrich his vision. Only at one point in his life, and then hardly for the space of more than a year or two, did he ever enjoy the means to settle in a house of his own and indulge in the amassing of furniture, books in any number, or works of art. In marked contrast to the more dedicated Aesthetes, such as Ricketts and Shannon, for whom the pursuit of Old Master drawings, Japanese prints, Persian paintings, Tanagra terracottas, Greek vases and other rarities and 'pretty things' was a religion and high calling, Beardsley chose always to travel light.

Similarly, unlike the majority of artists of his era, weighed down by equipment and accustomed, no doubt in part because of the old tradition of collecting props for their studios, to assemble about themselves magpie hoards of more or less 'artistic' treasures, Beardsley's art simply did not require him to surround himself with things. He worked at a plain table on a sheet of paper, dipping his pen into a single bottle of ink. His images came not from what he saw around him but from his inner eye. Later, as we shall see, he did own a sensational set of erotic Japanese prints by Utamaro, given to him by William Rothenstein, but these racy images he framed and hung on his wall no doubt partly through a desire to shock visitors, thereby confirming his status as *enfant terrible* of the London art world. For the time being, at least, his interest in oriental art was more formal, and indeed in the truer aesthetic tradition. Quite which Japanese artists he was familiar with at this stage we may never know. By this date, however, the prints themselves were not so difficult to see, and also the first books on the subject in English were beginning to appear. Again, the influence of Frederick Evans should not be discounted; for Evans, with his modest means and quiet but refined taste, had formed a small, but very choice collection of original prints by the best of the *Ukiyo-e* artists of the high period in late eighteenth century.

As Beardsley's letter to Scotson-Clarke revealed, he was already in considerable demand with London publishers anxious to give their books a boost of publicity. Many commissions for single frontispieces came his way, and he appeared regularly in the pages of the weekly illustrated papers. These contributions varied widely in style, but increasingly tended to be in versions of

the 'Jap manner'. One exception was the drawing he contributed to a curious production of the Cénacle: Ross's friend More Adey, one of the first to buy early drawings by Beardsley, had translated a Norwegian drama, *Pastor Sang*, by one Björnstjerne Björnson. Published under a pseudonym, the little volume appeared with a somewhat conventional binding designed by Aymer Vallance, but adorned with a frontispiece in which Beardsley – presumably to evoke a 'northern' spirit – not only copied Albrecht Dürer's linear woodcut style but also parodied his celebrated monogram signature, substituting AB for AD.

A very much better illustration, only slightly marred by being printed very small to fit the format of a pocket edition, adorned a volume of *The Wonderful History of Virgilius, the Sorcerer of Rome*, issued by David Nutt. With its unconventional cutting of the figure by the picture border and absolutely flat, stylised and richly patterned drapery, it reveals the very clear influence of the prints of the early nineteenth-century Osaka School. This eccentric placing of the image, so characteristic of the vision of the Japanese artists and also a trick that Toulouse-Lautrec learned to such interesting effect from his study of their techniques, would come to play an increasingly important part in Beardsley's compositional practice for the next year, during the short period in which oriental influences continued to hold sway. For the moment his interest lay mainly in the potential of playing with Japanese ambiguity of spatial form. Eliminating all conventional descriptive elements of shading

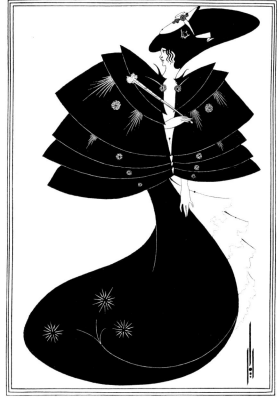

The Black Cape; from *Salome*, 1894. From line-block. Plate VI in portfolio edition. V&A E.427-1972

One of the designs substituted by the artist for an unacceptable image, and described by him as 'simply beautiful, but quite irrelevant'.

and modelling in the European manner, and concentrating on the sinuous quality of line and the effect of pattern, Beardsley became the master of an almost cerebral game involving the precise balance on the blank white page of a handful of steely lines and the perfectly judged 'black blot'.

Beardsley continued also to draw for Lewis Hind, who, having started *The Studio*, had, even by the time its first number appeared, left in order to work for William Waldorf Astor on the *Pall Mall Budget* and *Pall Mall Magazine*. Beardsley's contributions to these pages combined elements of his 'Jap manner' with the inventive grotesqueries that he had popularised in Dent's *Bon Mots* books. Hind later wrote that he and Beardsley took great, and rather conspiratorial delight in the fact that the chief editor at the *Pall Mall's* offices, Leslie, disliked his drawings intensely. But, as Hind observed, 'Leslie soon learned that many people talked of the *Pall Mall Budget* because Beardsley worked for it'; notoriety was a trump card that Beardsley was quickly learning to play. Two large and elaborate full-page illustrations, one an invention of the artist's own entitled *Of a Neophyte, and How the Black Art was revealed to Him by the Fiend Asomuel*, and a second illustrating a macabre short story, *The Kiss of Judas: A Moldavian Legend*, which appeared, respectively, in the June and July 1893 issues of the *Pall Mall Magazine*, are important as the first manifestations of Beardsley's most mature 'Jap manner'; both are drawn with the absolute assurance of line, the balance of blacks and whites, and that intense precision in the pen-work of the decorative motifs, that make Beardsley's work so entirely distinct at this moment; and both, too, reveal that particular blend of intricacy and curious suggestiveness in the details that would captivate the public's attention when Beardsley' s most celebrated set of illustrations, those for John Lane's edition of *Salome* made their much heralded appearance towards the middle of 1894.

The story of Wilde's strange poetic drama and of the illustrated edition that brought the book, the author and the artist such an immense *succès de scandale* is one of the key episodes in the great legend of the nineties. It was perhaps in admiration of the French literary *décadents* such as Théophile Gautier, and under the influence of his newer French friends – writers such as Pierre Louÿs, Catulle Mendes and the Symbolist poet Marcel Schwob – that Oscar Wilde had first turned his thoughts towards the creation of a solemn and sombre verse drama based, like his poem *The Sphinx*, on the richness of ancient legend. Certainly the biblical story of Salome, the young, beautiful, but depraved and sadistic princess who, crazed with desire for the perfect body of the imprisoned John the Baptist, offers to dance lasciviously for the tetrarch Herod, hoping to receive the Baptist's head as her reward, could hardly be bettered in its potential as a vehicle for examining that favourite theme of the age, the *femme fatale*, and for generally revelling in the excesses of the Decadent sensibility.

Wilde originally wrote the play, perhaps with a little help from one or two of his Parisian friends, in French. This prompted Beardsley, who, it will be remembered was also very fluent in the language and well-versed in its literature, to caricature the poet seated like an over-grown schoolboy at a

Cover design for *Salome* by Oscar Wilde (John Lane and Elkin Mathews, 1894). Stephen Calloway

Beardsley originally planned an elaborate design of peacocks' feathers to be blocked in gold on the cloth covers of the book. In the event it was decided to use only a small decorative medallion with motifs of roses, stems and dots for the upper cover and a version of the artist's emblem of three candles for the lower.

desk, working on his manuscript surrounded by cribs including not just volumes of Josephus and Swinburne and a vast 'Family Bible' , but also a French dictionary and *French Verbs at a Glance.* Wilde's French text was published simultaneously in Paris, by the Librarie d'Art Independant, and in London, by John Lane and Elkin Mathews, in a simple, unillustrated edition in 1893. Wilde, with his typical blend of impossible egoism and expansive generosity, presented a copy to Beardsley with a fulsome inscription that read, 'March '93 For Aubrey: for the only artist who, besides myself, knows what the Dance of the Seven Veils is, and can see that invisible dance. Oscar'.

When it became known that Sarah Bernhardt, the greatest tragedienne of her day had 'accepted' Wilde's play, and intended to take the role of Salomé herself, its reputation was made. Wilde was ecstatic at the honour conferred upon him as an author, and plans were laid for a production. Quite how the 'divine Sarah', then nearly fifty, already rotund and rather less mobile than she had been in her legendary youth, would have approached the scene in which the sixteen-year-old princess inflames the lustful passions of Herod to the point of madness by the gradual revelation of all her lithe charms and dances herself to a point of orgasmic frenzy is, to say the least, unclear.

As is well known, however, failure to secure the necessary licence for performance from the Lord Chamberlain's office – it was refused on the grounds of an old Puritan law forbidding the representation of any biblical character on the English stage – halted all further progress with the production. Wilde made the most of the situation, giving press conferences and threatening to throw up his British nationality in favour of taking himself across the Channel to France, where artists were less persecuted by the philistines. With so much good publicity already whipped up, however, Wilde was anxious not to lose the moment, but to capitalise upon the play's *réclame*. He proposed issuing an English version of his now famous text. John Lane, always alive to potential profits, was equally enthusiastic; all agreed that Beardsley had already demonstrated in the drawing reproduced in *The Studio* article, *J'ai baisé ta bouche, Iokanaan*, that he had grasped the essential nature of what was required.

On that basis, and without any need of further samples, Lane happily offered him the commission to make a suite of illustrations, proposing the sum of fifty guineas for the suggested ten designs. In relation to what he had been earning from Dent for his *Morte Darthur* drawings, the deadlines of which still dragged on, and in relation to the fees commanded by other illustrators, such as the more experienced Ricketts, for example, this valued Beardsley's contribution highly. A comparison with Wilde's deal for the publication is also revealing: as author he was to receive not a fee, of course, but a royalty. On the 500 ordinary copies of the work to be sold at fifteen shillings, his share would be one shilling for each copy sold, whilst on the de luxe copies, offered at thirty shillings, his royalty was three shillings; in all, the return Wilde could expect was no more than forty pounds.

In contrast with the reluctance with which he now tackled the weekly bundle of *Morte* borders and other drawings, Beardsley set to work on *Salome* with the greatest enthusiasm. As early as June 1893 he was writing to Robbie Ross to tell him that he could inspect the first drawings when next he visited the club-like offices of Lane and Mathews, the Vigo Street headquarters of the whole nineties literary movement. By later in the year, however, things were not going so smoothly, and Beardsley found himself embroiled at the centre of a first-rate bookish *brouhaha*.

For a start, there was the question of the text of the play. Wilde had, perhaps unwisely, agreed that the translation of his slow, repetitive and melodic French lines into English would be made by Lord Alfred Douglas, with

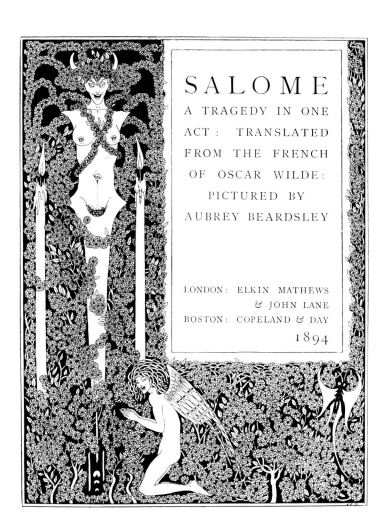

whom he was at this time utterly infatuated. When it transpired that
Douglas's version was slipshod, inexact and inelegant the trouble began. The
more his text was criticised the more difficult Douglas became, and matters
were, if anything, only exacerbated when Beardsley – whom Douglas both
disliked and distrusted – proposed, in all probability as he thought helpfully,
rather than with any malice intended, that he could make a better version.
Douglas naturally insisted that Wilde refuse. In the event, a curious com-
promise was reached whereby the wording of the text was silently but radi-
cally amended by several hands, whilst Bosie's name was gently, but firmly,
removed from the title-page, only to reappear in the dedication which
Wilde, in order to keep the peace, subtly rewrote so that it finally read, 'To
My Friend Lord Alfred Bruce Douglas, the translator of my play'. Douglas, it
seems, was for once content with the outcome of a quarrel and let matters
drop, but as far as Beardsley was concerned the damage had been done.
Always mortally sensitive about the way in which he believed Wilde
snubbed and patronised him – and Wilde had once, in the hearing of many,
claimed to have 'invented Aubrey' – Beardsley considered that his scholar-
ship, his mastery of the language of decadence and his carefully nurtured

Title-page of *Salome;* (Elkin
Mathews and John Lane, 1894).
Stephen Calloway

Beardsley conceded that in its
original state the drawing was
'impossible' for booksellers to
display. In all earlier editions the
genitalia of the priapic herm and the
little worshipping Amor were
deleted for the sake of propriety.

sophistication had all been impugned. Clearly exasperated and indignant, he confided his opinion of Wilde and Douglas to Ross: 'both of them are really dreadful people.' Perhaps as a result of the extremely stressful situation Aubrey suffered, for the first time after a long interval of remission, a worrying return of 'severe attacks of blood spitting'.

As if all this was not enough, Beardsley also found his drawings attacked on all sides. Lane was having cold feet about many of the details that the artist had included and, along with the inherently more timid Mathews, and spurred on by the further intercession of the novelist George Moore, then one of his most valued authors, was insisting on changes and bowdlerisations of many of the offending passages. 'The *Salome* drawings have created a veritable *Fronde*, with George Moore at the head of the *frondeurs*...', wrote Beardsley to his friend and ally in his dealings with Lane, Will Rothenstein. Working in his best 'Jap manner' – which it seems no-one thought to question for its pictorial relevance or *stylistic* suitability for a play set in biblical times in the great fortress-palace of the Machaerus on the borders of ancient Palestine – and spurred on by the lushly decadent eroticism of the text, Beardsley had freely invented his own scenes, characters and details, and introduced anachronistic elements of all kinds. More crucially though, he had submitted several drawings which contained, by the standards of the day, indecencies and indelicacies that would have created almost insurmountable problems when it came to publication.

Among these difficult details were a number of figures, such as a generously endowed priapic garden herm (based on a *Morte Darthur* chapter head) and a kneeling putto, both contained in a decorative framework intended for the title-page, in which the genitalia were very pronounced. Persuaded by Lane to rethink at least some details, Beardsley confessed in a letter to Ross, 'I think the title-page I drew for Salome was after all "impossible". You see booksellers couldn't stick it up in their windows. I have done another [version] with rose patterns and Salome and a little grotesque Eros, to my mind a great improvement on the last.' In the event, both versions appeared, the second being used for the 'list of pictures', whilst the original was allowed to stand as the title – but only once the offending elements had simply been blanked out.

Other drawings proved less easy for Lane and the blockmakers to doctor. In *Enter Herodias*, Beardsley introduced a retinue of dubious characters, including a bizarre, somewhat hermaphrodite figure of a page, whose feminine cast of features and uncompromisingly frontal nudity clearly revealed that he was unaroused by the splendid vision of the brazenly bare-breasted queen. Beardsley was required to conceal this sexually tell-tale detail, and therefore drew a large and quite clearly ironic fig-leaf tied in place with a bow across the equivocal page's loins. This satisfied the objectors, all of whom, astonishingly, failed to notice either the clear outline of a monstrous erection ill-concealed by the taughtly stretched garment worn by a second, far more grotesque – though sexually conformist – attendant, or the seemingly obvious phallic shapes barely concealed as the sconces of a strange candlestick in

John Lane. Photograph from *John Lane and the Nineties*, by J. Lewis May, 1936. Private Collection

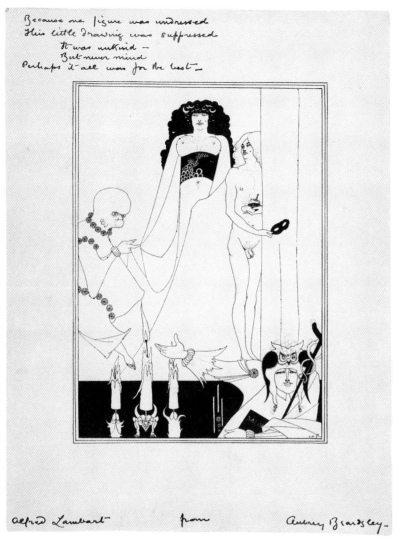

Because one figure was undressed
His little drawing was suppressed
It was unkind —
But never mind
Perhaps it all was for the best —

alfred Lambart from Audrey Beardsley

Enter Herodias; from *Salome,* 1894.
Annotated proof of line-block of the
original state. Princeton University
Library, Gallatin Collection

One of the key images in the
brouhaha over the *Salome* pictures, this
proof inscribed by Beardsley to a
friend preserves the original
appearance before the facetious and
cynical addition of the oversized fig-
leaf which made the illustration
acceptable to Lane and the public.

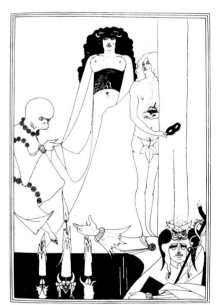

Enter Herodias; from *Salome,* 1894, as
published. From line-block.
Plate IX in portfolio edition. V&A
E.430-1972

The fig-leaf conceals the relatively
inoffensive and clearly inactive penis
of the effeminate page; the other
seemingly more outrageous phallic
details of the picture apparently
went unnoticed.

the lower frieze of the design. On a proof copy (made from a photograph
taken before the drawing was altered, and which therefore preserves the
entirely unexpurgated image) which he presented to his friend, Alfred
Lambart, Beardsley wrote a short, wryly funny rhyme:

> *Because one figure was undressed*
> *This little drawing was suppressed*
> *It was unkind*
> *But never mind*
> *Perhaps it all was for the best.*

Just as the nervous Lane's examination of the details of Beardsley's illus-
trations became ever more minute, so his inclusion of humorously suggestive
elements became increasingly devious. It was a game of cat-and-mouse that
the artist clearly relished, not perhaps especially for art's sake, but rather for
its own amusement, and as a way to *épater les bourgeoises.* At least three of

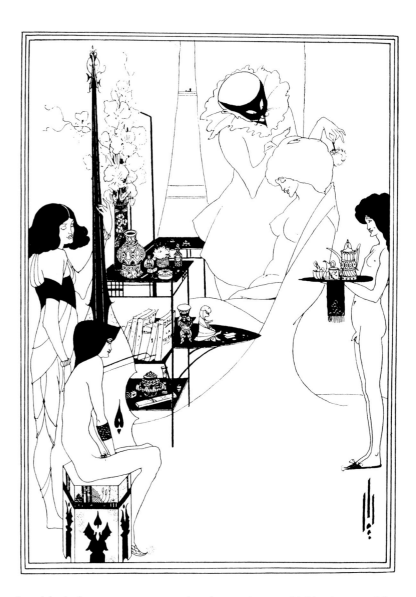

The Toilet of Salome I, from *Salome*, 1894. Intended for *Salome*, but unused in the first edition. From line-block. Plate XII in portfolio edition, 1906. V&A E.433-1972

A number of coded implications, all-too easily understood by a late 19th-century audience versed in the supposed visual evidences of moral and sexual decadence, convinced Lane that he could not include this design in the 1894 edition.

Beardsley's drawings were considered quite 'impossible' by Lane and his unofficial censorship board. The most problematic of all was the first version of *The Toilet of Salome*, a scene in which Salome is seen seated, naked except for a vague suggestion of a wrap, at a thoroughly modern dressing-table with elegant attenuated legs in ebonised wood in the smart, Aesthetic Movement style of E. W. Godwin. Apart from the curious extent to which, in setting and characterisation, the illustration wilfully strayed from Wilde's text in which no such episode occurs, the figure of Salome herself appears from the heavy lids of her eyes and dreamy smile, from the erect profile of the nipple of her bare breast and, not least, from the position of her hand, to be quite obviously lost in a masturbatory reverie. Indeed, on closer inspection of the supporting figures and incidental details, it is clear that the entire image is full of other, more coded references to depravity, any of which might, how-

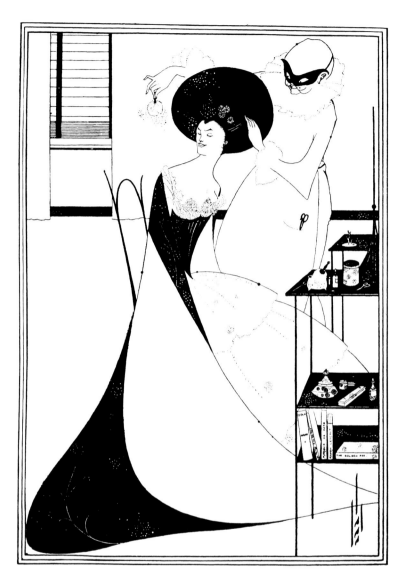

ever, have proved all too easy for a nineteenth-century audience to read. These included not just the facial and physical looks and gestures of the other attendants, but also subtle details such as the bent spine (thought by most moral Victorian observers to be an inevitable outcome and overt evidence of solitary vice) exhibited by the sexually ambiguous – and also masturbating – creature seated in the foreground on a fashionable Moorish stool.

In the event, Beardsley supplied in place of this drawing a second, yet more daringly abstracted toilet scene in which a bald pierrot of a barber, dressed in eighteenth-century ruffles, coifs a distinctly modern Salome, who sits, again, by a Godwin dressing-table. On a shelf he mischievously included a number books, the revealing titles of which were quite legible; this little decadent library comprised *Manon Lescaut*, and *Les Fêtes galantes*, the slightly more risqué *Golden Ass* and two volumes yet more scandalous according to

The Toilet of Salome II; from *Salome*, 1894. Replacement design, as used in the first edition. From line-block. Plate XIII in portfolio edition, 1906. V&A E.434-1972

Beardsley's revenge on those, such as Lane, who attempted to censor him, was to include fresh outrageous elements in his replacements of unacceptable designs; in this case, the titles of the books were subtly calculated to scandalise a conventional reading public.

Caricature of James McNeill Whistler, 1894. Pen and ink. National Gallery of Art, Washington, Rosenwald Collection

Whistler at this date was generally antagonistic towards Beardsley. Although Whistler was in no way effeminate, Beardsley has suggested his undoubted preciousness by the mincing gesture with which points at a butterfly, the symbol the painter had adopted as his personal emblem. Beardsley has seated him upon a frail-looking chair in the style of E. W. Godwin, a look which he favoured himself in his house in Pimlico.

Design for titlepage of *Keynotes*, by George Egerton (John Lane, 1893). Collection Anthony d'Offay.

The first of the long series of popular novels, mostly on contemporary subjects and with Society settings, published by Lane. In addition to designs that served for both cover and title-page of each volume, Beardsley also contributed ingenious monograms for each author in the form of intricate keys.

Bookplate for J. Lumsden Propert, 1893. Pen, ink and wash. V&A, Harari Collection, E.293-1972

This design for a bookplate for the bibliophile Propert, drawn shortly before the *Salome* pictures, introduces figures such as the white-faced pierrot typical of Beardsley's cast of characters in his *Yellow Book* phase.

the mores of the day: Zola's *Nana* and one simply lettered *Marquis de Sade*. In the same way, after much discussion at the Bodley Head and a great many hurried consultations and letters and telegrams back and forth between Wilde and Lane, Beardsley eventually submitted to criticism in two further cases, and agreed to add extra designs to the set, including another wholly 'modern' image, *The Black Cape*. As he wrote to Ross, 'I suppose you've heard all about the *Salomé* row. I can tell you I had a warm time of it between Lane, Oscar and Co. For one week the numbers of telegraph and messenger boys who came to the door was simply scandalous... I have withdrawn three of the illustrations and supplied their places with three new ones (simply beautiful and quite irrelevant).'

Wilde, to his credit as a judge of artistic merit in book design and illustration, but also perhaps because he nursed an obvious and understandable desire that his book would be much talked about, appears to have had few misgivings about Beardsley's drawings in general, and none specifically about their decency or lack of it. What did annoy Oscar in the weeks that followed the issue of the book was the extent to which Beardsley was generally perceived to have 'slighted' his superb text by wilfully making drawings that failed – in the conventional sense, at least – to illustrate the book at all. This question of the 'irrelevance', of the highly tangential relationship that exists between image and word, or simply of the 'impertinence' of Beardsley's designs, would be taken up by many of the book's critics as a key issue. As one writer in *The Studio* succinctly put it, 'we find the irrepressible personality of the artist dominating everything – whether the compositions do or do not illustrate the text...' And, as a final point of contention, there was the matter of how amusingly Beardsley had chosen to caricature the author in his designs. In fact, Wilde's distinctive cast of features appears, quite recognisably and, as most observers thought, somewhat unflatteringly portrayed in a number of the drawings; most notably as the pale, bloated face of the *Woman in the Moon*, and in the sinister figure – half dramaturge and half circus barker – in the foreground of *Enter Herodias*. No doubt the photograph of himself which Wilde had given to Beardsley, and which the artist kept prominently displayed near his work-table at this time, had served an unexpected turn. Mabel Beardsley later recalled that these images of the poet were 'too delicate' for him to resent; but they must have contributed to his overall dislike of the finished set, which he described – out of Beardsley's hearing – as resembling 'the naughty scribbles of a precocious schoolboy... on the margins of his copybooks'.

After all the earlier difficulties concerning the publication had continued to rumble for what had seemed an age, and just as things seemed finally settled, a further, final row blew up concerning the cover. Lane expressed his intention of using a curious, silky, but rough-textured blueish linen for the binding. Wilde, who was certainly very sensitive to the nuances of book design, immediately took up the fight, writing to Lane, 'The cover... is quite dreadful. Don't spoil a lovely book. Have simply a folded vellum wrapper with the design in scarlet – much better and much cheaper. The texture of

The Woman in the Moon; from *Salome*, 1894. From line-block.
Plate 1 in portfolio edition, 1906.
V&A E.422-1972

Although in no real sense an illustration to the action of the play, the scene is suggested by the author's poetic description of the appearance of the moon; Beardsley caricatured Wilde's broad features in the face of the moon.

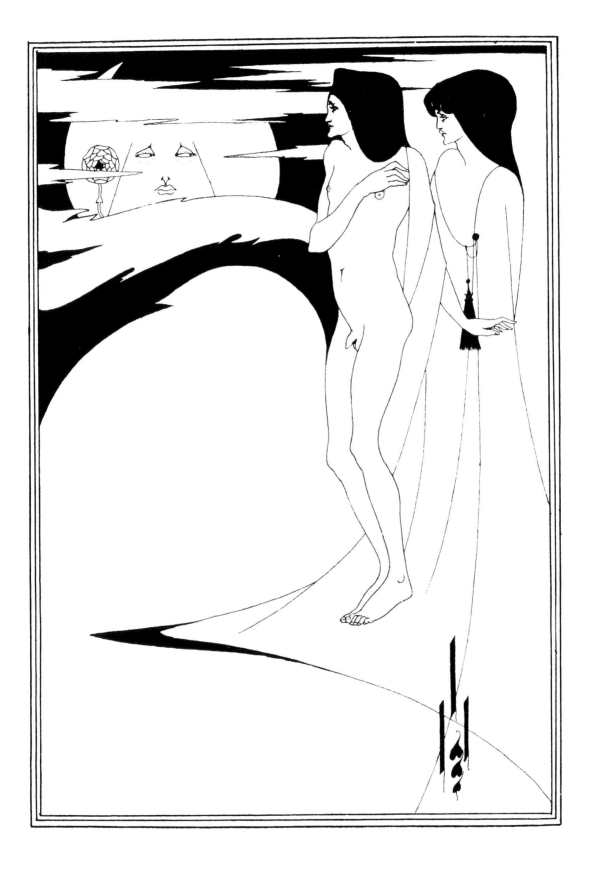

Design for cover and title of
The Dancing Faun, by Florence Farr
(John Lane, 1894). From line-block.
V&A E.1132-1965

For Florence Farr's first book, a
clever satire of the world of the
Aesthetes, Beardsley supplied
another thinly veiled caricature of
Whistler as a goat-legged faun
seated upon an impossibly delicate
Grecian sofa.

the present cover is coarse and common and spoils the real beauty of the
interior. Use up this horrid Irish stuff for stories, etc.; don't inflict it on a
work of art like *Salome...*' Beardsley, he added for good measure, agreed with
him. Perhaps he did. Lane, however, in a memoir written in 1922, suggested
that things were rather different by this stage: 'At that time', he recalled,
'Beardsley and Wilde were only just on speaking terms.' And John Rothen-
stein, writing at about the same distance in time, long after both the
protagonists were dead, but presumably giving information gleaned at first
hand from his father William (then still very much alive), reported that
'[Beardsley] himself always disliked *Salome*, and when he had finished his
illustrations for it he exclaimed, in the egotistical manner which he at that
time affected, "Now I have given distinction to that tedious book. I ought to
have done *The Sphinx* and Ricketts *Salome*."'

Nevertheless, when it finally appeared in February 1894 *Salome* caused
precisely the sensation that its creators had anticipated and hoped for, its
scandalous success easily eclipsing the publication of Wilde's other great illus-
trated book of the same year, *The Sphinx*, much to the chagrin of Ricketts,
who always considered himself Wilde's book designer and an older and more
constant friend. The *Art Journal*'s reviewer voiced the general reception when
he expressed the fear that '*Salome* is a book for the strong-minded alone, for it
is terrible in its wierdness and suggestions of horror and wickedness', whilst

The Times declared that Beardsley's pictures were 'unintelligible for the most part and, so far as they are intelligible, repulsive.' For good or ill, Beardsley was now regarded on all sides as *the* quintessential artist of the Decadent camp. But still he was not content. He wanted to be more than an illustrator; his desire, it seems, at this time was to be taken seriously as more than a mere draughtsman. In the manner of Alfred d'Orsay at the beginning of the nineteenth century, he aspired to be not only an artist, but also a Man of Letters, and, like the illustrious count, jealously nurtured his reputation as a wit and a dandy. Already, as Charlie Marillier, Oscar Wilde's sometime lodger, observed, he was becoming 'a model of daintiness in dress, affected apparently for the purpose of concealing his artistic profession. It was part of his pose to baffle the world. He did it in his exterior manner as in his work.' Like Wilde's *Remarkable Rocket*, Beardsley was determined to create a sensation.

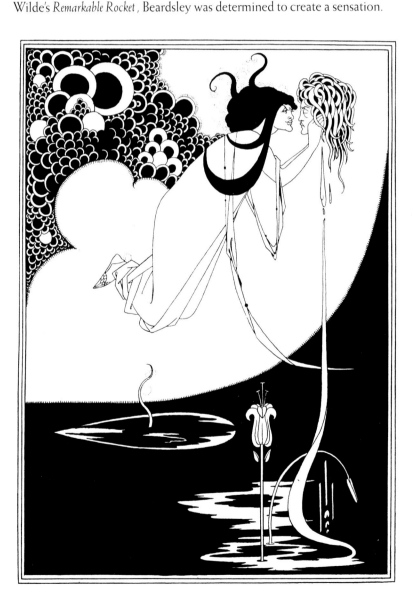

The Climax; from *Salome*, 1894. From line-block. Plate XV in portfolio edition, 1906. V&A E.436-1972

Because *The Studio* owned the copyright of Beardsley's original version of this subject the artist was obliged to redraw it; in fact this new version displays a considerable advance stylistically, even if it lacks something of the sheer menace of his earlier characterisation of the *femme fatale*, Salome. A comparison (illustration p.59) also reveals Beardsley's move away from his old preferred elongated upright format towards the more conventional page proportions favoured by Lane and other publishers.

Chapter five
THE GLARE OF YELLOW

In the myth of the nineties two dates have long been accorded a certain
spurious significance. New Year's Day 1894, the supposed occasion on
which Beardsley and his friend, the American writer Henry Harland sat talk-
ing and, as they claimed, more or less upon the spur of the moment con-
ceived the idea of *The Yellow Book*, has been pinpointed as the moment when
not just the celebrated periodical, but also the authentic Decadent sensibility
of the decade had its birth. The rather more ill-omened day in the February
of the following year, on which the failure of Oscar Wilde's libel suit against
the Marquess of Queensberry led to his own subsequent arrest and trial for
homosexual offences, has in the same way been taken – and perhaps with
greater justification – to signal the distinct day upon which the *Yellow Book*
and, indeed, the entire Aesthetic and Decadent sub-cultures of the nineties
started upon what would prove an ignominious and terminal decline.

Between those two dates four volumes of the *Yellow Book* had appeared.
Shortly before the fifth was due, Beardsley, until that moment riding high as
the cynosure of the sensational new quarterly and greatly in demand on all
sides, was dismissed. Brought down by his supposedly intimate association
in the public eye with Wilde and his circle, he was damned without trial,
his high hopes dashed and his prospects devastated. Curiously therefore, if
those dates have any true significance, it is that they mark with an all too
poignant accuracy the beginning and end of the only period of his short life
when Aubrey enjoyed a real degree of prosperity, and during which he was
enabled through the financial success of his art to live comfortably in a house
of his own, to buy furniture and books and prints, to express his remarkably
idiosyncratic tastes through the decoration of his rooms, and to entertain
on a fashionable scale. For a year or two Beardsley had played the quintes-
sential wit and dandy-Aesthete of the nineties; now for a while he lived the
fast, brilliant life of the young man-about-town. But the flame burned
brightly only for a short time, and this phase of his life can be measured in
months; such was the awful brevity of the young artist's real moment of
notorious fame and fleeting fortune.

Given the dislocated nature of Aubrey and Mabel's childhood years, and
the family's restless moves from one set of lodgings to another, the acqui-
sition of a house of their own in the second half of 1893 was a joyous moment
and marked a significant achievement. Made possible in part by the remains
of their Pitt aunt's legacy of £500 to each of them, but more on the strength
of Aubrey's ever-brightening prospects, the house was actually taken in
Mabel's name, perhaps because her brother, only twenty-one towards the
end of August was too young legally to sign a lease and could, anyway, admit

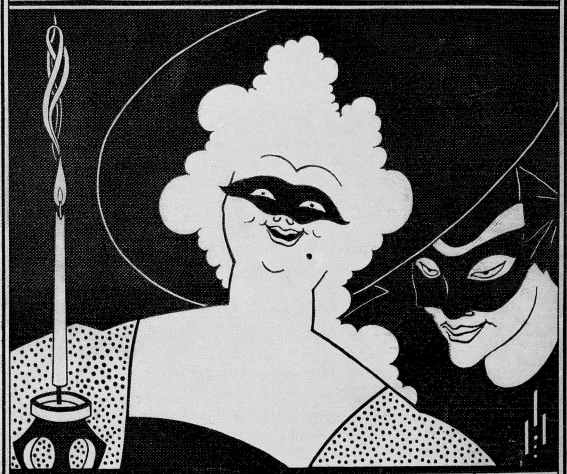

The Yellow Book

An Illustrated Quarterly

Volume I April 1894

London: Elkin Mathews & John Lane
Boston: Copeland & Day

Price
5/-
Net

114 Cambridge Street, c.1895.
Photograph. Private Collection

only to the dubious profession of 'artist', whereas she, a whole year older, could claim a certain 'steadiness', being (for the moment at least) in 'regular' employment as a teacher.

The house, 114 Cambridge Street, one of an otherwise unremarkable terrace of early nineteenth-century stucco dwellings in genteel, if hardly fashionable Pimlico, directly facing the church of St Gabriel, was one with nothing about the exterior to distinguish it in any way from its neighbours. Inside, by contrast, the young Beardsleys, having established their mother in conventional enough surroundings, rapidly set about giving the rest of the rooms a remarkable veneer of thoroughly modern sophistication. Their At Homes were held each Thursday at teatime; Mabel, vivaciously taking on the congenial theatrical role of society hostess, presided over a neatly elaborated tea-table; Aubrey shone in the harsh light of newly won celebrity; and Ellen Beardsley watched, perhaps a little awe-struck and mystified, as a succession of extraordinary guests called to view the Decadent artist, and hear his mannered conversation and delicate quips about art and books. A

few of Aubrey's *mots* are preserved. Some, such as 'The Brompton Oratory – the only place in London where one can forget that it is Sunday', are quite as good as Wilde at his best; a few clearly are spontaneous responses to the turn of the talk, whilst others, with that brittle sheen of the nineties seem – again like Wilde – to be the result of more careful preparation and polishing.

For Thursday callers there was also the opportunity to examine Aubrey's latest works – usually propped up for inspection, or politely passed from hand to hand for comment – but never was there any sign of work actually in progress. As has been observed, it was generally Beardsley's conceit to

conceal his work and his methods, to hide away his materials and to pose, like a Brummel – or more specifically like the painter-dandy D'Orsay – as a gentleman among his books. And, finally, there was the bizarre decoration, which had quickly helped to establish the celebrity of the Cambridge Street house not only in the social and artistic round of London, but, even from the outset, in the very mythology of the decade.

One of the crucial missing chapters in the history of interior decoration concerns the houses of Aesthetes and in particular the rooms of the decadent Aesthetes of the last years of the century. Photographs and paintings of grand houses and of comfortable, middle-class homes survive in great numbers, but, strangely, the houses of artists and writers – often the catalysts and crucial early protagonists of new styles – are less easy to document. Some rooms, such as those of the Pre-Raphaelite painters, who took such an interest in decoration, were recorded, and fortunately it is possible to know the precise appearance of, for example, the famously dark and mysteriously brooding interiors of Rossetti's great, decayed Queen Anne mansion on

Interior of 114 Cambridge Street, 1950s. Photograph. Private Collection

A few family snapshots, of which this is one, provide perhaps the only remaining evidence of the appearance of Beardsley's drawing-room; though the room has been much altered, the black paintwork still survives on doors and window frames, and a large looking-glass hangs between the tall first-floor windows. Most intriguingly, here some vestige can just be discerned of the Godwin-style chimneypiece, once *en suite* with an overmantel and large bookcase.

Cheyne Walk, where, as Richard Le Gallienne said, he 'dwelt in mysterious sacrosanct seclusion like some high priest behind the veil in his old romantic house'. Similarly, although The Grange, in North End Lane, Fulham, is long since demolished, we can still see, in vivid watercolours at least, the place where Burne Jones hung Beardsley's great *Siegfried* drawing close to his framed engravings by Dürer.

But of Oscar Wilde's remarkable Aesthetic interiors at Thames House by the Strand, of his Tite Street house and of many of Whistler's brilliant interior schemes we have nothing but words. The sensibility which animated these rooms we can recall, but the actual appearance eludes us all too often. W. B. Yeats's modest rooms above one of the perfect little Regency shops of Woburn Walk conformed to a degree to the new Decadent ideal. There were rich hangings of deep blue (the gift of his ever-generous patron Lady Gregory), quirky tall green candlesticks illuminating a collection of engravings by William Blake, a Rossetti and prints and perhaps also a drawing by Beardsley framed on the wall. In his bookcase were ranged mystical texts and choice editions from the Kelmscott Press, whilst a copy of the single most splendid book of its day, the great folio Kelmscott Chaucer, with its illustrations by Burne Jones, lay open on an old ecclesiastical lectern that might have come from Des Esseintes's library at the château de Loups in Joris-Karl Huysmans's novel *A rebours* (Against Nature). As Yeats's first biographer, Joseph Hone, observed, 'Somehow or other, out of slender resources, he had managed to make the room an expression of his mystical doctrines'.

Others, too, had invented their own rarefied surroundings, rooms to mirror their moods and their poses. The house in Fitzroy Square shared by Herbert Horne, the Aesthetic theorist and poet, and the designer Selwyn Image fascinated many visitors, especially during the period when its third inhabitant was the poet and scholar Lionel Johnson; fortunately it was described by Yeats in his memoirs. Johnson lived such a perfect existence among his books that it reminded Yeats of Philippe-Auguste Villiers de l'Isle-Adam's arch remark from his play *Axël*: 'as for living, our servants will do that for us...' Yeats spoke of the great pleasure he derived from visiting Johnson's library, with its grey curtains of corded velvet hung over windows, doors and bookcases. The walls, he remembered, were papered with plain brown paper, a Whistlerian badge of rejection of the commonplace wallpapers of the day, affected by Horne, Ricketts and Shannon, and others of their circle.

Le Gallienne recalled another room inhabited by Johnson a little later, in which he had sat drinking absinthe and observed the decoration, 'paradoxically monkish in its scholarly austerity, with a beautiful monstrance on the mantelpiece and a silver crucifix on the wall'. Like others of their generation, both Johnson and Beardsley tended towards a rather spiritual dandyism that could find expression as easily in the creation of evocative surroundings that played with the atmosphere of religiosity. It was an atmosphere that not everyone admired; Camille Pissarro, worried about the increasing influence exerted by the English Decadents, and Aesthetes such as Charles

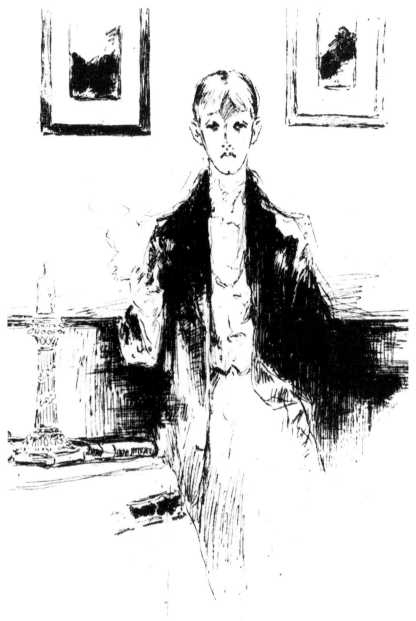

Penrhyn Stanlaws (fl. 1890s), Portrait sketch of Aubrey Beardsley; illustration for his interview 'Some Personal Recollections of Aubrey Beardsley', in *Book Buyer*, Vol. XVII, New York, 1898. From line-block. Library of Congress, Washington.

Stanlaws's original sketch was made at the time of his visit to the artist's house; although a poor likeness of Beardsley, the drawing remains one of the few authentic glimpses of the interior of Aubrey's house. The high black-painted dado, the framed prints on the wall above and an inaccurate impression of one of Beardsley's celebrated ormolu candlesticks can all be recognised.

Ricketts, over his son Lucien, sounded a serious note of warning: 'Damn it,' he wrote in an admonitory letter, 'neo-catholicism may be in style for a bit, but since real belief is necessary for it to succeed, the chances are it won't get very far; everyone cannnot be as sick as Huysmans is.'

In attempting to chart the rise of the Decadent sensibility in nineties England, the greatest disappointment is the lack of a single contemporary image of the famous rooms in his Pimlico house, which Beardsley decorated in a manner intellectually inspired by, but also closely following the schemes described by Huysmans in *A rebours*. Fortunately, written accounts, the evidence of one or two of the artist's own drawings and a hitherto unrecorded

Charles Ricketts (1866–1931)
Coyness and Love strive which hath greater grace. Illustration for *Hero and Leander* by Christopher Marlowe and George Chapman (Vale Press, 1894). Stephen Calloway

Ricketts's illustration, in a book distributed by John Lane, was published just a little before Beardsley began work on his remarkably similar design *The Mysterious Rose Garden.*

The Mysterious Rose Garden; for *The Yellow Book*, Vol. IV, January 1895. Pen, ink and wash. Fogg Art Museum, Harvard, Grenville L. Winthrop Collection

Originally begun in the latter part of 1894 as an Annunciation, the subject was later left rather more deliberately enigmatic. An old tradition identifies the naked girl as the artist's sister Mabel. Though this cannot be substantiated, the physical type – tall, slim and with small high breasts and long legs – does often recur in Beardsley's drawings; however this was a morphology popular with many artists of the Art Nouveau period, a shape of the era.

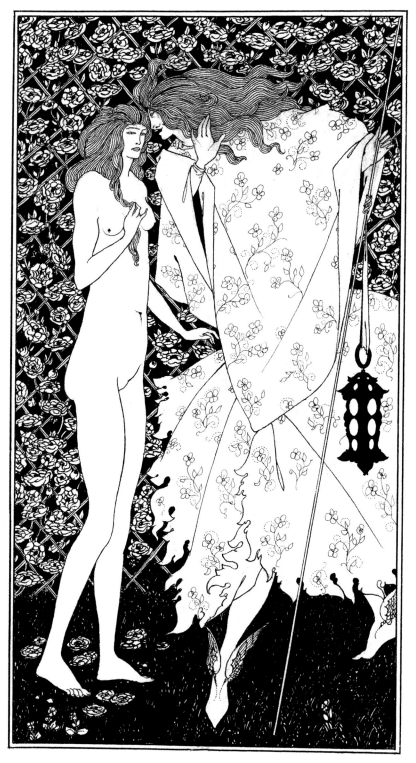

114 Cambridge Street,
estate agent's particulars, 1895.
Private Collection

printed set of agent's particulars of the house (originally kept amongst her papers by Miss Pugh, the purchaser of the lease in 1895, and subsequently preserved by a member of her family, along with other miscellaneous items from the house) supply just enough of the necessary clues to evoke a picture. It is perhaps entirely appropriate that Beardsley, in many ways the epitome of nineties sensibility, its most singular and entirely inimitable figure, should have been the one to realise most precisely the schemes of Des Esseintes, the most symptomatic fictional creation of the era's most characteristic writer; that Beardsley should have commissioned his old friend Aymer Vallance to paint his walls to resemble those of the château de Loups seems inevitable and perfect.

Huysmans had written of his hero's long investigation into colours, telling how each and every hue had been considered in turn, only to be dismissed. 'He was interested in their appearance by candlelight alone: what he wanted was colours which would appear stronger and clearer in artificial

Aubrey and Mabel were forced to put the lease of the house up for sale in 1895. It was bought by a Miss Pugh, a landlady who let out rooms, without, it seems, making any great changes to the decorations. The Beardsleys abandoned much of their furniture, including even Aubrey's drawing table, and a variety of other books, pictures and papers.

light. He did not care if they looked crude or insipid in daylight, for he lived most of his life at night, holding that night afforded greater intimacy and isolation and that the mind was only truly roused and stimulated by awareness of the dark.' Ultimately, Des Esseintes reduces the options to three: red, yellow and orange.

Of the three he preferred orange, so confirming his own theory . . . that there exists a close correspondence between the sensual make-up of a person with a truly artistic temperament and whatever colour that person reacts to most strongly and sympathetically . . . As for those gaunt, febrile creatures of feeble constitution and nervous disposition whose sensual appetite craves dishes that are smoked and seasoned, their eyes almost always prefer that most morbid and irritating of colours, with its acid glow and unnatural splendour — orange. There could therefore be no doubt whatsoever as to Des Esseintes's final choice.

Nor, indeed, about Beardsley's.

The drawing-room, the main show-piece of Aubrey's provocative interior schemes and the scene of the Beardsley's At Homes, was on the high-ceilinged first floor of the house. William Rothenstein wrote in his memoirs that its decorative effect was dramatic and taken straight from *A rebours:* 'The walls were distempered a violent orange, and doors and skirtings were painted black; a strange taste, I thought; but his taste was all for the bizarre and exotic.' Probably in the back room of the pair, the wall colour was a single flat tone of orange (which, being a fugitive colour, with time may have faded to the more pinkish hue remembered by Miss Pugh's niece Miss King) relieved only by the lacquered woodwork. In the front room however, Vallance's work was more complex, with a design of alternating broad stripes of plain colour and floral pattern. Haldane MacFall supplies the necessary visual reference: 'Beardsley greatly liked his walls decorated with the stripes running from ceiling to floor in the manner he so much affects for the designs of his interiors, such as the famous drawing of the lady standing at her dressing table, known as *La Dame aux Camélias.*' Beardsley's general predilection for very wide stripes may also be inferred from other examples, including the much later drawing of a woman at a dressing table from the *Mademoiselle de Maupin* series, *The Lady with the Rose,* but the floral element visible in the earlier of the drawings seems to be confirmed by the 1895 agent's particulars, which describe 'An artistically decorated double Drawing Room, in the style of William Morris'. Though hardly an accurate interpretation of Beardsley's intentions, the identification is understandable both in terms of Vallance's main stylistic affinities and in the light of the level of appreciation likely to have been accorded to an unfamiliar decorative effect by an ordinary estate agent of the day.

Although the particulars for the most part enumerate the more practical details of the rest of the house (thereby giving a picture of a well set-up town-house with gas lighting, a bathroom with hot and cold water supply and all 'mod. cons.' in the basement kitchen and service areas), a few further, and highly intriguing details are offered of the drawing-room: besides a 'parquet floor' and a fireplace with 'tiled recess, hearth and fender'

with a 'dog stove' (the classic nineteenth-century cast-iron fire-grate typical of London houses), particular mention is made of a 'specially designed mantel and over-mantel and large bookcase'. These elements were also singled out by a friend and colleague of Mabel Beardsley's, Netta Syrett, the novelist and a contributor to the *Yellow Book*, who was a frequent visitor. She left a description of the house in her book of memoirs *The Sheltering Tree*, which clearly reveals how little she thought of either the scheme or its creator Aymer Vallance: 'I recall the drawing room,'she wrote,'... with its deep orange walls, black doors, and black painted book-cases and fireplaces – a

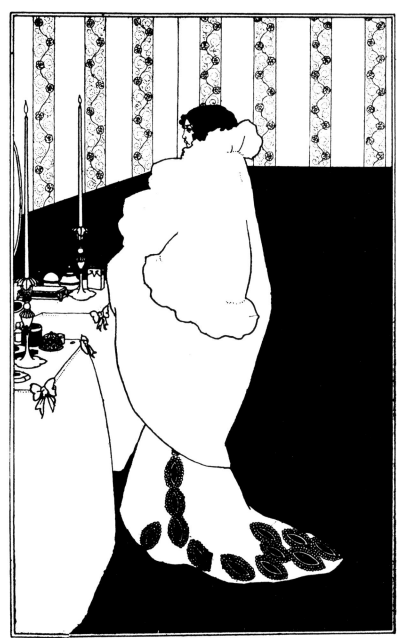

La Dame aux Camélias
published in *St Paul's*, 2 April 1894, and again in the *Yellow Book*, Vol. III, October 1894. From line-block. V&A E.1088-1996

Yet another expression of the artist's constant fascination or fixation with the theme of women at their dressing-tables and *toilette* scenes, this design may well give the most accurate picture that we can form of the nature of Vallance's decoration of the walls in the drawing-room of Beardsley's Cambridge Street house.

scheme of colour new to me, designed by an early "interior decorator", a friend of Aubrey's and the forerunner of many young men who now make their living by adorning and sometimes ruining other people's houses.'

A considerable degree of fascination attaches to these fireplaces and the bookcase. A now very indistinct photograph exists, taken some time in the 1950s; by this time the front room had, not surprisingly, been repainted, obliterating Vallance's stripes, but still retaining the original black-painted

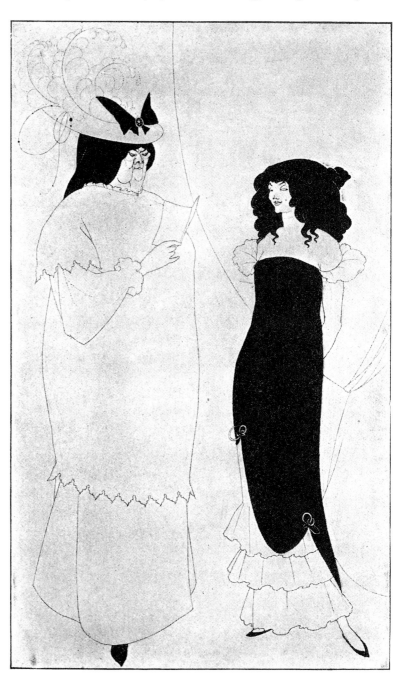

L'Education Sentimentale from *The Yellow Book*, Vol. I, April 1894. From line-block. V&A E.1093-1996

Max Beerbohm wrote that he was strangely haunted by this curious image of the contrasted cynicism and knowing innocence of age and youth. Beardsley later cut the original drawing into two halves; the left-hand section, now in the Fogg Art Museum, was one of the drawings upon which Beardsley experimented, not entirely successfully, with colour washes.

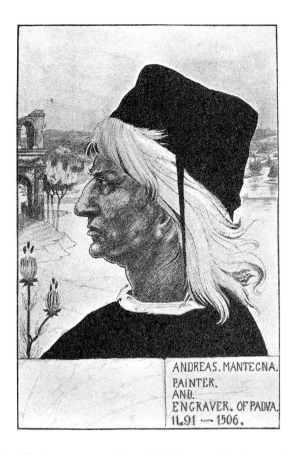

ANDREAS. MANTEGNA.
PAINTER.
AND.
ENGRAVER. OF PADVA.
1L91 — 1506.

woodwork. The last vestige of Beardsley's 'specially designed mantel' is visible and therefore gives at least some idea of the appearance of the rest of this, presumably, *en suite* group. Extraordinarily, what can be seen in the snapshot is the projecting corner of a mantelpiece in the distinct style of the 'Art Furniture' of the 1870s an 1880s, that hybrid, Japanese–Aesthetic style of attenuated black stick-work first popularised by E. W. Godwin. However from this unexpected starting point, Beardsley's taste can, again, readily be inferred from details of his illustrations. In his caricature of Whistler, for example, he seats the figure of the artist on an appropriate chair of this type, but, even more tellingly, he introduces pieces in pure Godwinian Art Furniture style in many other drawings, including most notably the two toilet scenes for the *Salome* set. Beardsley's evident liking for this style, which might in a sense have been considered *passé* by at least a decade at this stage, seems both curious and brilliantly idiosyncratic. Obviously the Godwin style in a way matched Beardsley's drawings; but did Aubrey choose such pieces for their visual associations with his own work, or was Godwin's style an influence on Beardsley's own in a more important way than has hitherto been suggested? A strange parallel to Beardsley's quirky taste for the past decade might be discoverable in Max Beerbohm's perhaps more ironic enthusiasm, expressed in his clever essay '1880', one of those which he chose to include in his first little collection, *The Works of Max Beerbohm* (1896).

Andrea Mantegna, from *The Yellow Book*, Vol. III, October 1894. From line-block. V&A E.1090-1996

As a tease to the critics, this drawing appeared attributed to the fictional artist Philip Broughton, whilst a second pastel drawing of a head was given to one Albert Foschter. Both were widely praised, much to the amusement of those sharing the joke.

Poster for T. Fisher Unwin,
'Publisher, Children's Books', 1894.
Colour lithograph.
V&A E.3162-1914

Along with Lane and Mathews,
Fisher Unwin was one of the more
progressive London publishing
houses of the nineties, with a
considerable list of modern novels.
However, the overt and dubious
sensuality of Beardsley's image
contrasts ironically with the nature
of the particular books advertised by
this poster.

To dignify this taste as a conscious Aesthetic Movement Revival may,
however, state the case too strongly. For when Aubrey and Mabel moved
into the Cambridge Street house they painted a considerable number of
pieces of otherwise unremarkable furniture with black paint, in order, we
must assume, to impose some sense of unity and style on a rather heteroge-
neous collection of second-hand items, which were the best that they could
afford when setting up home effectively from scratch. One such piece at
least survives: this is the 'desk' at which Aubrey sat to draw. It is not a fine
piece of furniture; it is, in reality, hardly more than an ordinary deal kitchen

Poster for *A Comedy of Sighs* and
The Land of Heart's Desire,
at the Avenue Theatre, 1894.
Colour lithograph. V&A E.726-1959

Beardsley's most famous, and most
abused, excursion into the art of
poster design was undertaken at the
behest of Florence Farr. The two
plays that it advertised, both by
prominent members of the Irish
literary community in London, John
Todhunter and W. B. Yeats, were
badly received by a rowdy audience.
The poster itself was the subject of
ridicule by Owen Seaman in one of
the poems, 'Ars Postera', reprinted in
his book of satiric verses *The Battle of
the Bays*:

> *Mr. Aubrey Beer de Beers,*
> *You're getting quite a high renown;*
> *Your Comedy of Leers, you know,*
> *Is posted all about the town;*
> *This sort of stuff I cannot puff,*
> *As Boston says, it makes me 'tired';*
> *Your Japanee-Rossetti girl*
> *Is not a thing to be desired.*

table given a suggestion of chic Aestheticism from a pot of black lacquer
paint, almost in the manner, though without the bathetic results of Mr
Pooter's 'do-it-yourself' efforts, chronicled by the Grossmiths in the *Diary
of a Nobody*. What created the rarefied atmosphere of the Cambridge Street
rooms was, above all, Aubrey's highly artificial manner and style of living.

Here, mostly at night and by the light from two candles only in his
famous pair of massive gilt French Empire period candlesticks, Beardsley
made his extraordinary drawings. Beardsley treasured these candlesticks,
and they had evidently become important totemic objects in his pattern of

PAR LES DIEVX JVMEAVX TOVS LES MONSTRES NE SONT PAS EN AFRIQVE.

Portrait of Himself in Bed; from *The Yellow Book*, Vol. III, October 1894. From line-block. V&A, Gleeson White Collection, E.429-1899

In a curious piece of self-analysis, Beardsley pictured himself as a febrile Aesthete, be-turbaned and all but engulfed in the opulent splendours of a sumptuously hung Baroque bed. He cherished the idea of himself as 'monstrous' and alluded to this in the enigmatic inscription.

OPPOSITE

Kitagawa Utamaro (1735–1806), *Shunga* print, *c.*1780–90. Woodblock print. Stephen Calloway

One of the most startling aspects of Aubrey's house decoration was the display of a prized set of Japanese *shunga* – erotic prints – from a 'pillow book' by Utamaro given to him by his friend William Rothenstein, who, having acquired the album in Paris, by his own admission found it too embarrassing a possession to keep himself. Beardsley did not share this reticence about such images either in his decorations or, later, in his own drawings. Such *shunga*, or 'Spring Pictures' of the best period towards the end of the eighteenth century, in addition to the curious appeal of their subject matter, reveal a beauty of line and delicate balance of black and white which clearly exerted a subtle influence on Beardsley's art.

work. At Charlwood Street they seem to have formed almost the sole decorative element in a 'red room' in which he drew; later they would accompany him on his last travels to France, where they are visible in the final photograph taken in the hotel room in which he died. At Cambridge Street, however, even during daylight hours they were prominently in use. Like every other visitor, Miss Syrett was struck immediately by the fact that 'The room was always rather dark, for it was an affectation of the Beardsley set to exclude the "crude light of day".'

Again, the echo of Des Esseintes is inescapable; but Beardsley must also have been aware of the fact that when interviewed, which he increasingly was at this time by writers such as the American Penrhyn Stanlaws, who also drew a portrait of him in his surroundings, such idiosyncrasies made good copy for wide-eyed journalists anxious to penetrate the mysteries of the Decadent and Aesthetic life. Another such was the German art historian Julius Meier-Graefe, who visited many of the leading British artists of the moment whilst preparing his great two-volume study *Modern Art*. He was clearly so struck by the contrast between the houses of Burne Jones and

Beardsley, by the differences in their characters and conversation and, not least, by what they hung in the way of pictures, that he opened his highly important chapter on Beardsley with a discussion of the Japanese prints on his walls, which seemed to him so startling and so expressive of an utterly modern and unconventional sensibility.

'At Beardsley's house', wrote Meier-Graefe, 'one used to see the finest and most explicitly erotic Japanese prints in London. They hung in plain frames against delicately coloured backgrounds, the wildest phantasies of Utamaro, and were by no means decent, though when seen from a distance delicate, proper and harmless enough. There are but few collectors of these things, as they cannot be exhibited.' But exhibit them Aubrey did. The first examples he owned had been the gift of Rothenstein, who was close during the first days at Cambridge Street, and often worked alongside him at the same black-painted table during the time when Beardsley was drawing his *Salome* illustrations. Rothenstein described how he had 'picked up a Japanese book in Paris, with pictures so outrageous that its possession was an embarrassment. It pleased Beardsley, however, so I gave it to him.' He was surprised to discover that, 'The next time I went to see him, he had taken out the most indecent prints from the book and hung them round his bedroom'. What is

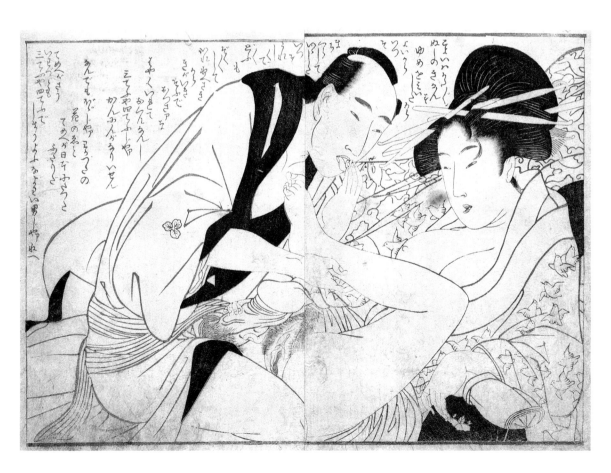

interesting is that from Rothenstein's description it is clear that the prints in question were *shunga* from one of Utamaro's pillow books, not the large and beautiful, single-sheet colour prints for which he is best known, but, rather, the smaller, black-and-white images that immediately suggest a rather closer comparison with Beardsley's own drawings at this time. Later, according to Haldane MacFall, Beardsley did collect other Japanese prints, but whilst in addition to Utamaro he names Haronubu, also renowned as a creator of fine book illustrations, it must, sadly, now remain unclear what kind of Japanese prints Beardsley possessed, or indeed what else besides his favourite reproductions from Mantegna hung on the walls at Cambridge Street.

If the Beardsley boom had begun in earnest in 1893, the year of his greatest fame and notorious celebrity was 1894 – the year in which his name and that of the *Yellow Book* were to become synonymous. To what extent such a brief period, however vibrant, and four issues of a magazine, however sparkling, can be said to epitomise an era and to encapsulate an entire intellectual and aesthetic philosophy is, of course, open to question. In reality, things are rarely so clear-cut, but there is nevertheless some measure of truth concealed in the over-simplified and often-repeated clichés about the importance of the *Yellow Book*; not least because the *Yellow Book* did so instantly spark the reaction and win the notoriety for which it aimed. It became for a moment the banner around which many disparate forces rallied. These young, enthusiastic and idealistic votaries of the arts vowed, if not perhaps to do battle to the death against the ranks of tired and unthinking tradition in the name of modernity, then at least to embrace 'Art for Art's sake' and try in all that they did to avoid the more obvious siren snares of vulgar commercialism. At times though, and especially when viewed from outside the charmed circle, their aim must have seemed more like a determined attempt always to *épater les bourgeois*, to publish and be damned.

Rapidly the *Yellow Book* attained a cult following amongst the self-elected ranks of the avant-garde, and even subsequently (and, to some degree, in the face of all the evidence) retained its mythic hold over the popular imagination as the unmistakable symbol of the decadence in nineties London. Beardsley, by all accounts, had come up with the all-important name and the look which went with it, basing both on the appearance of the ordinary, popular – and often 'naughty' French novels of the day, with their simple yellow paper wrappers. It was a brilliant idea, and one which worked so well in creating an instantly recognisable image for the new quarterly, that it would in the event ultimately prove fatal.

Undoubtedly, Beardsley's vivid designs and the arresting yellow and black livery of its covers secured for the *Yellow Book*, exactly as the editors and publishers planned, an almost unprecedented iconic status, which made it – both on the bookstands of the day and on the shelves of book-collectors, at whom it was particularly aimed – the inescapable visual embodiment of a daringly new, if at times, self-consciously risqué literary and artistic sensibility. From the outset, the *Yellow Book* was intended to create an effect, and be a sensation; for a brief moment, at least, in both these aims it succeeded. Its

Frontispiece for *The Wonderful Mission of Earl Lavender, Which lasted One Day and One Night*, by John Davidson (Ward and Downey, 1895). Collection Anthony d'Offay

Beardsley's ironic depiction of suburban domestic architectural details in this spare, elegant drawing is no doubt intended as a further wry reflection upon the nature of Davidson's intentionally humorous but heavy-handed algolagniac fantasy.

seismic waves were felt throughout Art Nouveau Europe, and Beardsley was, for the whole of 1894, perhaps the most watched of all contemporary artists.

Recent research has tended to explode almost all the old stories about the beginnings of the *Yellow Book*, revealing in particular its far longer gestation period and the much wider range of influences and cast of characters that played a part in its inception. Far from happening overnight, as Harland told the tale, the actual origins of the periodical can, it seems, be traced back almost half a year, to the long, lazy discussions held during a vacation spent at Sainte-Marguerite, near that favourite resort of the English bohemian coterie, Dieppe, by a large group of literary and artistic friends in the hazily idyllic summer of 1893. An unpublished memoir written by one of their number describes the house that several of them shared; nicknamed 'The Grob', from an amalgamation of their names, it was chosen – apart from its cheapness – out of amusement for the irresistible misspelling of a placard displayed outside its door, which read 'Propriety To Let or Sell'.

During their mornings and afternoons almost all of the group were active, painting and writing or just reading, but around 5 o'clock each day they would gather for drinks and serious talk about art, about literature and quite often about publishing. At these gatherings were the Harlands, Henry

The Advanced Woman.
Cover of *The Idler*, September 1894.
V&A E.3025-1921

Beardsley's cover and a similar illustration accompanied a humorous article by Angus Evan Abbott, 'How to Court the "Advanced Woman"', the first of a proposed series based upon comic themes suggested by the development of female emancipation. The so-called 'Beardsley Woman' was generally perceived to be a degenerate type and to combine both elements of the new creed of emancipation and characteristics more normally associated with the old-fashioned, and inevitably immoral *femme fatale*.

and his wife Aline, who also played a key part in all the discussions; Alfred Thornton, a minor landscapist; and Beardsley's friend, the artist Charles Conder, famed equally for his painted silk fans and his – even by the standards of his Bohemian milieu – increasingly dissolute and self-destructive way of life. The other major player was D. S. MacColl, also a friend of Beardsley, and, though an amateur, no mean watercolourist. Already long-settled in London from his native Scotland, at this time, before he became a Keeper at the Tate Gallery, he earned a living as a quick-witted and lively art journalist.

Although the idea of 'little magazines' devoted to the arts was very much in the air in the nineties, by all accounts it was MacColl who first sowed the seeds of the idea of a novel kind of magazine in which good new writing in prose and verse and worthwhile illustrative art should appear in the same pages, but in which, as Thornton described it, 'the literature and the pictures had nothing to do with each other, but each was to be in its way good in itself and above all of a "pioneer type" of a kind which was looked at askance by the publishers of the period'. Claiming to be 'too lazy to attempt the thing myself', MacColl says he 'made over the idea' to Harland in the hope that he might be the man to exploit it.

Before coming to England from New York towards the end of the 1880s, Harland had already achieved a very modest reputation for his realist fiction (his early novels of Jewish ghetto life, written under the pseudonym of Sydney Luska, suggest the attempt to become a sort of American Zola, whilst his subsequent lighter and more ironic work – especially his stories of Bohemian Paris – looked more obviously to Maupassant for their model), but he was undoubtedly a man in search of a more immediately lustrous and tangible form of success in the literary London of the nineties. He at once saw the possibility that MacColl's idea of offering avant-garde 'high art' and new writing in a deliberately popular and attractively got-up form could fit the temper of the times exactly, and that it could moreover, in the right hands, make money. When Beardsley, who was fond of Dieppe, visited Harland that summer, it is inconceivable that they, too, would not have discussed a project so full of potential for themselves and their circle of friends, and one which chimed so neatly with ideas about art that each held dear.

Now, it so happens that during that summer of 1893 John Lane, then still in slightly uneasy partnership with the more conservative Elkin Mathews, and very much on the look-out for new directions in which to take the publishing side (as distinct from the rare-books side) of their business, also paid more than one weekend visit to Dieppe, calling on the 'The Grob' group. It was at this point, if any, that the airy notion of the new magazine began to take on a reality, and so, when Harland and Beardsley set out through the bad London fog on the day after their New Year's talk to see John Lane with their proposal, it may well be that, as Lane later wrote, everything was settled 'during half an hour's chat over our cigarettes at the Hogarth Club'. Harland, of course, would be editor – that is to say the literary editor – whilst Beardsley, in addition to being the principal contributor

of the pictures, was to take on the role of 'art editor'; there can be little doubt though, that it was the ever-astute John Lane who played the key part in shaping the enterprise along such highly profitable lines.

It was Lane, too, who marshalled many of the Bodley Head authors and other journalistic contacts from his wide acquaintance among the bookish hacks of the town in the fierce and quite shamelessly 'log-rolling' publicity campaign that so successfully whipped up interest in the new magazine to a fever pitch in the early months of 1894. Part of Lane's particular genius lay in the extent to which he always managed to use one project to trail the next, one author to help sell the works of another. What his real opinion was of the adamant decision reached by both Harland and Beardsley absolutely to exclude Oscar Wilde, then his most newsworthy star, from the pages of the new quarterly remains unknown. Perhaps he, like Beardsley, had simply had enough of the squabbles that seemed to attend every project that involved the Wildean Cénacle; Oscar certainly by this stage had the reputation in the Bodley Head offices of being too much the prima donna ever to make an easy and generous collaborator in a team effort such as the *Yellow Book*.

The Wagnerites; from *The Yellow Book*, Vol. III, October 1894.
From line-block. V&A E.15-1900

Beardsley had an obsessive interest in Wagner, and avidly attended the London performances of the works. This depiction of the Wagnerian audience rather than the action of the opera identified by the fallen programme as *Tristan und Isolde*, is one of the greatest masterpieces of Beardsley's *manière noire*. Sickert claimed to have warned him that drawings in which the area of black exceeded that of the white paper were bound to fail artistically, and to have 'convinced him' of the truth of this aesthetic rule. Fortunately Beardsley seems to have ignored the advice.

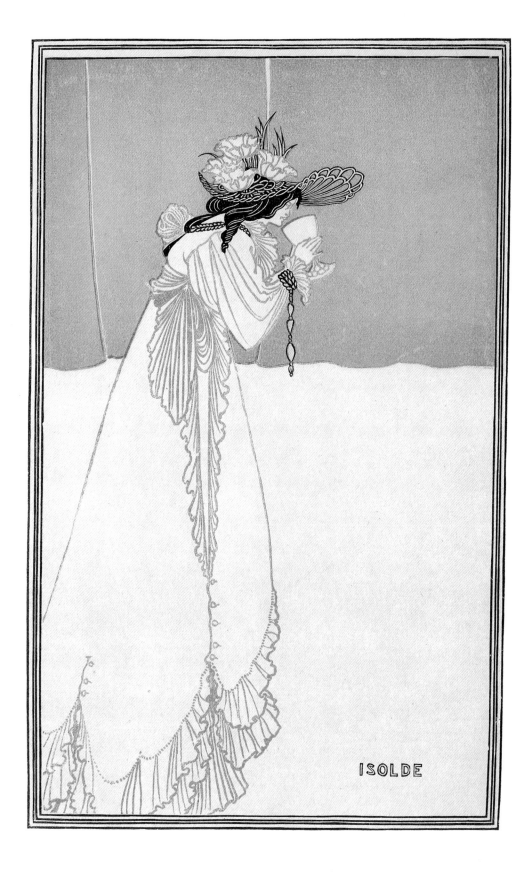

ISOLDE

The prospectus for the first volume of the *Yellow Book* was a masterpiece of swaggeringly self-confident puffery, which nevertheless still managed to strike many of the right notes, hinting at the editors' very real sensitivity to the important nuances of the best new art and writing of the day: 'The aim . . . of The Yellow Book', it trumpeted, 'is to depart as far as may be from the bad old traditions of periodical literature, and to provide an Illustrated Magazine which shall be beautiful as a piece of book-making, modern and distinguished in its letter-press and its pictures, and withal popular in the better sense of the word.' With its cloth hard-bound format like a book, and published at the considerable price of five shillings – at a period when most smart new novels cost no more than six shillings or 7s. 6d., and many as little as 3s. 6d. or half-a-crown, and when most of the illustrated journals sold for sixpence – the *Yellow Book* was aiming high.

Isolde; from *The Studio,* October 1895. Colour lithograph. V&A E.32-1996

Other than for his poster designs and in some essentially private experiments with watercolour washes added to already published drawings, Beardsley rarely used colour effects. In this lithographic image, one of his few really successful excursions into colour, his use of a flat, unmodulated red background suggests an awareness of and interest in the work of contemporary French poster artists.

Albert George Morrow (1863–1927), Poster for *The New Woman,* at the Comedy Theatre, 1 September 1894. Colour lithograph. V&A E.2682-1962

The New Woman, a play by Sydney Grundy was a popular success at the Comedy Theatre in September, and attracted a good deal of attention; *The Idler*'s 'Advanced Woman' number in September 1894 being a typical reaction. The poster advertising the play depicts an 'advanced' or 'New Woman'. She is clearly intended from her appearance and dress to combine a certain fashionable beauty with more intellectual attainments. Her black-and-white costume and heavy black hair perhaps subtly allude to the 'Beardsley Woman'.

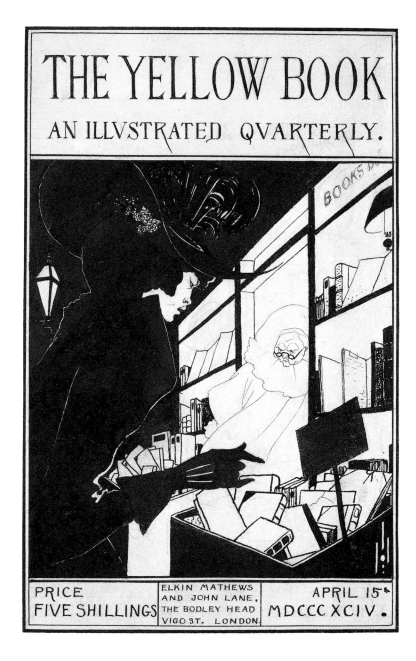

Design for the prospectus for
The Yellow Book, 1894. Pen, ink and
wash. V&A E.518–1926

The prospectus, an essential factor
in the marketing of books at this
date, clearly reveals the extent to
which the new publication aimed
to connect the new quarterly with
the rarefied world of antiquarian
books, fine editions and 'collectors
items', as much as with the brasher,
more 'modern' milieu of London in
the nineties.

The more general editorial lines upon which the quarterly would be con-
ducted were also made quite clear: there would be no serial fiction – the
great mainstay of most magazines, because that gave a periodical an unpleas-
ant 'choppy' feel, and well-known names and unknowns would find an equal
place in its pages, chosen, it was promised, according only to merit. Finally,
it was announced, with what seems like foolhardy confidence in the financial
buoyancy of a project predicated solely on the public's interest in art, that
there would be no advertisements printed in the volumes other than pub-
lishers' lists. 'Altogether' the prospectus concluded, flinging any last vestiges

of editorial modesty and decorum to the winds, 'it is expected that The Yellow Book will prove the most interesting, unusual, and important publication of its kind that has ever been undertaken.'

For the prospectus Beardsley drew a remarkable cover, which introduced a number of significant new elements in his stylistic development. Technically audacious, it was among the first of a highly important group of 'night-pieces', in which the artist employed his growing skill in the management of increasingly large areas of black-ink washes, played off against finely reserved white lines and razor-sharp patches of light, to suggest the vivid qualities of the London street scene captured by the flickering intensity of the gas jets of the street lamps or illuminated by the cold light of the moon. Depicting the sinister, intriguing figures of a *demi-monde* that walked a tightrope between the gay, open, fashionable hedonism of West End nightlife and the subtly suggested abysses of a half-hidden but ever-present urban depravity, in these drawings Beardsley struck a startling note of absolute modernity.

This image for the prospectus played deliberately upon the equivocal nature of the messages that its subject and details would send out to a middle-class audience. On the one hand it depicted a bookshop, a comfortable, cultural location, but showed it by night, when no respectable bookshop should be open. In fact the drawing depicts a shop very like the premises of Lane and Mathews in Vigo Street, to which Beardsley adds, it has been always been said, a caricature of Elkin Mathews himself as the genial, if oddly garbed, Watteauesque pierrot-bookseller in the doorway. The handling of the effect of the light emanating from the shop is quite masterful, suggesting with wonderfully observed precision the way in which at night-time a figure in the street appears silhouetted against the brightness of a lit up window; it gives the lie to the much-repeated idea that Beardsley was unaware of, or unable to compete with the contemporary artistic developments that placed so much emphasis on the subtle rendering of unusual light effects.

In Beardsley's scene there is only one customer, a woman of the 'advanced' kind we are to suppose, immaculately dressed in severest black in the height of fashion of the moment, her tightly gloved hand poised to exercise her own literary choice, rather than waiting to be offered a book to read. Elegant and assertive, she proclaims her, at best, dubious social position by the mere fact of her nocturnal shopping expedition, alone and unchaperoned in the street. As an image of English womanhood it was almost guaranteed to shock, but before long this very distinct and very modern type would automatically be referred to as the 'Beardsley Woman', a variant sub-species of that other alarming phenomenon of the period, the 'New Woman'.

In the first months of the year Beardsley and Harland worked hard to secure contributions of a high calibre for the all-important launch. There was much discussion concerning both the literature and the art, names were canvassed and some potential contributors were distinctly courted. Sometimes they met at the offices of Lane and Mathews in Vigo Street, so

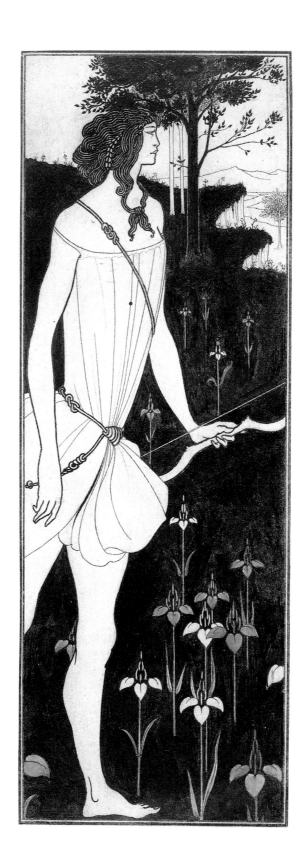

Atalanta, 1895.
Pen and ink. British Museum

A drawing intended for the fifth
volume of the *Yellow Book*, but
unused. The model for the figure
has again, upon the slenderest
authority, persistently been
identified as Mabel Beardsley.

conveniently situated for visits to the Café Royal, that favourite haunt of nineties bohemia, just around the corner on the quadrant of Regent Street. More often the real editorial work of the *Yellow Book* was carried out in a small, cramped and crowded back room at the Harlands' flat in the rather less fashionable Cromwell Road, where the editors' concentration was frequently disturbed by the rumble of the electric trains of the new District Railway.

For the first volume Beardsley designed a cover that was in a lighter key than the prospectus illustration, but which was no less open to a variety of interpretations. Influenced by the essential gaiety of imagery of French poster artists such as Toulouse-Lautrec – whom Beardsley admired greatly

Cover for *The Yellow Book*, Vol. III,
October 1894.
Stephen Calloway

The design for the cover of the third volume again caused outrage owing to the widely perceived implication of the woman's dressing-table glass being illuminated by street lamps.

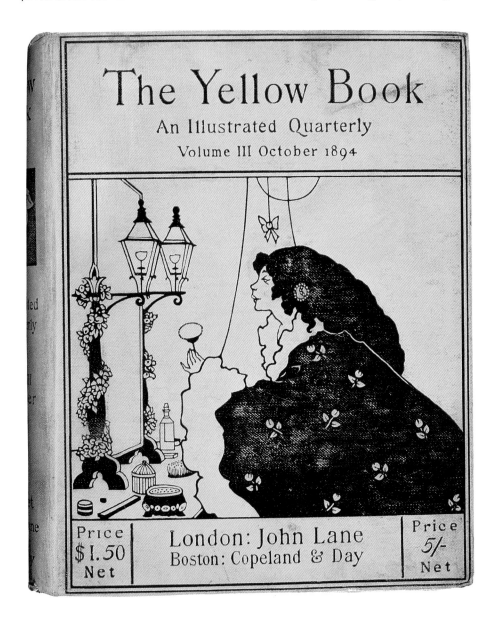

William Rothenstein (1872–1945), *Aubrey Beardsley*, 1893. Black and white chalk, from an old reproduction. From the estate of Sir William Rothenstein. Stephen Calloway

Rothenstein made two quite similar drawings of Aubrey Beardsley around 1893; tradition has it that he is depicted seated on one of the plush banquettes of the old Domino Room at that favourite Bohemian haunt, the Café Royal. One drawing, often reproduced, belonged for a while to the collector A. E. Gallatin. The other, once in the possession of Beardsley's friend and publisher Leonard Smithers, but now seemingly lost, is known only from an old cutting, reproduced here, and a photogravure plate in John Rothenstein's 1923 illustrated volume on his father's drawings.

for his 'modern' subjects – and, perhaps even more particularly, by the graphic mannerisms of the prolific master of the genre, Jules Chéret, it features a plump, laughing female reveller, masked, with a prominent beauty-spot and wearing a broad-brimmed hat that is indicated with a daring degree of formal abstraction. Behind her lurks a more sinister figure, whose almond eyes are also masked and who regards his companion – or is it us? – with an expression of almost oriental inscrutability. As a design it seems so simple, and yet it plays upon the observer's desire to interpret the subject, maintaining its fascination long after more complex designs have palled. Similarly, for the back cover Beardsley made a design to incorporate the panels listing the contributions (described as 'Letterpress' and 'Pictures') which is deliberately enigmatic. There is a frieze-like image in which appear the heads and shoulders of four typical Beardsley types, whose occupation can only be guessed at; are they, perhaps, members of the audience in boxes at a theatre, or, as seems more likely, denizens of the *maisons closes*, the more elegant and exclusive Parisian brothels, chatting at their balcony window.

Wilde, in a moment of evident good humour about the *Yellow Book* and its art editor, met Max Beerbohm in the Domino Room of the Café Royal shortly after encountering Beardsley, who had enthusiastically shown him the design for the first cover. Beerbohm recalled that, naturally, he had 'asked what it was like.' "Oh," said Oscar, "you can imagine the sort of thing. A terrible naked harlot smiling through a mask – and with ELKIN MATHEWS written on one breast and JOHN LANE on the other".'

Lane, as usual, felt the distinct need to scrutinise Beardsley's designs in case of trouble with hidden details. It was necessary he said to check them 'so to speak . . . under a microscope and . . . upside down before they could be passed for publication'. In particular, he was morbidly sensitive to the danger of caricatures, and although he had happily passed the one of Mathews as a pierrot, he balked at another, entitled by Beardsley 'The Fat Woman', clearly

an unflattering representation of the all-too-ample charms of Whistler's wife, Beatrix Godwin. Beardsley claimed that no one else who had inspected the drawing had objected to the image, and wrote facetiously to Lane, 'I shall most assuredly commit suicide if the Fat Woman does not appear . . .', adding a sketch of himself lugubriously pointing to a gallows. As a further tease, no doubt, he offered to give the picture a new, but in fact yet more Whistlerian title, 'A Study in Major Lines'. The 'Fat Woman' did not appear.

In the event, and largely owing to serious efforts on the part of the two editors, the contents lists of the first number were headed by several highly thought-of grandees of the nineties cultural scene. Literary London was represented first and foremost by the august figure of Henry James. As a friend and frequent visitor of his fellow American expatriates, the Harlands, he had been persuaded to send in a short story for the first volume, and would contribute again, until, that is, it occurred to him that the remuneration that the *Yellow Book* editors could offer him from their modest pool of funds for a 'long

Henri de Toulouse-Lautrec, Poster for the Divan Japonais, 1892. Colour lithograph. V&A, E.233-1921

Beardsley's trips to Paris made him well-informed about current trends in French art. In particular, having visited such attractions as the Moulin Rouge and other, rather more notorious and *recherché* low-life haunts, he keenly admired the vivid, modern-life scenes portrayed by Lautrec. Lautrec, like Beardsley had, from close study of the Japanese *ukiyo-ye* masters, learned much in the way of compositional tricks, about the flat rendering of complex forms and about cutting off elements of a design in a seemingly arbitrary way in order to create a startling silhouette.

Wenceslaus Hollar (1607–77), *Study of a Woman in Black*, c.1640. Oil on paper. British Museum, Bequeathed by Sir Hans Sloane, 1753. No. 5214-3

A small sketch by Hollar, the great seventeenth-century observer of fashionable women parading in their finery, which Beardsley may have seen in the British Museum. This offers a curious precedent for the latter's depictions of streetwalkers as well as prefiguring the unusual colour scheme of the *Yellow Book* by more than two centuries.

short story' (between ten and fifteen pounds) did not even approach the sort of sums that he could command for just the American rights repeat fee of an already printed piece. As it was, no other writer generally received much above the four guineas commanded by the pompous William Watson for a poem, and most got less still; Harland had been happy to pay James considerably more than any other contributor just to have him represented; perhaps simply out of generosity of spirit he had agreed.

With his impeccable charm and punctilious manners, James, in his opinion of this first *Yellow Book* doubtless spared Harland's feelings, but made his own clear in a letter to his brother: 'I haven't sent you The Yellow Book on purpose,' he wrote, 'I say on purpose because, although my little tale which ushers it in appears to have had, for a thing of mine, an unusual success, I hate too much the horrid aspect and company of the whole publication...' Yet in spite of this, as he explained, he was to be 'intimately, conspicuously associated with the 2nd number. It is for gold and to oblige the worshipful Harland.'

Similarly, Edmund Gosse, the second most important star in the Harland's Cromwell Road cosmography, had also lent his name and offered up a piece. Beardsley, on the art side, had, equally impressively, secured a contribution from no less a painter than Sir Frederic Leighton, the immensely popular and successful President of the Royal Academy, a figure of immense grandeur, but still, from his lofty eminence, willing, Zeus-like, to lean down and encourage the efforts of young artists such as Beardsley and Charles Ricketts, both of whose work he admired and had bought for his own collection. (To Ricketts he had said with an extraordinarily diffident charm, 'I'm afraid you won't care for my work, but I am interested in yours.') For the *Yellow Book* Leighton was a major coup.

In spite of the presence of these illustrious sponsors, the critics, for the most part, chose to attack both the literary and artistic contents of the *Yellow Book* as something new and dangerous. Among the prose and verse Arthur Symons's poem on 'his encounter of a night', 'Stella Maris', and Max Beerbohm's brilliant and facetious essay 'A Defence of Cosmetics' were mainly singled out for abuse, with the latter, especially, taken to task for affectations of style in such delightfully felicitous, and quintessentially Beerbohm-esque phrases as 'Rome in the keenest time of her degringolade'. Later P. G. Hamerton in his critique of Volume I, printed in Volume II, would try to defend Max's affront to the mores of the day in the 'Cosmetics' piece, by claiming it to be no more than a youthful *jeu d'esprit*; but the nimble Beerbohm had no need of help from the ponderous Hamerton when it came to holding his own with the Press. Beardsley, still a target for adverse comment since the appearance a few months earlier of *Salome*, came in for the roughest handling, being widely accused on all sides of introducing a reprehensible, foreign decadence to English art in illustrations such as 'A Night Piece' and his portrait of the actress Mrs Patrick Campbell. *The Times* commiserated with Leighton for finding his work 'cheek-by-jowl with such advanced and riotous representatives of the new art as Mr. Aubrey Beardsley and Mr. Walter Sickert'.

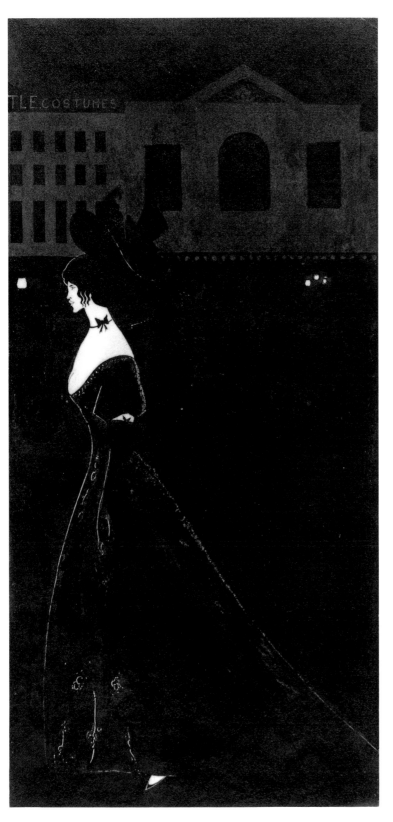

A Night Piece, from *The Yellow Book*,
Vol. I, April 1894. Pen and ink and
wash. Fitzwilliam Museum,
Cambridge

Beardsley's experience of some, if
not all, of the pleasures of the town
undoubtedly contributed to some
degree to the formation of a new
canon of contemporary imagery in
his art, and which he employed to
such effect in many of his
illustrations for the *Yellow Book*. His
night scenes of this period were no
less surprising technically than in
their choice of deliberately daring
subject matter.

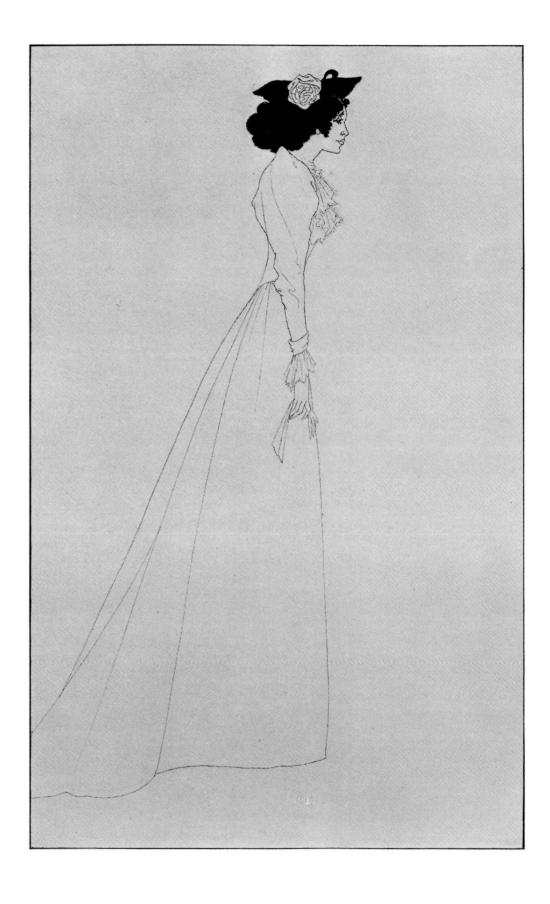

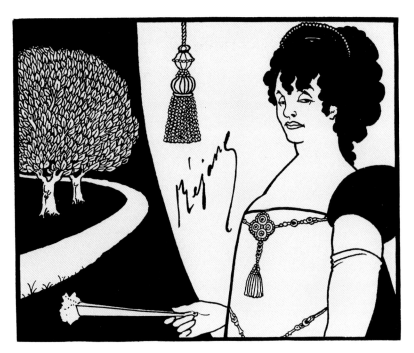

Réjane, 1893–4. Proof from line-block, signed by Madame Réjane. V&A, Harrod Bequest, E.40-1948

Just as he had sought the chance to pay his respects to Mrs Patrick Campbell, so too, when the great French actress Madame Réjane appeared in London at the Gaiety Theatre in June 1894, Beardsley craved an audience. Of the four or five drawings he made of her, one appeared in the second volume of the *Yellow Book*; another in rubbed red chalk – a medium unusual for Beardsley – and this heavy line drawing may possibly have been made earlier, in 1893. This print was autographed by the actress, it is presumed at the time of their meeting at the theatre.

OPPOSITE
Mrs Patrick Campbell; from *The Yellow Book*, Vol. I, April 1894. From line-block. V&A E.375-1899

In February 1894 Oscar Wilde wrote to the celebrated actress 'Mrs Pat.' asking permission to present Beardsley. Shortly afterwards she gave Beardsley a 'sitting' for this drawing; Wilde owned the drawing for a while until it was dispersed along with all his books and other treasures in the disastrously shambolic auction of his possessions at Tite Street in 1895.

Warming to the task, and continuing to use the designation 'new' as a stick with which to beat the victim, *The Times* supposed, in a sense rightly, that 'The Yellow Book...is...destined to become the organ of the New Literature and Art. The cover...may be intended to attract by its very repulsiveness and insolence.' The general tone of the volume and of the movement it represented was judged by *The Times*'s reviewer to be 'a combination of English rowdiness with French lubricity'. But most famously, in the *Westminster Gazette*, one J. A. Spender preposterously called for 'an Act of Parliament to make this kind of thing illegal', and cited Beardsley's drawings – 'excesses hitherto undreamt of' – as the primary reason for the need of so extraordinary and unprecedented a measure of censorship.

Beardsley revelled in all the excitement and notoriety. He rose to the defence in the case of two specific criticisms of his own work, winning one exchange, but losing the other to a far more experienced 'old-hand' in the journalistic arena. One reviewer had complained that his copy of volume II had been defective, missing the exquisitely Mannerist drawing by Beardsley of an impossibly attenuated Mrs Patrick Campbell (then starring to great popular acclaim in Pinero's *The Second Mrs Tanqueray* at the St James's Theatre). Beardsley, perhaps unwisely taking his editorial responsibilities too seriously, wrote a glib letter to apologise that the review copy did not contain the portrait, but pointing out that 'every other copy did'. Snared by this trick, the *Daily Chronicle*'s hack rounded upon him in the next issue with the reply that 'Our own copy it is true, contained a female figure in the space thus described, but we rated Mrs Patrick Campbell's appearance and Mr Beardsley's talent far too high to suppose that they were united on this occasion'.

Rather more successful was the artist's nicely judged riposte to a criticism that his title-page design showing a 'Beardsley Woman' playing a piano in a field was an example of unallowable artistic decadence. Invoking, surely, a spurious authority, he replied to the editor of the *Pall Mall Budget*,

Sir,

So much exception has been taken both by the Press and by private persons to my title page of The Yellow Book, that I must plead for space in your valuable paper to enlighten those who profess to find my picture unintelligible. It represents a lady playing the piano in the middle of a field. Unpardonable affectation! cry the critics. But let us listen to Bomvet. 'Christopher Willibald Ritter von Gluck, in order to warm his imagination and to transport himself to Aulis or Sparta, was accustomed to place himself in the middle of a field. In this situation, with his piano before him, and a bottle of champagne on each side, he wrote in the open air his two Iphigenias, his Orpheus and some other works.' I tremble to think what critics would say had I introduced those bottles of champagne. And yet we do not call Gluck a décadent.

yours obediently, Aubrey Beardsley.

Beardsley's delicate touch as a writer of prose was beginning to match the deadly rapier precision of his draughtsmanship with the pen.

That Beardsley and Beerbohm should have been particularly singled out for criticism in the establishment press as Decadents is not very surprising. Paradoxically, though, it was the arch-Philistine critic, Spender, in the full flow of his invective in the *Westminster Gazette*, who penned one of the most perceptive of all remarks when he observed – clearly far from intending any praise – that Beerbohm was 'the only writer who is entirely worthy to be ranked with Mr. Beardsley'. What is more surprising is the extent to which criticism and antagonism also came from certain quarters of the Aesthetes' camp. Wilde, predictably, was scathing; in a letter to Charles Ricketts he wrote, largely for effect it may be presumed, 'My dear boy, Do not say nice false things about The Yellow Book, I bought it at the station, but before I had cut all the pages, I threw it out of the window'. To Alfred Douglas he was probably rather more honest when he admitted, 'It is dull and loathsome: a great failure – I am so glad.'

On seeing the *Yellow Book* for the first time, Edith Cooper and Katharine Bradley, friends and neighbours of Ricketts and Shannon, who lived and wrote together in Sapphic union under the name of 'Michael Field', were horribly shocked. Ricketts and Shannon, perhaps siding *with* the excluded Wilde, but certainly rather *against* Beardsley, had held aloof from the whole enterprise, preferring to conduct their own rarefied periodical, *The Dial*; 'the Michaels', however, always desperate to seize any opportunity to publish, had not been able to resist the temptation of sending in a manuscript poem when contributions to the *Yellow Book* had first been solicited. Now they demanded its return. 'We have been blinded by the glare of Hell', they wrote melodramatically, 'the window [of Lane and Mathews's shop] seemed to be gibbering, our eyes to be filled with incurable jaundice . . . the infamous window mocked and mewed and *fizgigged*, saffron and pitchy . . . And the inside

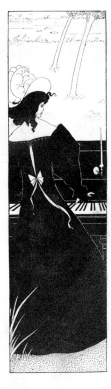

The Yellow Book

An Illustrated Quarterly

Volume I April 1894

London : Elkin Mathews
 & John Lane
Boston : Copeland *&*
 Day

of the book! It is full of cleverness such as one expects to find in those who dwell below light and hope and love and aspiration.'

Not all the reactions to Beardsley's work were quite so violent. *Punch,* which had kept up a campaign of essentially genial criticism of the foibles of the Aesthetes for the past twenty years, since the early days of the movement when Wilde, in his velvets and furs, had been a prime, if easy target for satire, now found a number of occasions to parody the words and pictures of the *Yellow Book.* It commissioned spoof Decadent poems, joke interviews and, with particular success, drawings in the style of Beardsley signed with various names such as 'Wierdsley Daubery'. Among the best of these examples of the sincerest form of flattery were those by the most talented of *Punch's* stable of regular contributors, such as Linley Sambourne and E. T. Reed. In verse, the cleverest of all the parodies was a paraphrase of Lewis Carroll's 'Jabberwocky', which began 'Beware the Yallerbock, my son...' and concluded with the inspired injunction to 'shun the fruminous Beerbohmmax'. When John Lane discovered that parodies of the *Yellow Book*

Title-page for *The Yellow Book,*
Vol. I, April 1894.
From line-block. V&A E.11-1900

The title-page design was deliberately provocative in its placing of a fashionably dressed woman at a piano in a field. Beardsley defended himself and this image in particular against charges of decadence in an amusing letter to the Press.

poets by Owen Seaman were amusing literary London, he shrewdly gathered them into book form and issued them quickly enough to profit in yet another way from the continuing, and seemingly insatiable public interest in anything to do with what was proving to be the most controversial of all the books of the day.

As sales of the *Yellow Book* continued to mount, Lane began to work out his profits. In fact when the original agreements had been made with the Bodley Head, Harland, who was far more worldly in such matters, and perhaps even a little ruthless in his ambitions towards a successful literary career, cut a much better deal with the canny publisher than that which the much less experienced Beardsley secured. Harland had dreamed of riches rolling in, and had, in truth, managed to secure a share of profits based on royalties at a level very close to the fifteen per cent which he had first optimistically proposed. As a result, this left a rather smaller share for the art editor. Nonetheless, with the enormous success of the first number, which ran though a first printing of five thousand in a week and rapidly into second and third editions each of at least another thousand, the profits were considerable. Similarly, Volume II sold some five thousand copies, and as a result for the first few issues it appears that both Harland and Beardsley each received sums, at that time very considerable, of the best part of two hundred pounds.

With the *Yellow Book* Lane undoubtedly made one of the greatest killings of his very successful career, and, perhaps for that reason in particular, he seems to have hastened the rather unsubtle moves which he was making towards severing his business connections with his old partner, the gentle and unworldly Elkin Mathews. Lane's first overt move in this direction was, extraordinarily, to exclude Mathews from the celebratory dinner held to mark the publication of Volume I; on the night, Lane told the company that Mathews was by chance out of town and so could not come to the great gathering, but someone in the know shouted 'That's a lie!' Later, he would equally disingenuously claim that he simply forgot to tell Mathews that the event was taking place and that the latter had, anyway, little interest in the whole *Yellow Book* undertaking, which he viewed with distrust if not actual disapproval.

The *Yellow Book* inaugural dinner was one of the great gatherings of the nineties. Lane, Harland and Beardsley presided as a triumvirate over the tables in a room at the Hotel d'Italia in Old Compton Street in the heart of Soho. Joseph Pennell, Beardsley's first champion in print and a powerful critic to be courted, was away, but his wife Elizabeth was diplomatically given a place of honour between Beardsley and Harland. She recalled, however, that both were too preoccupied with their speeches even to talk to her. Beardsley opened with the winning line that he intended to speak on a very interesting subject: himself. But it was the slyly humorous Walter Sickert who made the most appropriate remark of the evening, suggesting that there would, 'ere long, dawn a day when the writers in all artistic magazines would be compelled to "illustrate" the pictures submitted by the artists'. After the

dinner, a number of the guests went back to the Bodley Head in Vigo Street, but finally a small group including Lane, the Harlands, Mrs Pennell and Max Beerbohm ended up, long after midnight, at a little table in the 'drinking saloon' of the Monico restaurant on Shaftesbury Avenue.

When Volume II appeared, the names of Mathews and Lane still appeared side by side, but by October, when the third volume was published, the sole proprietor of the Bodley Head was John Lane. In a letter to Frederick Evans Beardsley noted laconically, 'Lane and Mathews are at last divorced'. Ruthlessly annexing the name and, of course, taking the *Yellow Book*, Lane crossed the road to the opposite side of Vigo Street and established himself in the pretty little bow-fronted shop, still in existence, that backed on to the fashionable Albany. Lane also did his best to lure as many as possible of the firm's more successful authors to follow him; and although a few of the best, such as W. B. Yeats, preferred out of loyalty to stay with Mathews, most of the more worldly and ambitious names sided with Lane. For a while, at least, the new Bodley Head was for Beardsley, as for other writers and artists of his circle, the centre of the world. For Aubrey this may well have been the happiest moment of his life.

Edmund Hart New (1871–1931), *The Bodley Head*. Illustration for John Lane's *Catalogue of Publications in Belles Lettres*, in *The Yellow Book*, Vol. VII, October 1895. From line-block. V&A Print Room Reference Library

The offices of Lane's Bodley Head in Vigo Street were the 'headquarters' of the nineties literary movement; here the mob gathered at the time of Wilde's arrest, stoning the windows of the shop in protest at the firm's supposed endorsement of the decadence of Wilde, Beardsley and the whole *Yellow Book* crew.

Strictly speaking, it was during the period of just over eighteen months that had begun in the middle of 1893 with the commission for *Salome*, lasted throughout 1894 and just into 1895 that Beardsley was at the height of his fame, basking in the attention of the Press – rarely very favourable attention it is true, but none the less flattering for that; courted by publishers, he found himself invited out on all sides. At first he was much in the company of Wilde and other members of the Cénacle, particularly Robbie Ross, and so naturally became an *habitué* of many of their haunts. At the Café Royal, where the Grill Room and, more particularly the Domino Room were favourites with Wilde, Beardsley, too, was often installed on a plush banquette, adding to the hubbub of conversation those dry remarks that displayed his own subtle blend of wit and precocious literary erudition, and which formed the basis of that very incomplete collection later published as *Table-talk*. With Wilde, too, he would eat in the famous glow of the pink lampshades at Kettner's restaurant or go for late, *louche* suppers at Willis's Rooms.

Once, in a letter written in September 1893, he informed Lane that he would be 'going to Jimmie's [the popular but ill-famed St James's Restaurant

Aubrey Beardsley's paper-knife c.1894. The blade of ivory, engraved; the handle of silver stamped with an indistinct Birmingham hallmark and engraved in a cartouche: 'TIM dd AUBREY'. Private Collection

Abandoned with other personal possessions when Beardsley quit Cambridge Street in 1895, the origins of this paper-knife remain obscure. The identity of 'Tim' has resisted all attempts at elucidation, although Malcolm Easton ingeniously suggested that the reference could be to the name of a celebrated homosexual novel of the day. The engraved arms, now first revealed here, are those of Lord Ashcombe, son of the famous builder Cubitt, enobled in 1893. No connection between Aubrey and this highly conventional Victorian grandee has come to light. The identity of the donor and the circumstances of the gift remain, for the moment at least, an enigma.

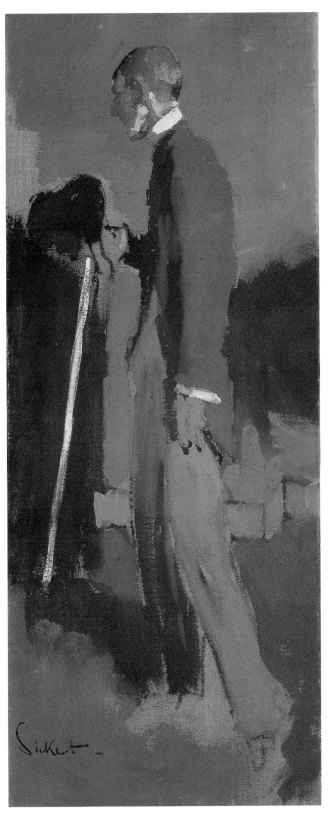

Walter Sickert (1860–1942),
Aubrey Beardsley, 1894.
Oil on canvas. Tate Gallery
© Estate of Walter Sickert 1998

Sickert observed Beardsley, angular,
stooping and painfully thin, but
characteristically elegantly attired in
morning clothes, crossing the
churchyard in Hampstead following
the ceremony to unveil a centenary
monument to Keats; the poignancy
of Aubrey's presence at a service
commemorating the poet's tragically
short life can hardly have been lost
on his friends.

in Piccadilly] on Thursday dressed up as a tart and mean to have a regular spree'. Whilst splendidly indicative both of Aubrey's idea of amusement in this phase of his life, and also of the kind of fast, smart talk that characterised the Cénacle at this time, his phrase has occasioned much solemn speculation as to whether it should be taken literally; did Beardsley then, as his sister later would, really manifest a desire to cross-dress? In fact, the word 'tart', then still newly in circulation, might apply equally to 'an immoral person' of either apparent sex. What seems just as likely, knowing the immediate milieu in which the note was penned, is that – if there is anything in it beyond a tease to the august Lane – Beardsley had in mind the kind of 'tart' that Wilde would have produced to be seen with; as likely to appear in a cheap suit or a telegraph boy's uniform as in a dress.

With the appearance of the fourth *Yellow Book*, published on 16 January 1895, and with the next in preparation, the operation seemed to be entering its second year running smoothly and to the great satisfaction of all concerned. But a sequence of events was about to be set in train that was to change this little world completely. Not long after the appearance of the fourth number of the *Yellow Book*, to which he had, of course, not been invited to contribute, Oscar Wilde had rashly, for the most part propelled only by Lord Alfred Douglas's irrational mania to see his father in court and very much against the better judgement of his friends, initiated a libel suit against the Marquess of Queensberry, on the basis of an illiterately scrawled card: 'To Oscar Wilde posing Somdomite', left provocatively at Wilde's club by Queensberry.

On 5 April the verdict went against Wilde in this celebrated action, and the failure to prove his accusation of libel against the Marquess's defence that he had declared Wilde a sodomite 'in the public interest' laid Oscar himself open to prosecution for offences against the law of the land; in this case the Criminal Law Amendment Act of 1885 proscribing all sexual acts between men. Faced with utter ruin, with outstanding courage Wilde took the decision not to slip away to France, as many men in his position might have done, but to stay, to stand trial and to defend 'the Love that dare not speak its name'. Harland, in a letter to Gosse, who perhaps also knew a little about this world, claimed that the usually half-empty late-afternoon Boat Train that day carried 'six hundred gentlemen' who all felt the need of a little French air.

By the early evening Wilde, supported by a few friends including the loyal Robbie Ross, had taken refuge not far from his Tite Street home, at the Cadogan Hotel in Knightsbridge. Ten minutes after six o'clock the hotel porter ushered into his room two detectives, who arrested him on charges of 'committing indecent acts'. Wilde picked up his fur-collared overcoat, his hat, his gloves and his cane, and a book – a *yellow* book – and followed them to a waiting cab. Among the newspaper headlines the following morning, one proclaimed 'Arrest of Oscar Wilde – Yellow Book under his arm'. Just what that book was may never now be discoverable; the old and most-repeated myth claimed that it was a copy of *Aphrodite*, but that rather silly,

risqué novel of ancient times by Wilde's Parisian friend Pierre Louÿs was not in fact published until the following year. The actual *identity* of the book hardly matters; the *identification* of the look of it was made instantly. The two great icons of the Aesthetic and Decadent Movements, Oscar Wilde and the *Yellow Book*, became fatally linked in the public eye.

If Wilde's stand had been an act of great individual nobility, his fall was far more than a personal tragedy, for effectively and at a stroke he brought down the whole movement in literature and the arts that was popularly designated the 'Decadent' school. In *De Profundis*, the curious testament that he began to write during his imprisonment in Reading Gaol, and in which he took both contrition and egocentricity to new poetic heights, Wilde wrote, 'I was a man who stood in symbolic relations to the art and culture of my age'. He spoke truly. Indeed, so close was that relationship in the popular imagination, that almost immediately a crowd began to gather in Vigo Street, pelting mud at the offices of the Bodley Head (or 'Sodley Bed' as it was called) and even breaking the elegant little Georgian panes of the bow window with rude cobble-stones. Elkin Mathews must have watched the commotion from the far side of the street with a certain wry amusement.

As bad luck would have it, although Beardsley was in London as the crisis broke, Henry Harland was holidaying in France and John Lane was away in New York, seeing to the thriving American side of his operations, having left his somewhat timid office manager, Frederic Chapman, in charge of things in London. With an ugly mob at the door Chapman panicked, and when two of the more 'respectable' (and best-selling) Bodley Head authors, William Watson and Alice Meynell started to demand that the firm publicly dissociate itself from Wilde, he began a series of frantic communications to Lane. Chapman cabled first on 6 April to Lane: 'Propose delete last name from catalogue and announce decision to supply no more books failing this watson and meynell withdraw.' At this time (before Theodore Wratislaw's defection to the Bodley Head from his earlier publisher, Heinemann) Wilde's name was the last in the Bodley Head alphabetical sequence. To this obviously prudent commercial move, Lane – probably imaging it to be a short-term expedient – acquiesced.

But Watson and Mrs Meynell, now backed by a number of others, were not prepared to stop there in their campaign against the 'decadent tendency'. Two days later Lane, perhaps unaware how high feelings were running in London, received a second even more urgent telegram from the fraught Chapman: 'Watson demands exclusion from [volume] five [of the *Yellow Book*] and future [volumes] all designs [by] art editor with whose name he refuses connection. meynell when urging former excision said this must follow[.] watson immovable[.] advise concession his defection now most damaging.' This was a clear threat.

As one of the most lucrative of the 'Bodley Poets', William Watson was important to Lane. Watson himself presumably feared that his verses, already set up in type for the new *Yellow Book*, would be irredeemably tainted by the 'connection' with Beardsley, his reputation tarnished and that sales

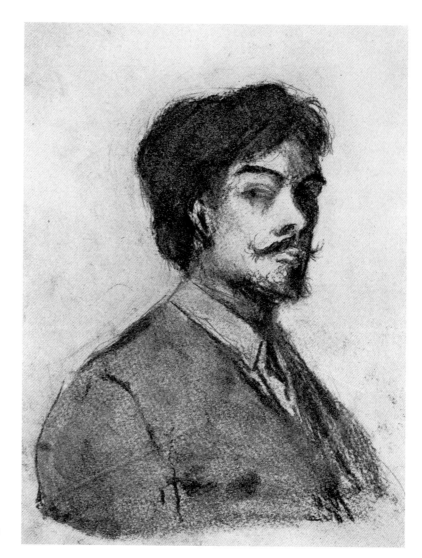

Portrait sketch of Henry Harland, 1894; published in *Early Work*. From line-block. National Art Library

Henry Harland, like Beardsley, was a diagnosed consumptive; but the two did not, as has often been picturesquely suggested, meet in the waiting room of Symes Thompson, the surgeon whom they both consulted. Like Beardsley in another respect, too, Harland was anxious to make a name for himself in the artistic and literary world.

Prospectus for *The Yellow Book*, Vol. v, March 1895. Stephen Calloway

The fifth volume of the *Yellow Book* was almost ready to appear when the Wilde scandal broke. The prospectus records the cover design by Beardsley that was, in the event, suppressed along with the rest of his contributions.

would suffer. What has subsequently come to be revealed, however, is that this fine and upstanding pillar of England and Empire was not merely urged, but actually offered what amounted to bribery by that self-righteously moralistic Mrs Grundy of a novelist Mrs Humphrey Ward to bring pressure to bear on Lane, pushing him to dismiss Beardsley. Watson sent yet another cable to Lane on 8 April 1895, saying, 'Withdraw all Beardsley's designs or I withdraw all my books', which, as Stanley Weintraub neatly put it, has become just about the only line of Watson's which is ever remembered. After a half-hearted attempt to defend Beardsley in print, by describing him as a latter-day Hogarth – that is, as a satirist of the vices of the day rather than a reveller in them – Lane caved in completely. By this time Ella D'Arcy, the assistant editor at the *Yellow Book*, had summoned Harland from France, and he and Chapman, on John Lane's instruction, informed the stunned art editor that, with immediate effect, he was dismissed.

The Yellow Book

An Illustrated Quarterly

Volume V April 1895

Price
$1.50
Net

London: John Lane
Boston: Copeland & Day

Price
5/-
Net

Lane's decision to abandon Beardsley along with Wilde in the face of this moral backlash was at worst pusillanimous and clearly motivated by an overwhelming need to protect the firm from further damage. Robert Ross, writing in 1909, and obviously in full possession of the facts of the matter, wrote with fairness and characteristic wit, 'A number of poets and writers blackmailed Mr Lane by threatening to withdraw their own publications unless the Beardsley body was severed from the Bodley Head. I am glad to have this opportunity . . . of defending my . . . good friend . . . from the absurd criticism of which he was too long the victim. He could hardly have been expected to wreck a valuable business in the cause of unpopular art.' The impression nevertheless remains that many did so expect, and censured Lane accordingly, especially in the light of several later attempts to gloss over the history of his dealings with his most important artist.

Only shortly after Beardsley's death Lane had had the temerity to write, 'Beardsley was responsible for the art of the first four volumes [of the *Yellow Book*], and it must be confessed that, when he severed his connection with the magazine, the quarterly suffered an irretrievable loss'. In fact, contrary to the popular version of the story, the *Yellow Book* did not from that moment cease entirely to contain any good or interesting work, but its 'decadent' period was over, and henceforth Harland and Lane trod a markedly safer path in terms of public taste. In E. F. Benson's smart novel of 'varsity life, *The Babe, B.A.*, the main protagonist, nicknamed 'the Babe', is a character based to a considerable extent upon the infamous, rich and precocious undergraduate Aesthete Herbert Pollitt – soon to become a friend and patron of Beardsley. Describing his rooms, Bensons writes that 'he possesses several of Mr. Aubrey Beardsley's illustrations from the Yellow Book clustered round a large photograph of Botticelli's Primavera', and in his bookcase, volumes of the *Yellow Book*, 'which the Babe declared bitterly had turned grey in a single night since he had ceased to draw for it', which just about summed up the general perception of the affair. In the event, Lane, Harland and a new assistant, the illustrator Patten Wilson, soldiered on with the quarterly. Volume XIII was the last, and as Robert Ross quipped, 'The *Yellow Book* perished in the odour of sanctity'.

Mabel Beardsley, adding her detailed reminiscence of the events of those momentous days of 1895 to her mother's rather general memoir of Aubrey's childhood, recalled that her brother was 'bitterly humiliated' by his enforced removal from the *Yellow Book*. But it was more than just his professional pride and self-esteem that were dented. Worse than any immediate damage to his relatively robust psyche, was the more tangible hurt caused by the instant severance, without warning or compensation, from his main means of support. Since the time of his work on *Salome*, and especially in the period of little more than a year since he had become the salaried art editor of the *Yellow Book*, he had worked mainly, if not exactly exclusively for the Bodley Head, supplying an impressive flow of drawings. He had come to rely on Lane's cheques to maintain his house, his family and a certain style of living, which if hardly excessively opulent, was at least comfortable by the standards both

of bohemian existence and ordinary 'artistic' middle-class life in the nineties.

Aubrey's income depended entirely on the payments he received for his drawings as they were done and reproduced. That anyone, at this moment, would want to use his designs had begun to seem very doubtful. Now in less than good health and with his mother serving more or less as full-time housekeeper and nurse as required, with his sister's at best only erratic earnings from the theatre, and with no hope of any helpful contributions to the family economy from his feckless father, things looked bleak. Discussing the situation (as always with his sister only), Aubrey and Mabel came almost immediately to the sad conclusion that they would inevitably be forced to give up the much-loved house in Cambridge Street, and along with it, in all probability, a good deal of their carefully constructed social life with its Thursday teas and little round of other pleasures. More worrying still was the very serious possibility that Beardsley might find himself almost literally unemployable.

Almost immediately after his unceremonious dismissal Beardsley crossed to France, in part perhaps to avoid any further adverse and damaging publicity for himself, but also no doubt to escape the general atmosphere of unpleasantness and even outright hostility so palpable in London at that moment, and to breathe the rather freer, more comfortably bohemian Gallic air. Towards the end of April, when the ill-starred fifth *Yellow Book* appeared on the bookstands, Aubrey was in Paris, and, perhaps oddly, with Harland. Quite what game Harland was playing is difficult to guess. It is true that as the crisis broke he was in France and may at first have been genuinely unaware what was happening, but as telegrams from the Bodley Head began to reach him he cannot have remained for long in the dark.

It is clear that, for financial reasons if for no other, Harland had sided with Lane and acquiesced in Beardsley's dismissal. To his erstwhile editorial colleague, however, he appeared to take a rather different stance, defiant in the face of Lane and bourgeois morality, and conciliatory and encouraging towards Beardsley. For whilst the only remaining sad vestiges of Beardsley's association with the enterprise were to be found on the spines and back covers of the copies of Volume V, from which, in their haste Ella D'Arcy and Frederic Chapman had by simple oversight forgotten to expunge his designs, Harland continued to assure Beardsley that he believed Lane would fairly rapidly climb down and reinstate him as soon as the *brouhaha* had quietened. Can Beardsley have believed him? Beset by deep anxieties about his work, his reputation, his health and, not least, about how he was to earn a living, he must have realised, in his heart of hearts, that the curtain had firmly come down on one distinct act of his life, and that another, far more uncertain, was about to rise. This time the cast of characters would be quite different.

Chapter six
THE ABBÉ AUBREY

With the Wilde affair sending serious shock-waves throughout literary and artistic London, and with all kinds of artists and poets, Aesthetes, Decadents and other so-called deviants running for cover, it began to seem highly likely that no 'respectable' publisher would care to employ the artist most closely associated in the public mind with the disgraced writer and notorious as the creator of the images so redolent of the supposed viciousness, degeneracy and depravity of their infamous Cénacle. Lingering on in Paris in the spring-like weather, but with fast diminishing funds, Beardsley began to view his now highly uncertain future with a rising sense of panic.

At the very end of the month of April 1895 he paid a fleeting visit to London for a few days in order, it seems, to 'consult' a new friend about his dilemma. Marc-André Raffalovich was both rich and charming; a Russian Jew whose family had emigrated to Paris in the 1860s, where his mother had established a considerable *salon*, the tale was told of André that this formidable woman considered him so ugly that, unable to bear the sight of such a reproach to her impeccable taste and poise, she had banished him. Whether this be true or not, certainly he had been sent in 1882 to Oxford, arriving in England with a vast allowance, with an extraordinary nanny-housekeeper-companion, a Miss Gribble, to look after him, and with a serious desire to cut a dash socially. At Oxford, predictably, Walter Pater – another lover of beauty who conspicuously lacked that quality personally – had succumbed to the young André's winning combination of cultivation, social prestige and wealth, and had taken him up. But finding academic life in a provincial city to be not quite the natural milieu in which to give free rein either to his ambitions or to what he conceived to be his talents, Raffalovich had quite quickly moved to London. He published a first, rather equivocal book of love-poems, *Cyril and Lionel*, in 1884, and before long was moving in the smartest Asthetic circles. He knew Whistler and Wilde, with whom he would later quarrel famously, and other artists and poets of the day, and he was for a while much in the set that centred on Wilde's great friend Ada Leverson, 'The Sphinx', at whose house he probably first met Beardsley.

Sadly, Raffalovich's highly cultivated and artificial manner, his almost painful desire to be taken seriously as a Man of Letters and an over-polished dandyism that proclaimed his wealth just a little too ostentatiously for English tastes, all conspired to make this essentially good-hearted and generous man the butt of many jokes and even to win him a good number of enemies in the London of the nineties. When John Gray, the author of that quintessential 'slim volume' of Decadent verse *Silverpoints*, and once one of

A. Dampier, *Portrait of Marc-André Raffalovich*, 1886. From an old reproduction, present whereabouts unknown.

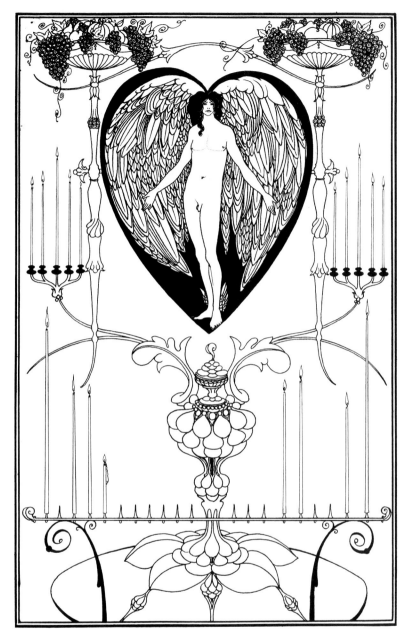

the 'slim gilt souls' in Wilde's entourage, became instead the inseparable friend and protégé of Raffalovich, it had signalled a crucial turning point. Wilde, almost certainly jealous, became more overtly hostile and even at times deliberately insulting. Once, bidden for lunch at Raffalovich's fashionable South Audley Street house, he had turned up, bringing with him several uninvited and rowdily drunk friends, and, when the street-door was finally opened to them, had had the effrontery to ask the bewildered butler for 'a table for six'. Later Oscar was heard to remark in a cruel and much-repeated quip that 'Poor André had come to London hoping to found a *salon*, but succeeded only in opening a saloon'.

The Mirror of Love, 1895. Pen and ink. V&A, Given by Canon John Gray in memory of André Raffalovich, E.1966–1934

Drawn as a frontispiece for Raffalovich's book of poems, *The Thread and the Path*, the design was rejected by the publisher David Nutt, owing to the hermaphrodite nature of the figure personifying Love.

Trial piece for covers of the Pierrot's Library, 1895. From brass block impressed in colour on book-cloth. V&A, Gleeson White Collection, E.421-1899

In spite of his dismissal from the *Yellow Book*, Beardsley actually continued with a number of other projects already in hand with Lane, including the *Keynotes* series and a new venture, the Pierrot's Library, named after the first book in a short list of titles, *Pierrot!* by H. de Vere Stacpoole, published in January 1896. Beardsley received a much needed £15 for the designs for covers, spines, endpapers and titles.

Besides working at his sonnets and other verses, Raffalovich was also already engaged on what he believed to be his important, ground-breaking study of the phenomena of 'congenital sexual inversion' and 'Uranianism' (the accepted 1890s terms for homosexuality). At the moment of Wilde's downfall however, Raffalovich dipped his pen in vitriol to write, in French, a curious, score-settling attack on both his literary style and his morals, *L'Affaire Oscar Wilde*, which was published in Paris later that year. Beardsley, in one of the first of many surviving letters to his new friend, makes mention of a line in this childishly petulant and unilluminating tract, which Raffalovich had clearly shown to him for comment: 'M. Aubrey Beardsley, un jeune artiste du plus grand talent,' wrote Raffalovich, 'eut la malcontreuse chance d'illustrer cette *Salomé* médiocre de douze dessins que je déplore en les admirant. Mais il n'a pas été dupe de cette publication.' Beardsley replied, 'As to the passage you send me I don't think it could possibly do me any harm; besides I in no way regret my pictures to *Salomé*'.

Though it was a mutual, deep-felt and entirely understandable antipathy to Wilde which initially made Beardsley and Raffalovich natural allies, there can be little doubt that their strange, oddly interdependent, and often largely misunderstood relationship rapidly developed into a rare kind of friendship, becoming for Beardsley quite genuinely one of the mainstays and determining factors of the last difficult years of his life. 'Raff' would always claim that he had been 'arrested' by Beardsley's singular character, which he would later describe as 'like wrought iron and like honeysuckle. . .' in its 'hardness, elegance, charm, variety. . .' Of course it would be naive to suggest that Raffalovich's constant subventions of funds did not play a major part in establishing his importance to Beardsley's existence. They did; but Beardsley's reliance on his strangely engaging friend was never, it seems, entirely or even predominantly cynical.

That being said, the letters which passed between Aubrey and André at this period record the artist's thanks for an almost constant stream of gifts, including books, exquisite flowers from Bond Street, expensive chocolates and elegant walking sticks, as well as invitations to concerts, lunches and dinners and innumerable other small kindnesses to both him and Mabel. Such solicitous attentions to his comforts and delights must, for the moment, have seemed like balm to Beardsley's wounded pride; for Raffalovich the reward must, to a degree, have lain in at last having a famous friend, and one who responded to each new gift with almost daily letters of thanks that trilled sweetly in the affected manner of the times, an over-elaborated epistolary style at which Aubrey excelled: 'I have noted your charming invitation on my tablets . . .', 'I have been writing most of the day and found the chocolate a great support in my quest for epithets', 'I shall be enchanted to assist at *Mefistofele* on Thursday . . .', 'your verses lie amongst my treasures. . .' or, perhaps most tellingly, 'Very many thanks for your book of verses which I am just dipping into'.

But more than this: clearly, Raffalovich's urbane, refined and essentially asexual but possessive passion for Beardsley's well-being, which in due

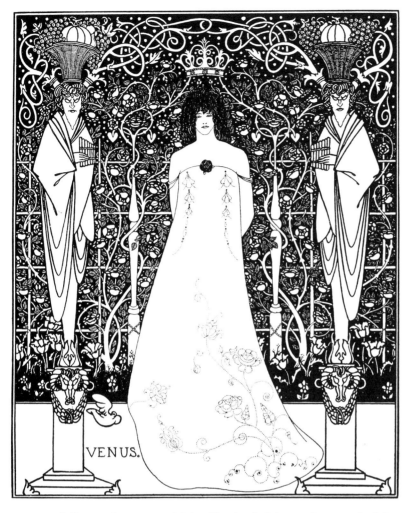

course – following his own and John Gray's wholehearted espousal of the Catholic faith – would also become an obsession with Aubrey's moral and spiritual path, fulfilled a crucial need in Beardsley's life. It has been plausibly suggested that Beardsley, whose own father remained both distant and ineffectual, either consciously or unconsciously responded to the always guarded but nonetheless intense emotional advances of Raffalovich, a man who, as a result of his own dislocated childhood and complex homosexual leanings, considered the search for real intimacy fraught with danger, but found the role of father-figure one for which he was ideally suited. Such an interpretation may gain some weight from the evidence of the names by which Beardsley and Raffalovich addressed each other in the earlier days of their correspondence: in a conceit based on the *Odyssey*, perhaps first begun by Beardsley with satirical intent, but with which Raffalovich, flattered by the implication, no doubt readily enough played along, Beardsley signed himself 'Télémaque' and referred to his friend as 'Mentor', the older, wiser adviser.

By late May 1895 Aubrey had finally determined that he must, indeed, sell the lease of Cambridge Street, and the auction was duly fixed for

Venus between Terminal Gods; frontispiece intended for *Venus and Tannhäuser*, 1895. From line-block. Stephen Calloway

This and the two following designs were among a group of 24 planned as the illustrations to Beardsley's tale in the version that had already been advertised as a forthcoming Bodley Head title, but which Lane cancelled. This drawing was particularly admired by Frederic Leighton, then President of the Royal Academy and, perhaps unusually for such a grandee of the art world, a man much given to encouraging younger artists. Stylistically it seems very close to the work of Ricketts at this date.

Page from the *Hypnerotomachia Poliphili*. Facsimile edition by J. W. Appel, 1889. V&A, Print Room Reference Library

The *Hypnerotomachia*, or 'Strife of Love in a Dream', a mystical text by the humanist poet Poliphilus, printed by the great Venetian publisher Aldus Manutius in 1499, is one of the most beautiful and celebrated of all Renaissance illustrated books. Rossetti and Burne Jones both owned copies of this valuable work and it was much admired by the Aesthetes. A South Kensington Museum facsimile edition, first printed in 1889, at last made the spare and elegant emblematic illustrations more widely available to bibliophiles of modest means. Other than Beardsley, many book illustrators of the day, such as Ricketts and Shannon, and in particular Robert Anning Bell were greatly influenced by the volume.

11 June; the advertisements offering what was described, with a certain degree of the usual optimistic gerrymandering by the agents, as a 'bijou residence' in 'South Belgravia'. The search for another house was undertaken by Mabel. Fortunately something slightly less 'bijou' and thus cheaper to rent, but still in their preferred part of Pimlico, became available, and Beardsley signed a short lease for 57 Chester Terrace. With things thus settled, much of his bitterness of earlier in the year seems to have evaporated, and when sentence was finally passed on Wilde on 25 May, following his third trial, Aubrey wrote to Raffalovich, then on holiday in Berlin, as he had earlier written to Ada Leverson, in a far gentler vein and with a touch almost of compassion: 'I suppose the result of the Oscar trial is in the German papers – two year's hard. I imagine it will kill him.'

Cushioned from his more immediate anxieties by a combination of loans and gifts from Raffalovich, and, perhaps surprisingly, still carrying on with outstanding commissions from Lane, including those for the title-pages, covers and authors' monograms in the form of keys which he had invented originally in 1893 for the Bodley Head series of popular novels, *Keynotes*, Beardsley began to get back into a pattern of work again. Asked by Raffalovich to do a portrait drawing, Beardsley responded warmly and began to discuss the idea of making a full length pastel drawing on brown paper, an eighteenth-century technique made popular again in the 1880s and 90s by Whistler. The picture would not, he promised, require lengthy, tiring sittings because he generally worked so quickly; but in the event nothing came of the plan.

He did, however, make a very fine, large line drawing intended for the frontispiece of Raffalovich's latest collection of poems, *The Thread and the Path*, about to be published by David Nutt. Unfortunately, when the rather con-

THE STORY OF VENUS AND TANNHAUSER, IN WHICH IS SET FORTH AN EXACT ACCOUNT OF THE MANNER OF STATE HELD BY MADAM VENUS, GODDESS AND MERETRIX, UNDER THE FAMOUS HORSELBERG, AND CONTAINING THE ADVENTURES OF TANNHAUSER IN THAT PLACE, HIS REPENTANCE, HIS JOURNEYING TO ROME, AND RETURN TO THE LOVING MOUNTAIN. By AUBREY BEARDSLEY. ❦ ❦ ❦ ❦ ❦

servative Nutt saw the design of a 'Nude Amor', a literal rendering of a line from the opening poem in the book, 'Set in the heart as in a frame Love liveth', he pronounced that he could not and would not publish it. 'Say what you will,' he protested, 'the figure is hermaphrodite'. In the wake of the Wilde affair, publishers could hardly be too prudent – for the time being at least. In spite of the poet's protestations and melodramatic threats to withdraw the book, Nutt remained adamant, and although Beardsley, no doubt thoroughly tired of such disputes, made the, at best, rather half-hearted suggestion to Raffalovich that he draw an alternative version, *The Thread and the Path* duly appeared, to no great acclaim, unadorned.

Mabel recalled that in these months her brother saw fewer people than he had during the hectic year of the *Yellow Book*, the period when he had been at his most butterfly-like and social. He went about much less, and was seldom to be seen on his banquette at the Café Royal or at other favourite haunts. Now, she said, he affected not to care to accept so many invitations; perhaps, in truth, ostracised by many who had previously courted him, he received far fewer than before. Paradoxically though, and despite continuing fears and poor prognostications concerning the progress of his disease, gradually, but distinctly, Aubrey's mood lightened. To a friend of Ada Leverson's, a Mrs Clarke, who had given the family some light, summery furnishing fabric to help make the dull Chester Terrace house seem less dreary after the visual delights of Cambridge Street, Beardsley wrote with an obviously relished return to his studied wit of former times, 'It was quite delightful of you to send me that art muslin. It suits me so well and will be so nice and cool in the hot weather. If my tailor finds that there is any over I shall get some curtains made.'

Title-page intended for *Venus and Tannhaüser*, 1895. From line block. V&A E.1409-1983

The architectural framework and the evenly spaced Roman lettering used in the typography reflect the influence of Renaissance book designs in general and of the *Hypnerotomachia Poliphili* in particular.

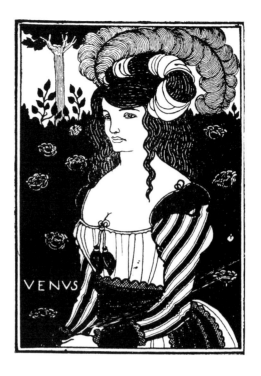

Venus; illustration intended for
Venus and Tannhäuser, 1895.
From line-block. V&A, Gleeson
White Collection, E.459-1899

For this ornamental panel, intended
for the title-page of the book,
Beardsley's reuses the costume details
of a Renaissance portrait; this
contrasts with his later, more
eighteenth-century visualisation of
the characters and settings of the tale.

The Abbé; illustration for *Under the Hill*,
1895. Published in *The Savoy*, No.1,
January 1896. Pen and ink. V&A,
Harari Collection, E.305-1972

One of the masterpieces of
Beardsley's later, intricate manner
deriving from the linear techniques
of French seventeenth- and
eighteenth-century masters of
copperplate engraving, this
illustration to the later version of his
own 'romantic story' of Venus and
Tannhäuser, *Under the Hill*, depicts
the moment at which the dandified
hero, called the Abbé Aubrey in an
early draft, pauses, 'quelling the little
mutinies of cravat and ruffle' and
'undoing a tangle in the tassel of his
stick', before he enters the 'ombre
portal' to Madame Venus's kingdom.

In a letter to Frederick Evans written probably as early as the previous
November, Beardsley had given one of the first hints concerning his grow-
ing preoccupation with what would become his own favourite and almost
obsessive undertaking in these months, and indeed for much of his remain-
ing life: the writing and illustration – at first projected on an ambitiously
extravagant scale – of a version of the Tannhäuser story. In spite of the con-
centration and efforts which the project demanded, work on it seems always
to have buoyed him up. To Evans, as an old friend, he had been able to
recount just how 'horribly weak' he had been left from yet another attack of
haemorrhaging from the lung, admitting that 'for the time all work has
stopped and I sit about all day moping and worrying about my beloved
Venusberg. I can think of nothing else.' He then went on to give Evans a
more precise flavour of what he is about: 'I am just doing a picture of Venus
feeding her pet unicorns which have garlands of roses round their necks.'

Like a piece of precious old porcelain reset in a brilliant, *rocaille* ormolu
mount, Beardsley took the old German legend and gave it a new and
unlikely *mise-en-scène*, steeped in the artificial world of his beloved eighteenth-
century French novelists. All his characters and many of their curious actions
reveal, however, a thoroughly modern and perverse sensibility. Ostensibly
he followed closely the main theme of the ancient tale, but viewed the plot
also, as it were, very much through the refracting lens of Wagner's nine-
teenth-century vision of the pilgrimage of the dandified knight from the
physical pleasures of the world towards spiritual enlightenment. But
Beardsley's conception of the unfolding story nevertheless placed great
emphasis on the detailing of Tannhäuser's first sojourn in the enchanted

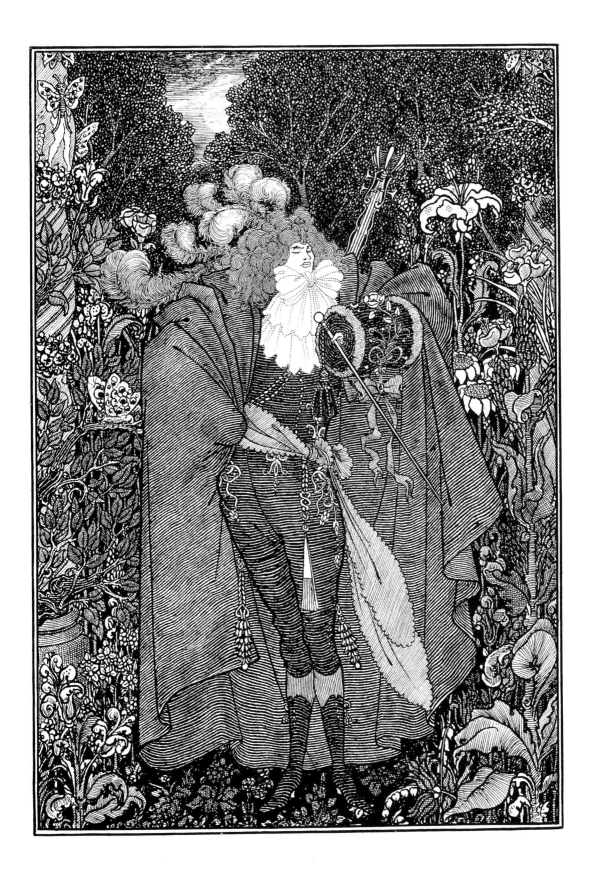

Cover for Leonard Smithers's
Catalogue of Rare Books, Vol. V,
1895–6. Collection Anthony
d'Offay

A design used for three of Smithers's
catalogues, but later, curiously,
taken over by Lane for his own, and
finally employed by Elkin Mathews
as late as 1932 for a catalogue of
Books of the Nineties, in which the
original drawing was offered for sale
at £105.

kingdom, and clearly envisaged his ultimate, and perhaps inevitable, return
to the sensual delights of the Hill of Venus. 'The book *really* will be fine. I
certainly don't mean to hurry', he told Evans, adding as a final injunction,
'By the way don't tell anyone of this subject'.

Perhaps understandably, he was anxious not to have too much known
about his plans, or for too many idle tongues around London to wag about
the state of his health and his ability to work. With a delicious irony, though,
Beardsley himself probably remained in the dark about a rival version to his
tale, even then in preparation. In a note, all but hidden in S. C. Cockerell's
lists of the Kelmscott books appended to William Morris's typographical
testament, *A Note on his Aims in Founding the Kelmscott Press*, published posthu-

mously in 1898, appears the curious description of a woodcut border 'intended for an edition of *The Hill of Venus*, which was to have been written in prose by [Morris] and illustrated by Sir E. Burne Jones'. This project, Cockerell adds, was 'afterwards abandoned'. But given the history of their relationship, how extraordinarily irritated both Beardsley and Morris would have been, had either known what the other intended, and how earnest would the Morris version have been when compared with the few brilliant and outrageous chapters which Beardsley managed to bring to completion.

Without parody, but occasionally resorting to subtle pastiche (as in the exquisite spoof dedication to the fictional Cardinal Giulio Poldo Pezzoli, 'Titular Bishop of S. Maria in Trastevere… and Nuncio to the Holy See in Nicaragua and Patagonia', offered 'by his humble servitor, a scrivener and limner of worldly things, who made this book'), in many passages Beardsley echoes both the satirical wit and cynical humour of the sort of eighteenth-century writing he most admired. At the same time he also succeeds in evoking powerfully that strange and highly polished artificiality, and cheerfully immoral atmosphere that he had come to prize as the essential qualities of many recent French books of the Decadence. In English literature there is nothing quite like *Under the Hill*.

Written in a most mannered style and with delicately lapidary prose, *The Story of Venus and Tannhäuser*, as Beardsley first titled it, was to be elaborated in a great number of fantastic episodes and set-piece descriptions, many of them conceived in terms of the most outrageous freedom. Those, in particular, which reveal Aubrey's growing fascination with some of the more bizarre aspects of sexuality, can never have been written with any realistic thought of publication – in the ordinary way at least; his evident delight in elaborating every detail of the pleasures of the inhabitants of the Hill of Venus, and his relish in describing the *minutiae* of their depravity immediately suggest the milieu of the strictly limited editions issued for the collectors of *curiosa* by publishers such as Leonard Smithers. Indeed, much of what Beardsley penned reveals the clear influence of classic eighteenth- and nineteenth-century pornographic writing, and suggests just how very well-read Aubrey must have been by this stage in such recherché material.

One particular passage, entitled 'Of the Ecstasy of Adolphe, and the Remarkable Manifestation Thereof', is related to the picture described to Evans, in which the unicorn Adolphe featured; necessarily suppressed from the early printed versions, it is highly indicative of Beardsley's curious blend of both seriousness and arch whimsicality driven by an over-heated imagination:

Venus … pretended to leave the cage without taking any further notice of Adolphe. Every morning she went through this piece of play, and every morning the amorous unicorn was cheated into a distressing agony lest that day should have proved the last of Venus' love … Poor Adolphe! How happy he was, touching the Queen's breasts with his quick tongue-tip. I have no doubt that the keener scent of animals must make women much more attractive to them than to men; for the gorgeous odour that but faintly fills our nostrils must be revealed to the brute creation in divine fullness … After the first charming interchange of affectionate delicacies was over, the unicorn lay down upon his side, and, closing his eyes,

beat his stomach wildly with the mark of manhood. Venus caught that stunning member in her hands and laid her cheek along it; but few touches were wanted to consummate the creature's pleasure. The Queen bared her left arm to the elbow, and with the soft underneath of it made amazing movements upon the tightly-strung instrument. When the melody began to flow, the unicorn offered up an astonishing vocal accompaniment. Tannhäuser was amused to learn that the etiquette of the Venusberg compelled everybody to await the outburst of these venereal sounds before they could sit down to déjeuner.

Adolphe had been quite profuse that morning.

Venus knelt where it had fallen, and lapped her little aperitif.

Haldane MacFall deplored the fact that *Under the Hill* contained such 'gloatings over acts so bestial that it staggers one to think of so refined a taste as Beardsley's, judged by the exquisiteness of his line, not being nauseated by his own impulses'. The whole text remained, for this otherwise besottedly admiring critic, little more than 'fantastic drivel, without cohesion , without sense...a posset, a poultice of affectations', merely 'the laboured stringing together of little phrases, word-pictures of moods'. But his most interesting observation, quite in opposition to the more customary reading of Beardsley's writing, and often his pictures too, was that *Under the Hill* 'explains much that would otherwise be baffling in his art...it is a frank emotional endeavor to utter the sexual

The Fruit Bearers; illustration for *Under the Hill.* Published in *The Savoy,* No. 1, January 1896. From line-block. V&A, Gleeson White Collection, E.443-1899

The fantastic elaboration of these full-page illustrations precisely mirrors the highly wrought prose style of Beardsley's text.

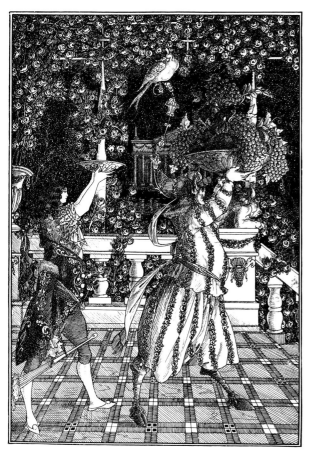

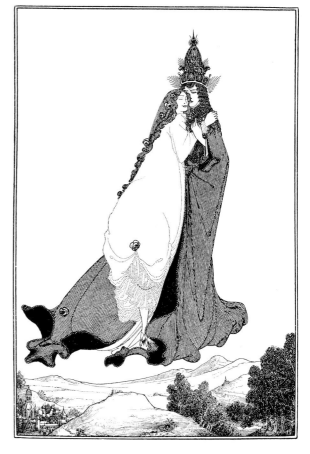

extasies of a mind that dwells in a constant state of erotic excitement'. It is, he continues, 'Beardsley's testament – it explains his art, his life and his vision – and it proves the cant of all who try to excuse Beardsley as a satirist. A satirist does not gloat over evil, he lashes it. Beardsley revelled in it.'

Others have equally plausibly seen in Beardsley's text a more deliberate attempt to write in an intentionally provocative and really quite novel manner, to shock certainly, but also to create a literary equivalent to that super-subtle blend of refinement and outrageousness that characterised his pictures. Some of the set-piece descriptions have a strange brilliance that is almost purely visual, and clearly represent a precise – even symbiotic – counterpart to his drawings of this period. Bernard Muddiman, more sympathetic to Beardsley's aims, and perhaps more alive to his literary antecedents, cleverly invoked the comparison with the late-Roman satirist Petronius, much admired by Beardsley (and also an author printed by Leonard Smithers). Muddiman observed that it was necessary to go back to Petronius'description of the feast of Trimalchio in the *Satyricon* to find anything quite like Beardsley's imagination and descriptive powers in the chapter 'How Venus supped; and thereafter was mightily amused by the curious pranks of her entourage':

The frockless Venus and Tannhäuser, with Mrs. Marsuple and Claude and Clair, and Farcy, the chief comedian, sat at the same table. Tannhäuser, who had doffed his travelling suit, wore long black silk stockings, a pair of pretty garters, a very elegant ruffled shirt, slippers and a wonderful dressing-gown; Claude and Clair wore nothing at all, delicious privilege of immaturity; and Farcy was in ordinary evening clothes. As for the rest of the company, it boasted some very noticeable dresses, and whole tables of quite delightful coiffures. There were spotted veils that seemed to stain the skin with some exquisite and august disease, fans with eye-slits in them, through which the bearers peeped and peered; fans painted with figures and covered with the sonnets of Sporion and the short stories of Scaramouch; and fans of big, living moths stuck upon mounts of silver sticks . . . there were masks of green velvet that make the face look trebly powdered; masks of the heads of birds, of apes, of serpents, of dolphins, of men and women, of little embryons and of cats; masks like the faces of gods; masks of coloured glass, and masks of thin talc and of indiarubber. There were wigs of black and scarlet wools, of peacocks' feathers, of gold and silver threads, of swansdown, of the tendrils of the vine, and of human hair; huge collars of stiff muslin rising high above the head; whole dresses of ostrich feathers curling inwards; tunics of panthers' skins that looked beautiful over pink tights; capotes of crimson satin trimmed with the wings of owls; sleeves cut into the shapes of apocryphal animals; drawers flounced down to the ankles, and flecked with tiny, red roses; stockings clocked with fêtes galantes, and curious designs; and petticoats cut like artificial flowers. Some of the women had put on delightful little moustaches dyed in purples and bright greens, twisted and waxed with absolute skill . . . Then Dorat had painted extraordinary grotesques and vignettes over their bodies, here and there. Upon a cheek, an old man scratching his horned head; upon a forehead, an old woman teased by an impudent amour; upon a shoulder, an amorous singerie; round a breast, a circlet of satyrs . . . But most wonderful of all were the black silhouettes painted upon the legs, and which showed through a white silk stocking like a sumptuous bruise.

The Ascension of St Rose of Lima; illustration from *Under the Hill.* Published in *The Savoy*, No. 1, January 1896. From line-block. V&A, Gleeson White Collection, E.423-1899

Beardsley's fascination with the often overt and perverse sensuality of Catholic religious imagery is apparent in this illustration to an elaborate episode which he inserted as a note in *Under the Hill*. The ecstasy of the beautiful young saint seems to exhibit the same equivocal origin as that of Bernini's *St Teresa*.

Not even Huysmans in his seminal novel of the decadence, *A rebours*, could sustain such a level of fantastic invention and minute description in the pursuit of perverse effect. Such weirdly wrought prose was, simply, too much for many English readers of the day, and Beardsley's writing had, indeed, to wait well into the twentieth century before it was to find many serious admirers or scholarly champions. But Mario Praz, writing between the wars, and from a more European standpoint, in his study of the morbid and Decadent tendencies in literature and the arts, *The Romantic Agony* (first published in 1933), found that 'the essence of the English decadent school is contained in the forty-odd pages of Aubrey Beardsley's *Under the Hill*'.

At times the hero of the tale is given the name of the Chevalier Tannhäuser, but in other drafts he is renamed the Abbé Franfreluche or, perhaps most tellingly of all, in the light of some of the more lubricious fantasy sequences, the Abbé Aubrey. In the same way, Venus becomes Helen at times, whilst many minor characters often seem to be interpolated merely for the pleasure of introducing their amusing names. Drafting and redrafting, and the continual honing of his phrases and sentences seems to have become for Aubrey pleasures in themselves. Similarly, the overall plan of the book was also constantly reshaped in Beardsley's mind; varying lists of pictures were invented and discarded, and later the entire book was rechristened, mainly it seems to outwit Lane, to whom it had originally been promised for publication, becoming first *The Queen in Exile*, before Beardsley settled on the more subtly suggestive *Under the Hill*.

This extraordinary piece of writing, with its clear psychological overtones of autobiography and wish-fulfilment, came to play a central role in Beardsley's existence throughout this difficult period of his life. Revealing Aubrey's very real wish to be regarded as highly as a man of letters as he already was an artist, work on the richly embroidered episodes of the tale increasingly obsessed him. His desire to publish even sections of the text became intense. Where once his portfolio had contained the latest drawings which he was eager to show, it now housed the precious, much worked-over manuscript book which he carried with him everywhere as a totem of his new, self-styled status as a writer.

Although one room in the Chester Terrace house was nominally set aside as Beardsley's 'studio', he seems never to have liked the place, and what drawing he did at this time he mostly did in the studio of his friend William Rothenstein, now established close by in Glebe Place, a rather fashionable street for artists off the King's Road in Chelsea; Rothenstein, remembering the time when he had had no place to work and was welcomed by Beardsley, was happy to return the favour. Aubrey's attendance was at best erratic, but Rothenstein recalled on several occasions the extraordinary sight of his friend arriving, usually very late in the morning, having walked from Pimlico, hastily and – most unusually for so dandified and normally so self-aware a figure as Beardsley – less than impeccably dressed; a few times he even arrived without a collar. As often as not he wrote rather than drew.

In the event, having, with Mabel's solicitous help, moved his, by now,

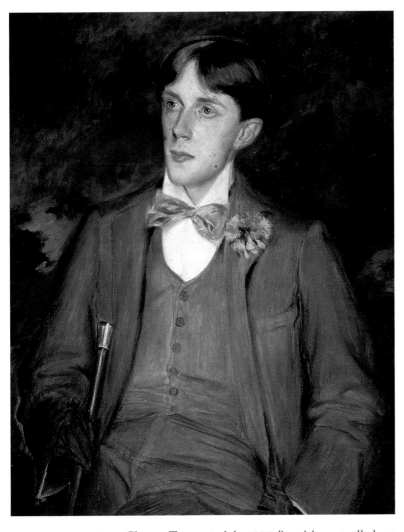

scant possessions into Chester Terrace in July 1895, Beardsley actually kept the house only for a matter of weeks. With the predictable protests of his mother simply dismissed, she, and this time Mabel also, were unceremoniously packed off back to lodgings in nearby Charlwood Street, where the family had lived in 1891. Aubrey, in a quite extraordinary choice of action, took for himself a smart set of 'bachelor's chambers' at 10–11 St James's Place, an apartment that had once been occupied by Oscar Wilde. Wilde had ostensibly rented the rooms as a hideaway in which he could write in peaceful seclusion from the distracting hubbub of family life in Tite Street, but in reality they had doubtless served also as a lair for 'feasting with panthers': a place in which he had been able to make undisturbed assignations with those very grooms, telegraph boys and other 'renters' whose perjured testimonies had done him so much harm during his trials. Quite what perverse desire thus to invite further association – of the worst kind, and with the most infamous part of Wilde's life in London – can have possessed Beardsley at this moment remains unfathomable.

Jacques-Emile Blanche (1862–1942), *Aubrey Beardsley*, 1895. Oil on canvas. National Portrait Gallery, London © DACS 1998

Blanche and Beardsley met in Dieppe in the summer of 1895 and their rapidly formed friendship resulted in this portrait of Beardsley in the pose of an exquisite. Only a few months later however, in Paris, Beardsley referred to Blanche as 'boresome'.

Dieppe, 1895. Published in
The Savoy, No. 1, January 1896.
From line-block. V&A, Gleeson
White Collection, E.444-1899

The drawing was intended to
illustrate an essay by Symons.
Recalling the period of several weeks
that both spent at the resort,
Symons said that Beardsley rarely
ventured out and never actually
looked at the sea. He drew the
beach as a deserted and inhospitable
landscape, adding the flight of birds
which he customarily introduced
into drawings to denote an outdoor
setting. The central figure can be
identified as the infamous actress
Cleo de Mérode; she caused a
sensation at Dieppe by bathing in a
fantastical costume and adorned
with heavy gold chains.

At St James's Place Beardsley re-established something of his earlier dan-
dified Aestheticism. Though many of his former possessions had gone, some
of his Japanese prints and many of his books sold, and much of his furniture
simply abandoned at 114 Cambridge Street, those who came to see him
found him once again the suave and languid artist and Man of Letters, reclin-
ing in an elegant floral-covered chair or seated at his desk. Lewis Hind wrote
a vignette of one visit to the 'large ground-floor apartment': 'Although it was
a day of brilliant sunshine,' he recalled, 'the curtains were drawn, and the
room lit by many tall candles. On the wall hung framed reproductions of
Mantegna drawings – an artist to whom he had given his full fealty. In this
chamber Aubrey Beardsley, clad in a yellow dressing gown, and wearing red
slippers turned up at the toes, was working. As I entered he waved, laughed
his gay laugh, then coughed horribly.'

In spite of deteriorating health, or perhaps more accurately in that vain
but perennial hope that travel, new locations and new climates might do his
lungs some good, Beardsley was at this time coming and going between
London and France. Spending time, as he had done before, in the heat of the
summer at Dieppe, he began to see more of the self-styled 'English apostle'
of French Symbolism, Arthur Symons, and of other members of the floating
Dieppe colony, such as Charles Conder, a painter celebrated for his delicate
fans and painted silk panels, and the poet Ernest Dowson. In Dieppe he also

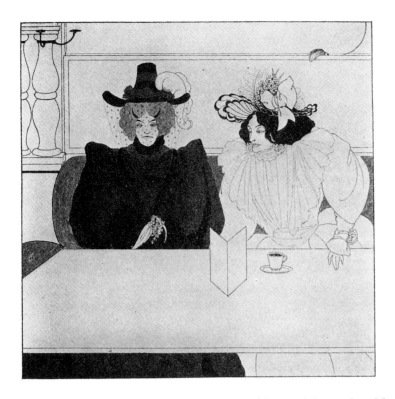

Suppressed frontispiece for
An Evil Motherhood by Walt Ruding
(Elkin Mathews, 1895). From
half-tone block. V&A E.1087-1996

Beardsley tried to pass off this *Yellow Book* drawing as a new design for
Mathews's book; Lane claimed it
back, and naturally a fight ensued.
Beardsley was obliged to produce a
replacement before Mathews was
satisfied and Lane's ruffled feelings
appeased.

OPPOSITE RIGHT
The Coiffing; from *The Savoy*, No.3,
July 1896. From line-block.
V&A, Gleeson White Collection,
E.439-1899

Beardsley's illustration for his own
poem *The Ballad of a Barber*, a carefully
wrought and chilling little fable
concerning a thirteen-year old
princess and a Sweeney Todd-like
coiffeur, who slits her throat with the
jagged glass of a broken bottle of
cologne, and then creeps away 'on
pointed feet'.

began to fall increasingly into the erratic orbit of Symons's larger-than-life
friend, Leonard Smithers, 'the most original publisher of his age', and, as all
who fell under his spell agreed, a most curiously compelling character.

It was in this milieu, at once more dissolute than the company he kept in
London, but seemingly at this moment more creatively stimulating as well,
that Beardsley found the new direction he so badly needed. In fact it had
been Symons, perhaps realising Beardsley's financial situation, but certainly
divining his feelings with some degree of accuracy, who had approached
him with the attractive proposition that they should together create a new
avant-garde magazine to rival and supplant the hated *Yellow Book*. Symons, in
a curious echo of Henry Harland's mistaken memory of the events sur-
rounding the inception of the *Yellow Book*, later constructed the myth that
the call he paid to Beardsley's rooms, during which he first proposed the new
venture, was their first meeting. However, a letter which Symons sent to
Herbert Horne almost two years before documents the fact that he had first
encountered Beardsley when the latter had been taken by John Lane to that
favoured watering-hole of the period, the Crown in Soho; on that occasion
Symons had described Beardsley as 'the thinnest young man I ever saw,
rather unpleasant and affected'.

In the meantime, the two had without doubt become at least slightly
acquainted, for Symons was a key *Yellow Book* contributor, and also an invet-
erate frequenter of those specifically artistic haunts of the era, the Café
Royal, the Crown, 'Jimmie's' and the Cheshire Cheese, the famous old pub-
lic house which stands in the Strand, very close to where Symons and

First prospectus for *The Savoy*, December 1895. Line block on pink paper. V&A E.1-1900

The first 'Pierrot' version of the design, to which Smithers objected on the grounds that the British public would expect and require something 'more robust'.

Second prospectus for *The Savoy*, December 1895. Line-block on pink paper. V&A E.2-1900

Beardsley's second, 'John Bull' version of the prospectus proved, upon closer scrutiny – but too late to recall the thousands of copies already distributed, to portray a figure that was actually robust to the extent of minor indecency.

W.B. Yeats shared rooms in Fountain Court in the Temple, and in which the dark-panelled upstairs room served in the nineties as the official meeting-place of the poets of the Rhymers' Club, at whose gatherings, presided over by Yeats, Beardsley had from time to time, albeit infrequently, put in his appearance.

Even the exact date of Symons's momentous visit is in question; probably he came to see Beardsley in the last days at Cambridge Street, when his 'expulsion' from the *Yellow Book* was still 'sufficiently recent . . . to make [him] singularly ready to fall in with my project'. But whilst his dating may be vague and inaccurate, the description that Symons left of his first sight of Beardsley on that day remains vivid and arresting: 'He was, just then, supposed to be dying; and as I entered the room, and saw him lying out on a couch, horribly white, I wondered', Symons continues, just a touch melodramatically, perhaps, 'if I had come too late.' After this shock he must have been both relieved and gratified when the idea of the new venture and that of becoming an art editor again miraculously revived Beardsley. The invention of the name of the new magazine, *The Savoy*, chosen for its abstract suggestions of chic modernity and luxury through association with the smart, and then newish London hotel, was in all probability a flash of inspiration on Aubrey's part, although an old and persistent, but quite unsubstantiated legend of the nineties once credited Mabel Beardsley with the original idea.

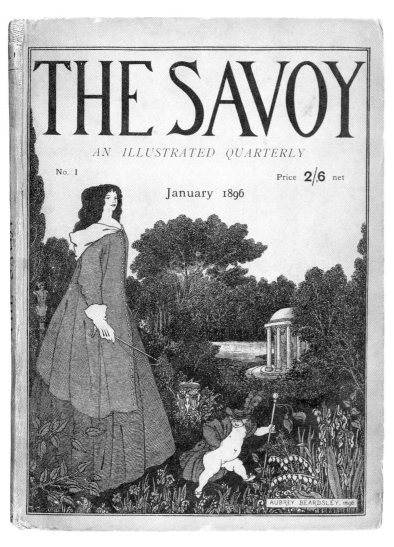

Whatever the doubts that remain about the inception of the magazine, there can be none that the reason *The Savoy* came into existence was because Leonard Smithers was willing to back the project with his then considerable resources, and because he trusted in its two main protagonists and what they hoped to achieve. It was always Smithers's proud boast that he would publish what 'all the others' were afraid to touch. At this moment, to bring out a magazine devoted to art and literature of a self-proclaiming Decadent sensibility and strongly marked by contact with dangerous French ideas, edited by the author of the infamous poem *Stella Maris,* and other such effusions of an unrepentant sensualist, and illustrated by the notorious artist of Wilde's *Salome* and chief perpetrator of the *Yellow Book,* must have looked less like an act of bravery than one of utterly foolhardy madness.

Smithers remains one of the key figures of the era; he was in many ways one of the nineties' most complex and fascinating products, and a man treated both by history and by the often all-too potent myth-making of the

Cover for *The Savoy*, No. 1,
January 1896.
Collection Anthony d'Offay.

In Beardsley's original design the putto was urinating over a copy of the *Yellow Book;* Smithers prudently removed the target, but curiously also the source of the offending stream.

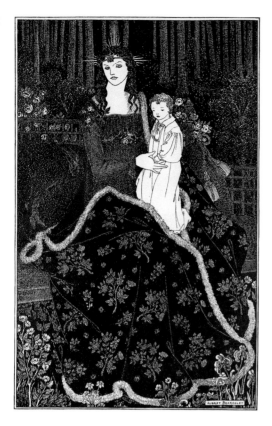

A Large Christmas Card. Issued with *The Savoy*, No.1, January 1896. From line-block. V&A, Gleeson White Collection, E.440-1899

Publication of the first number of *The Savoy* had been planned for the weeks immediately before Christmas 1895; in the event it did not appear until early in the new year. The Christmas card, intended as a supplement, to be shut loose inside each copy, was nevertheless still included.

Cover design for *The Savoy*, No.4, August 1896. From line-block. V&A E.4-1900

From Number 3, the July issue, *The Savoy* became a monthly, issued in paper wrappers printed in red and black on bluish paper instead of the previous pink boards.

decade with startling unfairness. That he was a pornographer and trafficker in dubious books, pictures and photographs is undoubtedly true; but he was also a dealer in objects of rare beauty, a passionate bibliophile with an exquisite discrimination in books and a publisher of rare courage and remarkable taste. Almost single-handedly, and at a time when no other London publisher would help them, he published the works of Oscar Wilde, Ernest Dowson and Aubrey Beardsley, and thereby provided each with the means to live and carry on their work.

In addition, Smithers was responsible for producing a mighty handful of the finest books of an age which prided itself upon the invention of 'the book beautiful', and he continued, even as his resources diminished, to help to best of his abilities and beyond those writers and artists who depended upon him. At his death in somewhat mysterious circumstances in 1909, it was discovered that, with the exception of a few hampers of his most precious volumes, he had given away everything, including his furniture and perhaps even most of his clothes in order to fund the projects in which he believed. He was found dead on a miserable palliasse in an empty suburban house; his silk hat, his glacé kid boots and even his monocle were gone.

Smithers had been the valued and respected collaborator in several projects with Sir Richard Burton, and it was widely held that the covert pub-

lication of *The Arabian Nights* was the true source of Smithers's apparently considerable wealth. To the exacting Burton, as to many others, he was a friend prized for his wit and almost overpowering *joie de vivre*. He combined in his large and outgoing nature both earthy and idealistic elements in the most generous measure, and in his picaresque charm the Rabelaisian and the quixotic elements were poised in precarious balance.

Robert Ross called Smithers 'the most delightful and most irresponsible publisher' he had ever come across, but to Max Beerbohm, who especially disliked him and always resisted becoming part of his set, he always remained 'strange and depressing'. However, it is Wilde's celebrated description of Smithers that perhaps captures most truly some of the qualities which made him an irresistible, if sometimes dangerously uncontrolled boon-companion: 'he is usually in a large straw hat, has a blue tie delicately fastened with a diamond brooch of the impurest water, or perhaps wine, as he never touches water – it goes to his head at once. His face, clean shaven, is wasted and pale.' Smithers's tastes and predilections Wilde neatly summarised thus: 'He loves first editions, especially of women: little girls are his passion. He is the most learned erotomaniac in Europe. He is also a delightful companion and a dear fellow.' By a curious historical mischance, Smithers became perhaps the single character of the nineties most damned by Wilde's praise.

Leonard Smithers had arrived in London from the provinces in 1891 with a little capital, and set up in an unlikely combination of businesses as both solicitor (on the basis, perhaps, of scant legal training at a provincial college in his native Yorkshire) and as a printer and purveyor of semi-clandestine literature. In the second enterprise he seems at first to have been in business with a much more unpleasant and unscrupulous partner, one H. S. Nichols, initially in Old Compton Street and later at premises in Wardour Street and Soho Square. Rapidly Smithers prospered. Before long he had established a shop selling rare books and works of art, and it was through this 'respectable' operation that he mostly encountered the customers, and indeed many of the writers, for his other more obscure publishing enterprises.

The exact nature of Smithers's existence remained unfathomable even to his closest acquaintances. At the height of his two most successful periods as a dealer in works of art and fine books he operated from very smart premises, first at Effingham House in Arundel Street hard by the Savoy, where his elegant green-painted rooms were hung with choice prints, and later in the Royal Arcade, off Old Bond Street. From this shop he issued catalogues that revealed the extraordinary range of his interests, listing everything from examples of Renaissance and seventeenth-century fine printing in gilt-tooled royal binding through to rather more surprising, and, it might be imagined, even rarer curiosities such as books bound in human skin. At various times Smithers also lived well, for a while at least owning a 'palatial house' at 6 Bedford Square, said to have been at one time the residence of the Spanish ambassador, which he filled with pictures and fine antique furniture, and also a comfortable 'place in the country' at Walton-on-the-Naze.

Leonard Smithers. Photograph from *The Early Life and Vicissitudes of Jack Smithers* (Martin Secker, 1939). Private Collection

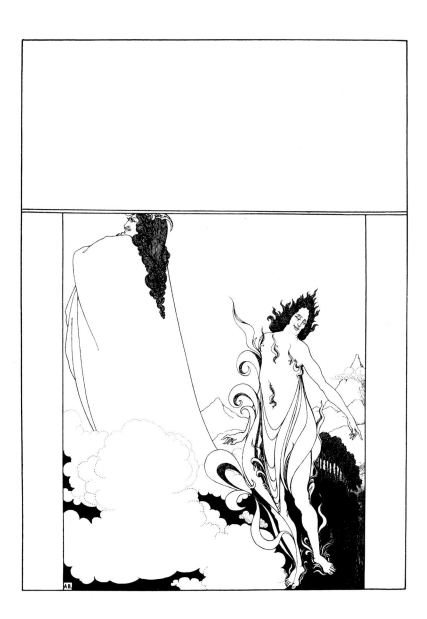

Fourth tableau of *Das Rheingold*; design for the paper cover of *The Savoy*, No. 6. Pen and ink. V&A, Harari Collection, E.307-1972

Around this time, in addition to his own Venus and Tannhäuser story, Beardsley also planned to both write and illustrate a version of Wagner's *Rheingold*. Several of the drawings intended for this ultimately unrealised project appeared in later numbers of *The Savoy*.

At Bedford Square he entertained his writers and artists, such as Beardsley, on occasions Wilde and Dowson, or Conder, who went perhaps rather more unwillingly, and other more shady revellers, including such forgotten men as Hannaford Bennet and Ranger Gull. Smithers maintained, it was known, a rather dowdy and rarely produced wife, and had a son Jack (who later wrote reminiscences that fill in at least some of the gaps in his father's history); he was also reputed to have several mistresses. Two at least, it was rumoured, were abroad: one installed in each of the flats he kept in Paris and in Brussels. A third, Kate, one of his 'first editions', a beautiful girl of just seventeen or eighteen, he particularly prized for her ability – so useful in his line of business – to set type with remarkable accuracy, while also keeping up an unbroken stream of risqué conversation.

Picturesque legend and more sinister rumour constantly attached to Smithers. He had, it was hinted, perhaps made and lost more than one fortune through various shady enterprises, but his ultimate achievement came in those three years between 1895, when he met Beardsley for the first time, and 1898, when Beardsley died. Haldane MacFall later wrote of Smithers's 'consummate flair' in his choice of the editors of *The Savoy*, and then went on in his study of Beardsley – a book, it should be remembered, published by John Lane – to give the following assessment of Smithers: 'it was to this dandified adventurer that Beardsley was wholly to owe the great opportunity of his life to achieve his supreme master-work. Had it not been for Smithers it is absolutely certain that Beardsley would have died with the full song that was in him unsung.'

The Savoy magazine was largely planned in Dieppe during the July and August of 1895. Beardsley and Symons were almost inseparable, meeting almost every day and working more closely and sympathetically together than had ever been the case in Beardsley's more edgy collaboration with Henry Harland. About art and literature they found themselves mostly in easy agreement, sharing in particular a high regard for the work of a small

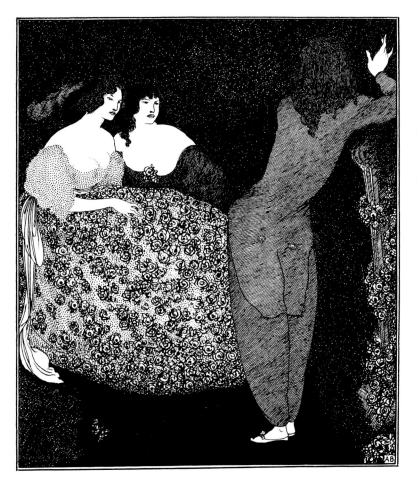

A Répétition of Tristan and Isolde. From *The Savoy*, No. 8, December 1896. Pen and ink. V&A, Harari Collection, E.306–1972

Originally the design celebrated Chopin rather than Wagner. The penmanship, which is controlled and superb, shows the evidence of Beardsley's growing desire to achieve a richness and solidity in some of his drawings.

coterie of English Decadents whose style, subject matter and general out-look upon things had been markedly touched by France. Symons called upon his friends, including Yeats, Dowson, Havelock Ellis and George Bernard Shaw to provide literary contributions, whilst Beardsley secured from his some worthwhile promises for the art contents. He began also to plan his own campaign to come back and startle the critics with a bold show of new work. In marked contrast to the *Yellow Book*'s desire to have 'names', the emphasis in *The Savoy* was always intended to be on the inherent quality and interest of the work.

Symons's recollection of Beardsley in these weeks in Dieppe is that he seldom walked outside and never once looked at the sea. Although for two days whilst visiting Arques-la-Bataille they had lounged together on the grass of the old castle ramparts working at their respective manuscripts, for the most part Beardsley preferred to sit, from time to time adding intricately wrought phrases to his manuscript of *Under the Hill,* in the 'little close writing room' of the hotel. In the afternoons he would drift through the deserted concert hall and pass the hours lost in daydreams in the faded gilt and plush of the casino. Every night, Symons recalled, Beardsley was drawn irresistibly to the *petit chevaux* tables, either to indulge himself or to watch with a curious 'hypnotised attention' as others played.

Smithers paid them several visits, usually on his way to or from Paris, but stopping for longer in the middle of August, and almost taking over the Café des Tribunaux as his headquarters to work on the magazine. Conder had reported that 'there has been a great deal of excitement about the new quarterly here and discussion. Beardsley is very pompous about it all.' The presence of Smithers in person was however too much. 'At present,' Condor wrote to Rothenstein, 'Symons, Beardsley and X [meaning Smithers] are here but I hope they do not intend to remain . . . X is too awful for words but very good hearted. He has decked himself out in a whole suit of French summer clothing from the Belle Jardinière, and although it suits his particular style very well one is not exactly proud of his companionship.'

It was probably at the Café des Tribunaux that Symons, with no doubt a great deal of intervention from Beardsley, composed his 'slightly pettish and defiant "Editorial Note"' for first number of *The Savoy*, a masterpiece of subtly phrased insouciance:

It is hoped that 'The Savoy' will be a periodical of an exclusively literary and artistic kind. To present Literature in the shape of its letterpress, Art in the form of its illustrations, will be its aim . . . Readers who look to a new periodical for only very well-known or only very obscure names must permit themselves to be disappointed. We have no objection to a celebrity who deserves to be celebrated, or to an unknown person who has not been seen often enough to be recognised in passing. All we ask from our contributors is good work, and good work is all we offer our readers. This we offer with some confidence. We have no formulas, and we desire no false unity of form or matter. We have not invented a new point of view. We are not Realists, or Romanticists, or Decadents. For us, all art is good which is good art. We hope to appeal to the tastes of the intelligent by not being original for originality's sake, or audacious for the sake of advertisement, or timid for the convenience of

the elderly-minded. We intend to print no verse which has not some close relationship with poetry, no fiction which has not a certain sense of what is finest in living fact, no criticism which has not some knowledge, discernment, and sincerity in its judgment. We could scarcely say more, and we are content to think we can scarcely say less.

With the contents of the opening number of the quarterly planned, the Dieppe party began to break up. Committed to produce designs for a prospectus, for the covers, title and contents pages as well as several pictures to illustrate three chapters of *Under the Hill* that were to be included, and even an inserted Christmas card prompted by the projected December issue date, Beardsley had much to do. However, perhaps unwilling to break the spell of what had proved to be one of the happiest interludes of his adult life, a period of stimulating talk and optimistic planning in relaxed and sympathetic company, Aubrey simply 'lingered on' in France. Meeting the intensely Anglophile portrait painter, Jacques-Emile Blanche, whose family's summer house lay close by on the coast, the two interested each other and became good friends. Over a number of convivial sittings Blanche painted one of his most penetrating likenesses, capturing with a rare insight a certain essence of Beardsley's delicate dandyism, while no doubt minimising those all-too-evident signs of the illness that had already at the age of just twenty-three taken its toll on his thin frame and ravaged his youthful appearance.

Only at the very end of August did Aubrey finally leave Dieppe. Still believing that he could only really draw properly in his own rooms in London, he returned with the intention of starting work, but he was soon writing of 'this desolate city'. In September he was travelling again, this time further afield than ever before, and to places he would never go again. André Raffalovich, who was often in Germany, may have made the suggestion that Beardsley travel to see the Rhineland settings of his beloved Wagnerian legends; no doubt he also provided the necessary funds for such an expensive undertaking. No letters document Beardsley's journeyings, just one note written much later to Raffalovich suggests that he may have visited the great Old Masters' gallery in Munich, the Alte Pinakothek, and admired there a painting by Francia. In Cologne he presumably stayed at the rather grand Englischer Hof hotel, or at least sat in its writing room, where he used a sheet of ostentatiously headed writing paper to begin a draft of his poem, 'The Ballad of a Barber', a piece later, in spite of misgivings from Symons, printed in *The Savoy*. The rest is silence.

Returning, apparently, through Belgium, he ended up in Dieppe again, with nothing clean to wear and lacking the funds even to cross back to England until a parcel of clean clothes and a couple of small cheques from Smithers bailed him out. In exchange, he sent to Smithers from Dieppe a fine drawing for the cover of *The Savoy*, proving to himself that he could work elsewhere than at home, and thereby establishing what would increasingly become the pattern of his existence: promising drawings to be sent as soon as they could be completed, then anxiously awaiting the all-too-often erratic remittance of Smithers's cheques and money orders in return.

Cover of *The Rape of the Lock* by Alexander Pope (Leonard Smithers, 1896). Stephen Calloway

The cover design, blocked in gold on bright turquoise cloth, is one of Beardsley's most perfectly judged; it appropriately introduces another dressing-table motif with an oval looking-glass flanked by elaborate candles treated in a highly conventionalised manner.

Back in London, the final months of this difficult year were filled with expectations about the launch of *The Savoy*, but they were also less pleasantly enlivened by more of the kind of disputes concerning his drawings that Beardsley had once relished but now come to dread. One concerned his attempt to pass off an old drawing, *Black Coffee*, originally intended as one of his contributions for the fifth volume of the *Yellow Book* – and thus, in the event, suppressed by Lane – as a freshly drawn frontispiece commissioned by Elkin Mathews for a sensational new novel, *An Evil Motherhood*, by Walt Ruding. With no love lost between them, both Lane and Mathews were furious; Lane because he claimed the original drawing was his, Mathews because he had already begun to bind, and had even issued a few advance copies of the book including the contentious image. As a result, the normally gentle and self-effacing Mathews headed straight for St James's Place and refused to leave until Beardsley sat down to produce an alternative design, as he said 'at the sword's point'.

Not surprisingly, even Smithers balked at the original version of

Beardsley's cover image for the first issue of *The Savoy*, which on close inspection revealed that, beside the beautiful 'Beardsley Woman' elegantly dressed in a eighteenth-century-style riding habit, a small, pot-bellied putto standing with legs astride in the grass was in fact urinating over a copy of the *Yellow Book*. Lane, always quick to guard his own financial position, and certainly touchy about the failing health of his quarterly, which was generally now perceived to be in a state of decline, would without doubt have sprung to his own defence in the face of so blatant – and so actionable – an attack. For the published version, printed on chic and cleverly chosen, provocative flesh-pink, paper-covered boards, the offending details of Beardsley's design were easily expunged.

The row which broke out over the prospectus for the first number, however, was not so quickly resolved. Again Smithers had objected to a first version, this time because Beardsley's drawing of a winged pierrot figure seemed to him too calculatedly limp. Fatally, Smithers suggested that 'John Bull', meaning the English public, would expect something more robust. Beardsley obliged with a second, subversively mischievous version in which an all too robust John Bull presents the new volume. It is unclear who first noticed that the John Bull figure also presented a very modest, but ill-concealed erection; George Moore, a tireless scrutiniser of Beardsley's details may again, as with *Salome*, have been the prime objector, but several others joined the hue and cry. Smithers, probably more amused than annoyed, at first decided to do nothing, but then upon realising that, of the vast 80,000 print-run, almost every copy had already been distributed, he agreed, principally in order to keep the peace with his other authors, nominally to 'withdraw' the offending sheet. In the end Beardsley redrew the image yet again for the contents page of the first number, smoothing over the last ripples of the over-heated dispute by the simple expedient of smoothing the offending wrinkles from the strained front of John Bull's breeches.

As early as December, the planned publication date for *The Savoy*, *The Globe* had given the new publication a friendly paragraph of pre-publicity at the expense of its natural rival: 'It was hardly to be supposed', it suggested, 'that the young decadents who once rioted in the *Yellow Book* would be content to remain in obscurity after the metamorphosis of that periodical and the consequent exclusion of themselves.' But still the much-awaited *Savoy* did not appear. Following a number of delays, the first number finally made its debut only on 11 January 1896; but hardly being aimed at a family market, missing the Christmas period can have made very little difference to its sales. According to William Rothenstein, among those who were awaiting its arrival it 'created a stir' as intended, and Dowson, judging both its contents and the technical qualities of its typography and reproduction of the illustrations, went so far as to enthuse that it 'licked *The Yellow Book* hollow'. By contrast, the perhaps more prevalent view was that *The Savoy* lacked the immediate startling graphic impact of the *Yellow Book*.

It has often been remarked that the larger page-size of *The Savoy*, together with Smithers's preference for more old-fashioned and opulent

De Larmessin after Nicolas Lancret
(1690–1743), *L'Adolescence*.
Engraving. V&A E.590-1888

Beardsley had been interested in,
and perhaps occasionally bought
examples of French eighteenth-
century engravings from at least as
early as 1893. Now, a variety of
influences, including perhaps that of
the enthusiast Charles Conder with
whom he spent time in Dieppe, and
a renewed interest in rare books and
their illustrations, fostered by
Smithers, turned his attention again
more closely to the period. Looking
particularly at the prints of Watteau
and his circle, he learned valuable
lessons from the engravers' linear
techniques and also from the
complex, multi-figured compositions
and strangely artificial landscape
settings favoured by Lancret, Pater
and, of course, Watteau himself.

typographical effects, when compared with Lane's neat, or even slick and
self-consciously novel format for the *Yellow Book*, constitutes one of the major
differences between the two quarterlies. In fact each was highly character-
istic of the productions of its publisher, and Beardsley's removal from the
Aesthetic orbit of one to the other was of some considerable consequence to
the development of his art. With the generally larger formats favoured by
Smithers, whose publishing experience was almost entirely in the field of
expensive, limited and private editions rather than those aimed at a popular
market and calculated to achieve a high turnover on the railway bookstands,
Beardsley, it has been said, was encouraged to conceive his designs more
grandly, and enabled to indulge in greater and denser detail than at any time
since the height of his fascination with the 'hairy-line grotesque'.

The dinner that Smithers threw in the private room of the New Lyric
Club to mark the launch of *The Savoy* was a rowdier and notably less elegant
affair than that Lane had hosted on the occasion of the appearance of the
Yellow Book. Beerbohm, who clearly hated the entire evening, remembered
that although an almost all-male company was assembled Mrs Smithers had
been permitted to attend and tried, with predictably little success, to engage
the interest of Yeats in the 'novel' bamboo wallpaper of the room. The mys-
tical poet had preferred to talk about his favourite topic, diabolism – which,
according to Beerbohm he pronounced, with his usual extravagance as
'Dy*ah*bolism'. 'He evidently guessed that Beardsley...was a confirmed
worshipper in that line,' Beerbohm recalled,

N. Lancret pinxit. N. D. Larmessin Sculp.

Dez que de ses rayons la raison nous eclaire *L'Adolescence*. On cherche a se parer, on s'etudie a plaire ;
Elle fait acheter le plaisir et l'honneur : Et des regards d'autruy depend notre bonheur.

So to Beardsley he talked, in deep vibrant tones across the table of the lore and the rites of diabolism... I daresay that Beardsley, who seemed to know by instinctive erudition all about everything, knew all about Dyabbolism. Anyway I could see that he, with that stony common-sense that always came upmost when anyone canvassed the fantastic in him, thought Dyabbolism rather silly. He was too polite not to go on saying at intervals, in his hard quick voice, 'Oh really? How perfectly entrancing' and 'Oh really? How perfectly sweet!'

Later in the evening, though, Beardsley spoke again to Yeats, making one of the very few serious remarks about himself that is anywhere recorded. Yeats had, perhaps unwisely, brought to the dinner two letters he had received from friends urging him not to be associated with Smithers or with any of his circle. Symons provocatively read out a few lines from one of these warning notes, in which 'A.E.' (the Irish poet George Russell) declared *The Savoy* to be 'the Organ of the Incubi and Succubi'. Furious, Smithers shouted 'Give give me the letter; I will prosecute that man', but Symons hid the offending scrap of paper, and the moment past. Beardsley's curious response was to murmur to Yeats, 'I am going to surprise you very much. I think your friend is right. All my life I have been fascinated by the spiritual life – when a child I saw a vision of a Bleeding Christ over the mantelpiece – but after all to do one's work when there are things one wants to do so much more, is a kind of religion.'

The Battle of Beaux and Belles; illustration for *The Rape of the Lock*, 1896. From line-block. V&A, Gleeson White Collection, E.437-1899

Beardsley described the patient elaboration of the pen lines of these designs, which imitate the style of eighteenth-century engravings, as 'embroidering' the text.

The Rape; illustration from *The Rape of the Lock*, 1896. From line-block. V&A, Gleeson White Collection, E.426-1899

Whilst adhering to the steely, controlled linearity of the engravers of the early eighteenth century – the actual period of Pope's poem, first published in 1712, Beardsley actually uses settings, costumes and wigs which date from the decades nearer the mid-century, and even later.

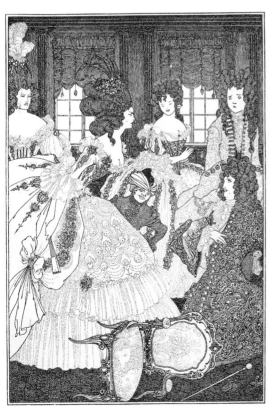

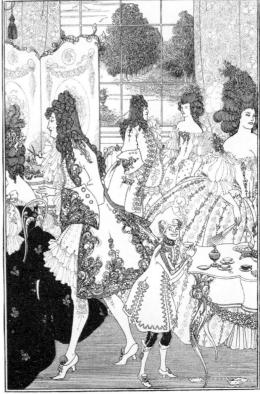

This ghastly evening concluded at Smithers's rooms above his offices. Smithers, sweating profusely, cranked an automatic piano, of which Beardsley professed to admire the 'beautiful tone'; Max realised this was 'his method of keeping our publisher at a distance'. At one point Beardsley looked 'grey and exhausted' and 'went into another room to spit blood', but reviving he became the life and soul of the evening until, as Beerbohm observed 'quite suddenly, almost in the middle of a sentence, he fell asleep in his chair. He had overstrained his vitality, and it had all left him. I can see him now, as he sat there with his head sunk on his breast: the thin face white as the gardenia in his coat, and the prominent, harshly-cut features; the hair, that always covered his whole forehead in a fringe and was of so curious a colour – a kind of tortoiseshell; the narrow, angular figure, and the long hands that were so full of power.'

The press reception of the first *Savoy* was unenthusiastic – with comments such as *The Star*'s 'dull – at once eccentric and insipid' – and predictable, with the expected accusations of decadence. Symons turned things to his own advantage in an amusing 'Editorial Note' in the second number, in which he thanked the Press for the 'flattering reception which they have given to No.1. That reception', he wrote, 'has been none the less flattering because it has been for the most part unfavourable. Any new endeavour lends itself, alike by its merits and by its defects, to the disapproval of the larger number of people.' Perhaps the funniest reactions came from *Punch*, where Ada Leverson, always well-disposed towards Beardsley and his circle, contributed a genial parody of his chapters of *Under the Hill* with the title 'Dickens Up to Date', and a review, couched in ironic complimentary phrases suggested that 'There is not an article in the volume which can be put down without feeling the better and purer for it . . . it should be on every schoolroom table; every mother should present it to her daughter, for it is bound to have an ennobling and purifying influence'. Criticism of Beardsley, however, who appeared in such great strength in this issue, was strangely unperceptive. Closest to the mark was Dowson's opinion that his drawings were, like his poem 'The Three Musicians' and his prose, 'abominably clever'. Curiously, most observers seem to have missed one obvious fact. Either through a desire to further distance himself from the unhappy experience of the *Yellow Book* debâcle, or ever-restless to experiment, to absorb and reinterpret new influences and to steep himself in new literary worlds, Beardsley had begun not just to draw a new kind of subject, but also to work in an entirely new manner.

Beardsley's fascination with the eighteenth century was nothing new, but around this time several circumstances combined to lead his art ever more into a charmed fantasy world that centred on his beloved books. The increasing amount of time he spent in France, and the intense concentration which he gave to *Under the Hill* played their parts in filling his head with imagery. But gifts of novels, poetry books and other choice editions from André Raffalovich and access to Smithers's curious stock of rare volumes encouraged him, perhaps more than ever before, to look at the work of French eighteenth-century illustrators and engravers, as well as the texts.

Watteau had long been an enthusiasm of Beardsley's. Even as early as 1893 he had written in excitement to Rothenstein that he had discovered a print shop in London where 'very jolly *contemporary* engravings from Watteau can be got quite cheaply. Cochin etc.' And to Raffalovich in one of the last letters written from Cambridge Street, in the summer of 1895, he talks about the 'cult' for Watteau which is 'so entirely modern'. In fact this cult and the associated revival of the taste for things of the eighteenth century is a more widespread phenomenon of the times. In France, of course, it had been the Goncourt brothers who had really given new impetus to both the serious study of the painters of the period and the mania for collecting their prints and drawings. This enthusiasm had also begun to cross the Channel. Intriguingly, it had been none other than John Gray who had written, in the first number of Ricketts and Shannon's magazine, *The Dial*, one of the very first English appreciation of the Goncourts' achievement. When the brothers' own collections were dispersed in April 1897, Beardsley in a moment of extravagance paid a large sum for a pair of highly characteristic prints after

Cover of *The Rape of the Lock*, Bijou Edition (Leonard Smithers, 1896). Collection Anthony d'Offay.

Smithers's ingenuity as a publisher and Beardsley's inventiveness made them excellent partners in devising books. The idea of creating a miniature edition of *The Rape of the Lock* (5 ¾ x 4 ¼") was particularly successful. The illustrations still work remarkably well even when considerably reduced in scale. Beardsley supplied a new, simplified cover for these volumes which he referred to as 'Rapelets'.

Watteau's follower de Troy. Paul Helleu's celebrated etching of his wife viewing the framed drawings by Watteau in the Louvre captures this milieu with an elegant charm that helps to explain why such things must have seemed so seductive to English eyes.

Though what is known of Beardsley's other interests and enthusiasms in this area is limited to the random mentions that he makes to books and prints in his letters, everything suggests that he was visually aware of a wide range of artists and engravers of the seventeenth and eighteenth centuries, just as he was phenomenally well-read in the literature of the period. At times he discusses with John Gray books on the etchings of Jacques Callot and the Moreaus and at one point even asks for information on a book in the British Museum library on the recherché subject of the famous family of ormolu founders and sculptors, the Caffieri. He admits at another moment to plans to 'steal' details of ships and harbours from Claude, while to Smithers he writes thanking him for a book of illustrations by Prud'hon, which will, he says, prove invaluable when he starts a projected series of designs for *Les Liaisons dangereuses*, the great epistolary novel of erotic seduction by Pierre Choderlos de Laclos. And finally there is the simple evidence in his drawings of this period of a deep knowledge of and love for the strong, even-handed, precise engraving techniques of the French printmakers of the golden age of the early eighteenth century, and for the lighter and more

Paul-César Helleu (1859–1927), *Au Devant les Watteau du Louvre*, 1895. Drypoint etching printed in colour *à la poupée*. Private Collection © ADAGF, Paris and DACS, London 1998

By the 1880s and 90s both in England and in France, where the new cult of Watteau had originated some years earlier with the Goncourt brothers, the taste for French eighteenth-century things had become more widespread. The etchings of Helleu and Beardsley's drawings, although so very different, both represent aspects of this revival of interest in *ancien régime* art and culture.

frivolous rococo style of the following decades, which so perfectly mirrors the age's pretty conceits of artificial landscapes, of *fêtes champêtres*, and of wistful *commedia dell'arte* figures.

Another great enthusiast of the literature of the eighteenth century, Edmund Gosse, had, since first encountering Beardsley through Henry Harland in the early days of the *Yellow Book*, continued to take a friendly, rather curiously avuncular interest in both him and his work. Watching with what became increasing dismay at what he considered to be the waste of the young artist's talents on frontispieces and covers for worthless 'modern' books and other ephemeral illustrations, Gosse urged Beardsley to turn his attention to 'great books'; helpfully he proposed a few. His suggestions had a touch of genius, for his three suggested titles, Congreve's *Way of the World*, Ben Jonson's play *Volpone*, and Pope's 'heroi-comical poem', *The Rape of the Lock*, each engaged Beardsley's imagination to the full and two at least inspired him to great things.

Starting with Pope, Beardsley immediately planned a de luxe volume with a dozen full-page 'embroideries' and other incidental illustrations. Smithers was happy to take on the idea, and Beardsley worked quickly, completing half the drawings in London and then finishing the set in Paris. Considered by many critics to be his greatest book, the pictures are drawn with a staggering mastery of the coolly controlled hatched-line technique that Beardsley derived from close study of the work of the old engravers. As book illustrations they exhibit a strange, yet highly successful blend of almost static, hieratic intensity, linear clarity and opulence, and, at the same time a vivid dramatic and narrative quality, all of which contrive in different ways to echo Pope's highly mannered language and satirical characterisation. Gosse, to whom the finished volume was dedicated, considered that there had never been a subject to which Beardsley's talents had been better suited, or upon which he had 'expended more fanciful beauty'. As a man whose whole life was devoted to books, Gosse claimed to be proud to have been 'connected with such an ingenious object'.

But the most extraordinary reaction to *The Rape of the Lock* was that of James McNeill Whistler. Over the years the irascible old painter had always maintained a stance of complete disdain for Beardsley and his work, the result perhaps of nursing a certain jealousy and deep-seated irritation at what he still considered to be the use Beardsley had made in the *Salome* pictures of his original ideas from the Peacock Room. More than once he had been deliberately rude and hostile, and even gone out of his way to be petulantly and childishly insulting. However, when they met by chance in Paris, their mutual friends Joseph and Elizabeth Pennell persuaded Beardsley to show Whistler some of the originals of his designs for Pope's poem: 'Whistler looked at them first indifferently, then with interest, then with delight' and finally pronounced his opinion, 'Aubrey, I have made a very great mistake; you are a very great artist'. There was no answer. For once it was the wasp who was stung, and not by words of wit but by simple emotion. 'I mean it,' he muttered, 'I mean it, I mean it.' Beardsley burst into tears.

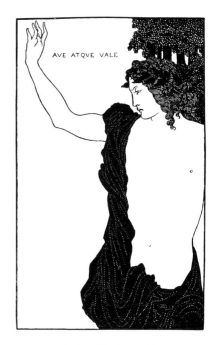

Ave Atque Vale. From *The Savoy*, No. 7, November 1896. From line-block. V&A, Gleeson White Collection, E.433-1899

This exquisitely judged drawing is another example of Beardsley's increasing desire to create both text and illustration. It appeared accompanying his own translation of one of the poems of Catullus, the Carmen CI, 'Hail and Farewell'; there is a tragic poignancy in Beardsley's treatment of the theme of loss and premature death.

Chapter seven
'ALL OBSCENE DRAWINGS'

In the 1920s, at a time when interest in the connection between art and sexuality was considerably more developed than in the nineties, Haldane MacFall found throughout Beardsley's oeuvre the evidence of 'that overwhelming eroticism, that inquisition into sex, which dominated his whole artistic utterance from the day . . . he became an artist.' It could be identified, thought MacFall as 'that erotic mania so noticeable in gifted consumptives'. Beardsley, he suggested, so cultivated this aspect of his persona 'that eroticism became the dominant emotion and significance in life to him. He was steeping himself in study of phallic worship – and, when all is said and done, the worship of sex has held a very important place in earlier civilisations, and is implicit in much that is not so early.'

Certainly, Beardsley was deeply interested in all aspects of sexuality; he was unusually well-read in what was then described as the 'curious' literature of the past, and knowledgeable about the erotic art of ancient Greece, of Japan and of eighteenth-century France. He was also intrigued by contemporary erotic and pornographic works, and, no doubt encouraged by Leonard Smithers, eager both to write and to create illustrations in this vein himself, and, to some degree at least, to explore at first hand the seamy side of life in London or Paris with this equivocal but indisputably knowledgeable *cicerone* of the Victorian underworld. However, it is equally true that throughout his life Aubrey also felt the inescapable pull of a strongly developed religious sentiment, which led him to an early appreciation of the 'beauty of holiness', and ultimately into the embrace of the Catholic Church.

That Beardsley chose to reveal these apparently very different sides of his character only at certain times, and only to those whom he felt would be sympathetic, has tended to heighten the contrast between them and to make his identity as an artist and as a human being seem, at times, contradictory and unduly enigmatic. In fact, this seeming paradox of impulse was by no means as unusual as might be imagined amongst the intellectual dandies, Decadents and Aesthetes of the nineteenth century. Many similar cases of characters in whom such irreconcilable traits coexisted could be instanced; indeed, by the nineties, this parallel seeking after rarefied spiritual enlightenment and pursuit of strange sins had become something of a cliché of 'the Decadence' both in France and in England.

For Beardsley these two very different aspects of psychological make-up did coexist, held in easy equilibrium. But in part, perhaps, such a reading of both the man and the artist has been based on the accidental fact that of all Aubrey's letters to survive, by far the largest numbers form just two separate

Lysistrata shielding her Coynte; illustration for *Lysistrata* by Aristophanes (Leonard Smithers, 1896). Pen and ink. V&A, Harari Collection, E.294-1972

Seven of the eight Lysistrata drawings were acquired by Beardsley's friend, the precocious undergraduate with a taste for *curiosa*, Herbert Pollitt; the eighth, *Two Athenian Women in Distress*, belonged to Herbert Horne, but was lost in a fire that destroyed many things from his collection.

LYSISTRATA.

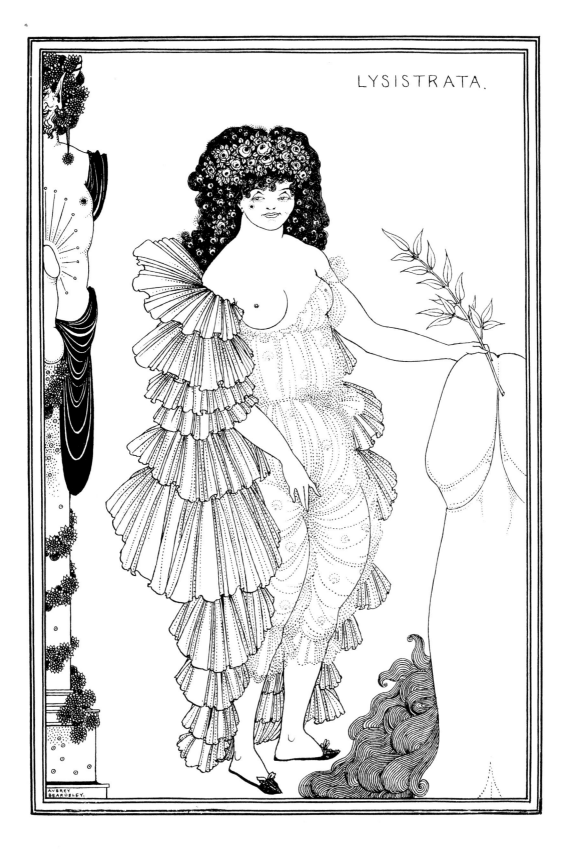

sequences: those to Raffalovich, his spiritual mentor, and those to Smithers, the most successful pornographer of his day and the publisher of Beardsley's most outrageous and erotic designs. That it was these two men who provided Beardsley with the means to live for the last difficult two years of his life also had the effect, unsurprisingly, of leading him to try to please each with the content and manner of what he wrote.

When the Raffalovich letters were published by John Gray (as *Last Letters* to an 'unnamed friend'), Robert Ross, commenting on this chance survival, regretted that it created a distorted picture of Beardsley's character: 'far more interesting', added Ross, who was in a position to know, 'would have been those written to Mr Joseph Pennell, one of the saner influences . . .' But these and many others, and the wider picture they might have afforded, are lost. Raffalovich, in order to alleviate Aubrey's 'anxieties', offered his friend what was in effect an allowance in the form of a quarterly 'gift' of ninety pounds.

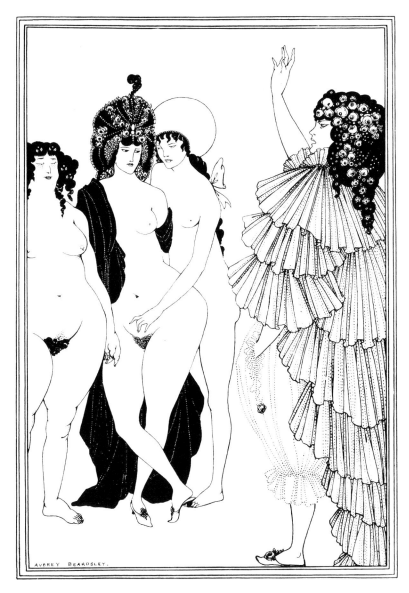

AUBREY BEARDSLEY.

OPPOSITE
Marcantonio Raimondi, Marco Dente and Jacopo da Caraglio after Giulio Romano, Sheet of cuttings from the series *I Modi*, early 16th century and later. Engravings. British Museum

The engravings after Giulio Romano's infamous set of 'Postures', accompanied by an equally amusing sequence of sonnets by Pietro Aretino remained one of the most celebrated sets of erotic images, though few perhaps had ever had the opportunity to examine many of the prints. The British Museum Print Room preserves a set of 'cuttings' which provides a remarkable parallel with the expurgated versions of Beardsley's illustrations to Aristophanes and Juvenal. Could Beardsley and Smithers have known these prints at first hand? Certainly, it seems likely that they were both knowledgeable about the history of erotic imagery.

Smithers, always the businessman, had originally proposed to pay the artist the considerable sum of twenty pounds a week for all his work; in reality he made somewhat erratic payments, more usually of only twelve pounds or even less, often delayed in arrival or, worse, sent in the form of post-dated cheques with elaborate injunctions not to present until a specified day. Perhaps inevitably, therefore, for Beardsley Raffalovich and Smithers became the Scylla and Charybdis between which he attempted to chart an increasingly precarious course.

The curious idea of the dapper, monocled figure of André Raffalovich as the artist's good angel gently drawing him towards a Romish heaven, and, as a counterpart, that of Leonard Smithers, also monocled but distinctly more *déchevelé*, a sort of licentious demon dragging poor Aubrey progressively

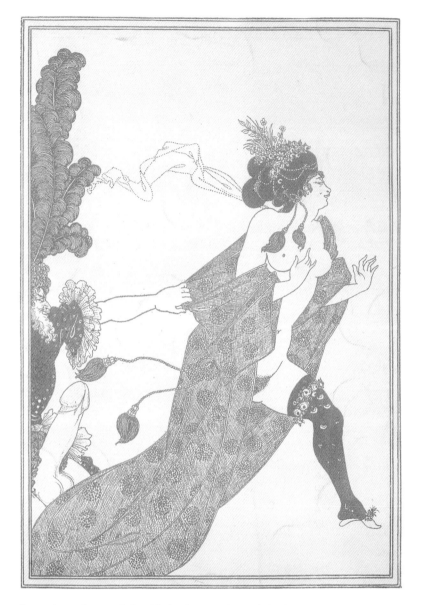

Cinesias entreating Myrrhina to coition;
illustration from *Lysistrata* by
Aristophanes (Leonard Smithers,
1896). Proof from line-block in
purple ink. V&A, Harari Collection,
E.345-1972

Smithers published the highly erotic
illustrations to Aristophanes'
comedy of sexual mores in a private,
limited edition of 100 copies. Unlike
most of Beardsley's illustrations they
adhere closely to specific lines of the
text. An original plan to ink the
plates in 'imperial' purple was
abandoned, but a few proofs printed
thus survive in the Harari
Collection.

OPPOSITE LEFT
Two Athenian Women in distress;
illustration from *Lysistrata* by
Aristophanes (Leonard Smithers,
1896). From line-block. V&A
E.747-1945

The appearance of the lost original
drawing, destroyed by fire, is
known, of course, from the original
line-block, but also from this later
collotype impression, from a set of
prints of rather higher quality than
the 1896 blocks, made around 1925
and issued again in a very private
edition by Philip Sainsbury.

down through a sordid publisher's equivalent of the lower circles of Dante's
Inferno, has become an unshakeable part of the Beardsley mythology. But, in
fact, long before Ellen Beardsley began to try to establish this interpretation
of these two men, each tugging an increasingly feeble Aubrey in opposite
directions, there is good reason to suppose that Beardsley himself saw
things, at least to some degree, in this light. Certainly in his letters to each,
he adopted the language, even the character he considered appropriately
pious or dissolute, or, perhaps more accurately, he presented a knowing pose
nicely calculated to please, impress or amuse his correspondent – and pay-
master – of the moment.

To Raffalovich he talked of books, of spiritual matters and the lives of
the saints, and of small domestic comforts. He discussed the merits of

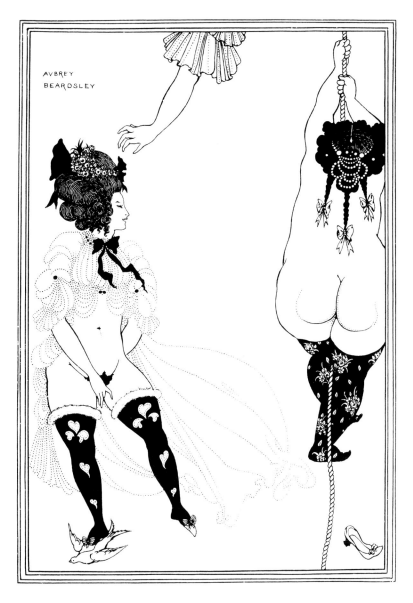

Two Athenian Women in distress; illustration for *Lysistrata* by Aristophanes (Leonard Smithers, 1896). Censored print as issued in *Later Work.* From line block. Stephen Calloway

The Lysistrata pictures were only shown publicly and finally published as late as 1966; until that time they had been seen only in the drastically expurgated versions prepared for the *Later Work* volume and reprinted in other books such as Ross's 1909 monograph. These versions were little more than cuttings, edited highlights of the originals, sufficient perhaps to give the merest flavour of the drawing style, but in no way suggestive of the entire compositions and their startling frankness. Whether Beardsley himself chose the 'selections', or whether they were made by another arbiter at a later date remains unknown.

obscure sermons and the charm of certain priests (though surely an admiration for the pious works of Bourdaloue must have been tinged by amusement at the fact of that worthy divine's name also being the eighteenth-century word for a lady's carriage convenience or bedpan). At times, he even managed to sound interested in response to what must have been Raffalovich's painfully detailed descriptions of books such as Ward's life of Cardinal Wiseman or another on the subject of co-education in schools. By contrast, Beardsley's often wickedly amusing letters to Smithers are full of an idiosyncratic mixture of references to French and English books of the kind Smithers kept in stock and which they both enjoyed, to his own ever-changing plans for illustrating new texts, and to all manner of other, highly profane amusements.

Cover for *The Houses of Sin*
by Vincent O'Sullivan
(Leonard Smithers, 1897).
Collection Anthony d'Offay.

Beardsley also supplied a number
of individual designs for Smithers's
incidental publications. The design
for O'Sullivan's book of short stories
is one of his best, the perverse
nature of the pig-faced female head
contrasting with the conventional
opulence of the design blocked in
gold on vellum-coloured boards.

In particular he seemed to take delight in harking upon a variety of sexual
themes, which clearly fascinated both the artist and his publisher.
Discussing, facetiously, the notion of the erection of a statue of Smithers
opposite his house in Bedford Square, Beardsley suggested that the base
should be covered in designs from the *Priapeia,* a famous book of phallic erot-
ica. Considering travel plans and remembering an embarrassingly unpaid

Parisian hotel bill, he wrote, 'I rather funk going to Dieppe, as I have alarming notions of the perfection of the French police system. I don't believe there's a gendarme in France who hasn't either my photograph or a model of my prick about him.' At another moment, having had a tooth drawn, he makes a sketch of its curious shape and observes that 'even my teeth are a little phallic'. Most oddly of all, when sending Smithers a Christmas card with an image of the Virgin he observed that 'the lace around the picture will do very well for the lace of her pantalons,' and then blithely informed him, 'There, I've given myself a cockstand! Still!'

The question of the real nature of Aubrey Beardsley's character has been argued endlessly, if inconclusively; and about his true sexual nature there has always been a great deal of discussion, for the most part necessarily speculative, and all too often ill-informed historically. Since so little irrefutable evidence has ever come to light, it remains all but impossible to make precise statements about Beardsley's real sexual predilections or his fantasies, about the extent to which his obviously highly developed interests remained theoretical, or were ever explored, and about the ways in which these aspects of his character find true mirror images in his art.

Frank Harris's much-quoted hint concerning the possibility of Aubrey and his sister Mabel having shared some form of incestuous relationship should probably be viewed in the light of that thoroughly untrustworthy writer's journalistic taste for the sensational and almost pathological desire to link his name with the famous. Yeats, too, who did so much of the myth-making of the period, seems at his least reliable when he writes of one occasion when Beardsley and Dowson were part of a group who shared the bedraggled charms of a 'painted woman' brought in from the rain to Yeats's rooms by one of their number. At another time he encountered Beardsley, slightly drunk one morning at Fountain Court, with a notorious prostitute 'who belongs to our publisher's circle and certainly not to ours', and known disparagingly as 'Penny Plain', ostentatiously on his arm. Beardsley, 'his mind . . . running upon his dismissal', leaned against the wall. This time Yeats's recollection seems to have the ring of truth: 'he . . . stares into a mirror. He mutters, "Yes, yes. I look like a Sodomite", which he certainly did not. "But no, I am not that."'

Whatever the public may have preferred to believe about his affectation and 'unmanliness' (a nineteenth-century coded imputation of homosexuality) the simple truth may well be that Beardsley's natural instincts were fairly straightforwardly heterosexual. However, mainly for reasons of his always fragile health, his inclinations were, it would seem, relatively rarely indulged; instead he seems to have lived in a world of sexual reverie in which more fantastic tastes gradually came to replace the conventional; these were the tastes which Haldane MacFall characterised – and thereby attempted to excuse – as the 'generally obscene moods and desires such as come to plague a certain type of consumptive whose life burns at fever heat in the troubled blood'. Much of Aubrey's hinting at perversity was, however, surely intended to create an effect. Lewis Hind may have caught a truer nuance when, in the

introductory essay to *The Uncollected Work of Aubrey Beardsley*, he quoted from a letter of Aymer Vallance: 'He was never really bad... He had a sort of impishly mischievous pleasure in shocking people – that was all.' In Hind's own astute opinion, Beardsley 'had a strange, age-long intuitive knowledge of things hidden and evil. It amused him to exploit this knowledge, and Leonard Smithers was not the man to check so marketable a commodity.'

Aubrey's mother professed that to the end he remained the good-natured and ultimately religious boy, stoic in his suffering and devoted to his art. According to her interpretation, only financial pressures enabled the unscrupulous Smithers to prey upon his fine talents, forcing him towards the end of his career to draw dubious illustrations to the sort of books that could, at the close of the nineteenth century, only be sold clandestinely. In addition, she laid at Smithers's door another charge: that he alone had ruined Aubrey's health. At the time of the Wilde debâcle, she claimed, extraordinarily, that her son's condition was more or less mended; 'perfectly well, he had had no haemorrhages for years, apparently lost all traces of consumption'. But, seduced by Smithers, he then 'went abroad, lived less simply and regularly than at home – went out late, caught a chill, and immediately all the symptoms recurred'. That there is a faint flicker of the truth in this otherwise patently absurd line, we shall see; however, it clearly reveals, too, how much of the actual pattern of Beardsley's life, of his thought and his reading, and, significantly, just how much of his work always remained concealed from Ellen, even though she was for so much of the time his almost constant nurse and closest companion.

It was John Rothenstein, writing thirty years after Beardsley's death, who first put into print what others had carefully avoided. Presumably basing his remarks on information from his father William Rothenstein, who had, of course, been very close to Beardsley, he wrote, 'It is necessary to lay some emphasis on a fact which many... have omitted to mention or by implication denied... It has been said that his morbid tendencies were expressed in his art alone. I have the best authority for believing this to be wholly untrue, for asserting that during one short period his life was very dissolute.' That period is undoubtedly the one in which Smithers most held sway over Beardsley; a period during which Aubrey was much in his company and during which he recklessly tried to emulate or keep up with the more robust publisher's dissipations, greatly to the detriment of his own health.

In the early part of February 1896 Beardsley, still at that moment finishing his pictures for *The Rape of the Lock*, had travelled to Paris in the company of Smithers and his latest mistress, a girl named Yvonne, whom the theatre-loving publisher had discovered at the Thalia, a theatrical supper club with a *louche* reputation. In Paris they fell in with the journalist and *bon viveur* Gabriel de Lautrec, at whose house Beardsley took hashish for the first time. That Baudelaire and his circle had been devotees of the drug in the earlier years of the century in the days of their experimental debaucheries at the hôtel de Lauzun, would have been well known and appealing to Beardsley. By the nineties the drug had associations not only with those late Romantics,

Cover for *Verses* by Ernest Dowson (Leonard Smithers, 1896). Collection Anthony d'Offay

Though moving in similar circles, Beardsley had little liking for his colleague in Smithers's stable of dubious collaborators. Of this masterly exercise in spare, but highly tensile and steely Art Nouveau line, he quipped that the whole design was a thinly veiled comment on the verses: 'Y were they ever written?'

Mask design for covers of volumes in the series *La Comédie humaine of Honoré de Balzac* (Leonard Smithers, 1897–8). Pen and ink. V&A, Harari Collection, E.333-1972

This design of an exotic mask was repeated on the spine of all the volumes of the series. Beardsley also drew a boldly stylised portrait of Balzac, one of his literary heroes, for the upper covers.

but also with the exotic, North African subculture of Paris. The reality was, perhaps, less beguiling; initially the hashish had seemed to have little or no effect, but after three hours and by the time the party were at dinner at Margery's, a fashionable restaurant, it took hold. Beardsley became first uncontrollably riotous and then sick. But for the fact that they were dining in a private *bôite*, they would certainly have been turned out on to the street.

On 11 February Beardsley and Ernest Dowson went together to the opening night of Wilde's *Salomé*, the first real performance of the play on the public stage, realised by the French actor-manager Lugné-Poe, but sadly lacking the star attraction of 'the divine Sarah'. Poignantly, Wilde, incarcerated in Reading Gaol, heard of the performance only through reports in the letters of a few loyal friends, but was nevertheless pathetically touched that his infamous drama should finally have been staged in a professional manner, Even so, it would be many years before an English audience would be given the opportunity to judge the merits of the piece for themselves.

Although Dowson left the city the following day, bound for Pont-Aven, the gathering place of the artists of the Nabis group and other Symbolist painters and writers, Beardsley, as always loathe to break the spell of an interlude of enjoyment, simply stayed on. Ensconced in a cheap, but respectable enough establishment, the Hotel Saint Romain in the rue Saint Roche, he wrote that he intended to remain 'a deuce of a time', stay by himself and continue his work in this congenial atmosphere. But any plans of settling into a pattern of industrious tranquillity were shattered by the arrival again in mid-March of Smithers, as usual intent on a spree of rowdy entertainment. Several days of drinking, smoking and late nights can have done Beardsley little good, but, rather the worse for wear no doubt, he nevertheless decided to accompany Smithers to the station, from which the publisher intended to depart for Brussels. As the train pulled out, Beardsley was still on board bidding *bon voyage* to his companion, and, on a fatal spur-of-the-moment impulse, decided to go on to Brussels with Smithers, travelling with only the clothes he was wearing, and abandoning his things at the Saint Romain.

In Brussels the dissipations continued. Whether they were to Beardsley's taste or not, they proved to be hopelessly beyond his strength, and Beardsley suffered a terrifying return of haemorrhaging from the lung. Laid low, he was unable to do anything except submit to the regime of a strange doctor, who insisted upon the need for constant 'blistering', which caused Aubrey the greatest distress. Abandoned after just a few days by Smithers and fast running out of funds, Beardsley's position was alarming; nor were his spirits improved by anxieties about the progress of *The Savoy* and his other projects. He must have been painfully aware of his need at this time to continue to have his work appear in print.

Almost too weak to draw at all, he fretted at his attempts to write poetry. This was a long-held and serious aspiration, but one to which, as he increasingly came to realise, Symons maintained a certain jealous hostility. From the July number, it had been announced, *The Savoy* would appear monthly, and so more material would have to be found. But as the deadlines

approached it became clear that Beardsley would have little ready in time, and in the next few issues he is, indeed, only poorly represented. The serialisation of *Under the Hill* was discontinued, with the announcement that owing to the author's temporary illness the entire work, embellished with many new pictures, would in due course be offered in book form to his waiting public. By contrast, there was no possibility that the other project which he and Smithers were hatching, and which began to engage him at this time, could ever be sold openly. Together they had conceived the idea of printing a very private edition of a bawdy classical text, that highly amusing sexual comedy, the *Lysistrata* of Aristophanes.

Cheered to some degree by this prospect and with his strength returning a little, towards the end of April Beardsley finally persuaded his Belgian doctor that he could travel back to London. Mabel, enjoying a one of her rare, brief successful runs in a play, was unable to go to fetch him. Ellen Beardsley therefore asked Ross if he could help, and when he also could not get away decided reluctantly that she would have to go in person. Arriving in Brussels she was ill herself and the planned return was again delayed. Finally back in London, Beardsley moved into rooms in Campden Grove arranged for him by Robert Ross. With a certain, no doubt unintentionally awful symbolism, the ever-thoughtful and kindly Ross had sent round a chaise longue, that all too evocative icon of the circumscribed existence of the nineteenth-century invalid.

Beardsley's old physician Symes Thompson now examined the patient again. As Aubrey reported, he 'pronounced very unfavourably'. Writing to Raffalovich, Beardsley admitted, for the first time perhaps, to being not merely depressed but frightened by the doctor's verdict. Rest and a change of air, the two mainstays of all medical treatment at the time, were prescribed. So Aubrey was packed off at the end of May to Crowborough, on the supposedly healthy Sussex Downs. Hating the town he quickly returned to London, only to move again, this time to Epsom, the place to which he had been sent as a child to improve his health. Believing perhaps in the restorative power of Epsom for sentimental reasons, he settled more happily, and at the Spread Eagle Hotel he worked with startling speed and consummate craft at the magnificent set of drawings for *Lysistrata*.

The pictures for *Lysistrata* mark another major phase in Beardsley's development as an artist. Moving on from the eighteenth-century filigree work so perfectly attuned to the mood of the *Rape of the Lock* designs and the proto-Baroque ornamentalism of his *Under the Hill* illustrations, the *Lysistrata* group match an extraordinarily frank and free sexuality with a bold simplified, almost abstracted quality of drawing, which derives in part, and this time highly appropriately, from his earlier enthusiasm for Greek vases. Julius Meier-Graefe made the most perceptive comment about this influence when he observed that Beardsley had understood the work of the ancient vase painters more clearly, and made more interesting use of their example than all other nineteenth-century academic classicising artists. 'Of all these painters,' wrote Meier-Graefe, 'none approached one side of the Greek

artists so nearly as Beardsley; not so much in their line as in the physiology and intelligence of their line...'

Meier-Graefe, who interviewed Beardsley in some detail about the things he had studied, helpfully gives some rather more precise indications of the sort of vases that had particularly caught Beardsley's attention during the long hours he had spent in the British Museum:

He cared less for the solemn processions or the vigorous drawings of the battles with the giants, than for the playful struggles of bald-headed satyrs with gay nymphs, the favourite pictures of the Greeks as designed by the brilliant Brygos in the last quarter of the fifth century, or by Duris, the most unrestrained of these artists... and perhaps yet more delicately audacious in his figures. The British Museum possesses wonderful examples of this group. The side of them which we would prefer to see is generally turned to the wall, and in some cases the dainty details have been painted out by well-meaning guardians of the public morals. As these are necessary for the understanding of the whole design ... the best elements are often lost... The most beautiful Duris vase is the psykter in the British Museum with the dancing satyrs, inspired by wine to perform all kinds of acrobatic feats as they drink. It was here that Beardsley learnt the most precious secrets of his work, and certainly he had none of the prudishness of the curators. He owed it even more to the Greeks

Greek red-figured wine-cooler by Douris, with a scene of satyrs revelling. Attic, 490–480 BC. British Museum

Beardsley's interest in the Greek vases at the British Museum had both a general influence on his drawing style, but also, as Meier-Graefe recalled, the treatment of 'free' subjects seen in certain examples, such as this celebrated fifth-century psykter by Douris, had a particular relevance when Beardsley came himself to depict specifically erotic scenes.

AVBREY BEARDSLEY.

Toilet of Lampito; illustration for
Lysistrata by Aristophanes (Leonard
Smithers, 1896). Pen and ink. V&A,
Harari Collection, E.295-1972

*than to the Japanese that he had no need to be prudish and that the unrestrained eroticism
of certain pages remains what it was intended to be, a device to intensify the rhythm. He
loved both the Greeks and the Japanese, and his love was such that he attained in play
what intellect fails to perceive and scholars regard as a regrettable aesthetic accident,
accomplishing a union of divided worlds which our historians do not like to mention in the
same breath.*

By about the middle of July 1896 Beardsley had completed his eight illus-
trations, and wrote to Smithers 'the last of the Lysistrata is finished. Surely it
is the occasion for a little prayer and praise.' Originally Smithers planned to
print the plates in pale purple ink, and a handful of proofs in that manner, so
evocative of ancient decadent splendour, survive. Even in black however,

Ali Baba, 1897. From line-block.
V&A E.1089-1996

Beardsley completed only a single illustration and this stunning cover design for a projected book of Arabian Tales, *Ali Baba and The Forty Thieves*. The figure of the fat potentate is superbly realised, the subtle rendering of his plumpness adding to the characterisation. The decorative details of tassels and jewels are related to a rare form of seventeenth-century ornament print of which Beardsley might have seen examples in the South Kensington Museum, or studied in books such as Guilmard's *Les Maîtres ornemanistes* (1881), the standard work on the subject. In the plate volume of this standard work a number of echoes of Beardsley's imagery may be discerned.

the illustrations are redolent of what, in the introduction to the edition is referred to as the Rabelaisian style of Aristophanes – a manner of writing that veers from the mock-heroic through the colloquial and lyrical to the burlesque. In the text, wrote the translator, Samuel Smith, an Oxford schoolmaster friend of Dowson's, 'we can still catch glimpses of the ribald melancholy, the significant buffoonery, and he grotesque animality which are amongst the ingredients of the play'. In order to capture these qualities Beardsley adhered surprisingly closely to the text, illustrating several specific incidents that the author describes.

Even the most noticeable and outrageously erotic elements, the vastly engorged penises that dominate a number of the designs, might be said to be directly inspired and justified by the subject matter of the play, which treats the theme of sexual frustration with such deliciously unabashed ribaldry, and, in a more general way, by what is known of Greek stage representations of such bawdy comedies, in which the actors were equipped with monstrous phalluses to demonstrate the nature of their characters more clearly to a distant audience. That they demonstrate all too clearly the intense, aching sexual frustration felt by the artist is, however, hard not to infer from these anatomically precise and psychologically obsessive images. Needless to say, by the standards of the day such details rendered the finished book wholly impossible to publish or even to advertise in the normal way, but they also made copies of the book desirable items for Smithers's more clandestine trade. The edition was of one hundred copies, as well printed as any luxury book of the time, and each was numbered and signed with his initials by Smithers in his distinctive purple ink; the spines of the books are quite plain and entirely innocent of any identifying title or label.

In a letter to Raffalovich Beardsley had teased him with a sly mention of his work on *Lysistrata*, perhaps mainly to see what reaction he would get. Raffalovich, who was himself well-read in modern French literature duly enquired whether it was the rather more modest, 'classical' treatment of the subject by Donnay which had engaged his friend's interest. Beardsley shared this particular joke at Raffalovich's expense with Smithers. Whilst still at Epsom he was also toying with several other ideas for books that he would like to illustrate or that he had plans to write himself. A book of *Table Talk*, intended as a collection of *bons mots* and anecdotes concerned especially with artists and musicians absorbed him for a while, but, like so many other schemes, eventually came to nothing. The notion of illustrating a collection of Arabian Nights tales, *The Forty Thieves*, resulted in just two designs, one of them the superb *Ali Baba*, a magnificent piece of drawing in which spare lines and intense bursts of rich ornament combine to suggest a bizarre and decadent opulence merely by the bulge of the potentate's belly, the plumpness of his jewelled fingers and the richness of a tassel.

On 6 August Beardsley informed Smithers in his light-hearted way, 'Quite an exciting overflow of blood on Tuesday night'. Once more the doctors suggested a change, and this time the sea air of Bournemouth or Boscombe was proposed. A couple of days later his last letter from Epsom

thanks Smithers for a welcome fifteen pounds and informs him that
Boscombe is to be the next place. He also asks for an edition of Juvenal's
Satires. Increasingly, Beardsley was slipping into a pattern of taking up new
projects with enormous enthusiasm, only to tire of them quickly and abandon
all thought of seeing them through. At times Smithers must have found it
exasperating, but he seems to have cheerfully continued to support each
new plan, sending such volumes as Beardsley took a fancy to from his cata-
logues of rare books or seeking out others specially.

Of all these projects the one which held sway for longest was Beardsley's
intention to make an illustrated translation of the infamous Sixth Satire, that
'against Woman', of the late Roman poet Juvenal. As far back as 1894 he had
asked Elkin Mathews to find him a copy of 'the first or some early edition of
Gifford's translation' and had made one drawing, an intended frontispiece,
which had appeared in the January 1895 *Yellow Book*. Now he took up the
idea again with renewed vigour. He asked for other editions from Smithers
and even demanded a Latin dictionary to help with the text. That he pro-
gressed some way with the literary side of the project seems likely, but what-
ever sections of his translation were completed, none has apparently
survived. At the same time he began to formulate plans for an extensive
series of illustrations, at one moment projecting publication in parts with
numerous pictures.

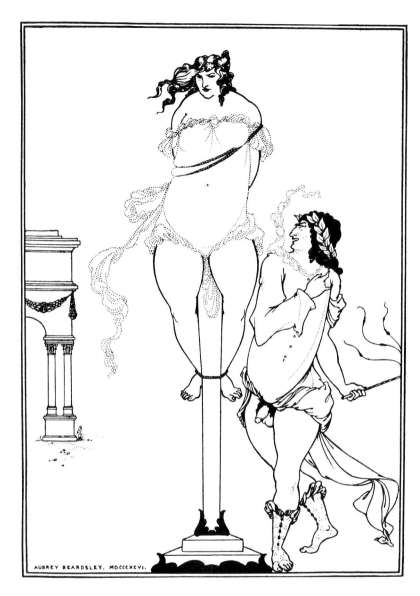

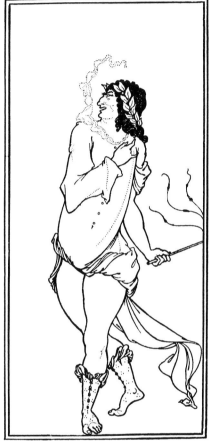

Only six designs were ever finished, and of these at least three were probably too indecent for ordinary publication. Some, including the 'new' frontispiece *Juvenal scourging Woman*, described by Beardsley in a note to Smithers as 'scrumptious', were completed just after the *Lysistrata* pictures and are in the same bold, linear style. For the idea and general composition of this frontispiece Beardsley seems to have looked very closely at a celebrated example of the erotica of the past, a print from Agostino Carracci's extremely rare, but nonetheless notorious 'Lascivious Series', the *Satyr flogging a Nymph*, a copy of which he could have seen in the British Museum Print Room.

Similarly, he would appear to have adapted another, rather more easily available printed image as the inspiration or starting point for one of two small pictures which depict the dancer Bathyllus, famed for his female

Juvenal scourging Woman, 1900; censored print. From line-block. Stephen Calloway

The censored version, again little more than a cutting hinting at the nature of the original, reveals little of the actual point of the picture; the very object of Juvenal's scourging is missing, as is the subtle tell-tale detail of the penis, revealing whether the poet's satirical thrusts were made from a position of sexual strength or one of impotence, has been expunged.

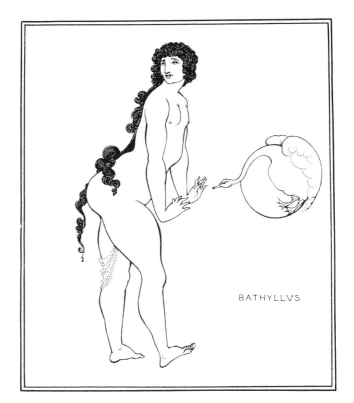

Bathyllus in the Swan Dance;
illustration for the Sixth Satire,
'Against Woman', of Juvenal, 1896.
Pen and ink. V&A, Harari
Collection, E.303–1972

Bathyllus posturing; illustration for the
Sixth Satire of Juvenal, from *An Issue
of Five Drawings Illustrative of Juvenal
and Lucian,* published by Leonard
Smithers, 1906. From line-block.
V&A E.685-1945

Bathyllus was a lewd and effeminate
dancer, a favourite with the
decadent Romans. In fact he is only
mentioned in passing in Juvenal's
text, but Beardsley nevertheless felt
that he required two pictures to 'do
him justice'. For the second, much
more indecently suggestive portrait,
it appears that Beardsley once again
turned to D. S. MacColl's book of
illustrations of Greek vases,
selecting the figure of a lascivious,
drunken faun with a wine skin from
the base of a kylix by the painter
Epiktetos, the original of which rests
in the Museo Municipale at
Corneto, Italy; his use of borrowed
details seems quite direct.

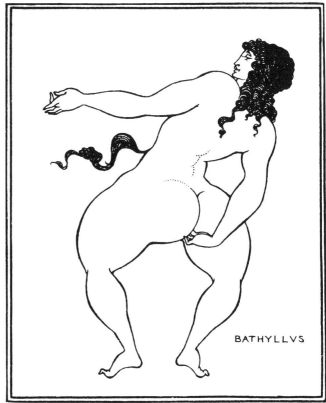

Interior of a Greek kylix by
Epiktetos depicting a satyr with a
wine skin. Plate IX from *Greek Vase
Painting*, by J. E. Harrison and
D. S. McColl (Fisher Unwin, 1894).
National Art Library

impersonations and wildly suggestive movements and gestures. For the
more indecent of the two images, *Bathyllus posturing*, the motif, the compo-
sition and even the drawing of the gesturing hand all seem derived from the
interior decoration of a kylix attributed to the painter Epiktetos. The vessel
is preserved in an obscure Italian provincial museum; a line-rendered illus-
tration of it, however, appears as a plate in that same volume of Greek vase
paintings by MacColl from which some years before Beardsley had
extracted another image as the source for his *Merlin* roundel in *Le Morte
Darthur.*

Another intriguing insight into Beardsley's methods at this time can be
gleaned from an examination of the details of the various texts that he would
have consulted. Clearly fascinated by the original, he certainly looked hard
at the different versions in English that Smithers supplied. The classic 'lit-
erary' translation of Juvenal has remained that of Dryden, but this is in fact
a free rendering, often wide of the original text in many points, and not, it
would seem, the text the artist principally used. A copy (now in a private
collection) of the rare first English version by Sir Robert Stapylton printed
in 1647 is marked at two points, both of which correspond much more
closely with Beardsley's illustrations, and it may very well have been con-
sulted by him. For the picture of Messalina returning from the stews, this
translation offers the most precise details corresponding to Beardsley's
image, whilst Stapylton's version of the lines that give rise to the artist's most
outrageous image, *The Impatient Adulterer*, is the only one which properly
explains the subject of this curious illustration, in which the would-be
seducer of a young girl has her charms revealed to him by an unscrupulous
mother who

casts off the Rugge. Whilst the hid Knave attends,
And masterprates, mad to be so delay'd.

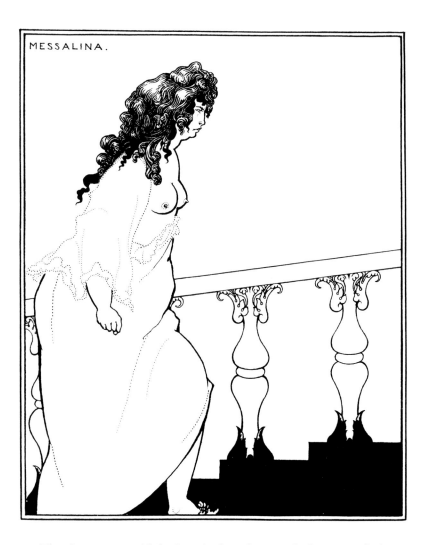

MESSALINA.

Messalina returning from the Bath; illustration for the Sixth Satire of Juvenal. Pen and ink. V&A, Harari Collection, E.302–1972

Beardsley had attempted the subject of Messalina before; this version is more robust, the figure of the lascivious empress, hell-bent upon the sating of her lust in the stews of Rome, yet more disturbing. For the specific details Beardsley appears to have compared the translations carefully, opting for that of Stapylton, whose version was the first published in English.

This drawing, unpublished until relatively recently, has generally been accounted the most indecent of Beardsley's erotica, but a persistent rumour suggests that others, yet more 'impossible' at one time existed. Beardsley certainly at least once offered Smithers specifically erotic works and may also have created such special illustrations for Herbert Pollitt, who eventually purchased *The Impatient Adulterer*, and also came to own some of the *Lysistrata* pictures. In a curious passage of his memoirs, Smithers's son refers to another group of drawings that Beardsley had pressed on his father: 'When commissioned to do legitimate work for The Savoy,' wrote Jack Smithers,

Beardsley was not content with this; he persisted in sending to London, or bringing them personally, obscene drawings which from their very nature were unsaleable, begging my father to take them and sell them for him. Beautifully executed in such technique and medium as only Beardsley was master of, yet devilish in subject. I have seen some of these, and believe me, they could only have sold to the utterly depraved. Wishful of further continued work from Beardsley, Smithers accepted them and hid them away, promptly forgetting all about them.

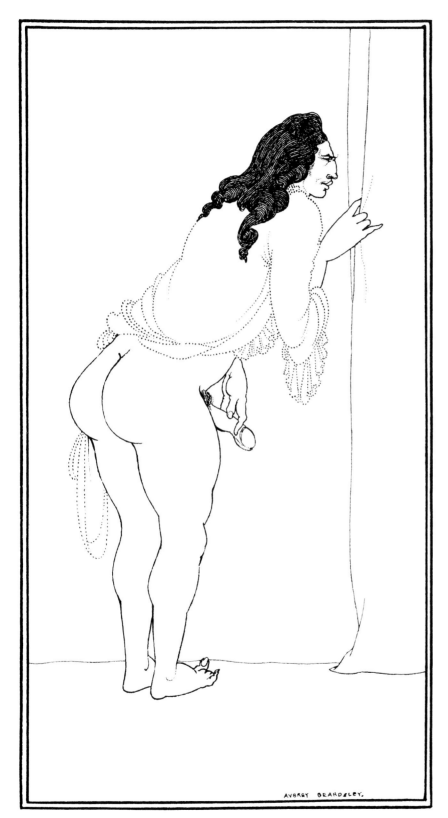

AVBRY BEARDSLEY.

The Impatient Adulterer, 1896;
illustration for the Sixth Satire of
Juvenal. Pen and ink. V&A, Harari
Collection, E.338–1972

If the *Lysistrata* pictures, for all their
outrageous details, maintain a
certain early Greek innocence, this
drawing, perhaps Beardsley's most
indecent, exudes the sleaze of the
late Empire and a thoroughly
Roman nastiness. The scene is again
derived specifically from Stapylton's
version of Juvenal's text. The original
drawing was bought directly from
the artist by Herbert Pollitt, and
unpublished until recently.

Count Valmont; frontispiece for
Les Liaisons dangereuses by Pierre
Choderlos de Laclos (Leonard
Smithers, 1896). From line-block.
V&A E.10-1900

The translation of the famous
epistolary novel of seduction was
being undertaken by Ernest
Dowson, who, sinking fast, was glad
of Smithers's commissions for hack
literary work. Beardsley planned an
edition with an illustrative initial for
each of the many letters. His excuse
for abandoning this plan was the
discovery that in translation the
initial letters naturally differed from
those of the original French text.

His father, he added in a telling line, 'as a business man realized that he
could never have sold the stuff and made money by it. The sales would have
been far too risky, slow, and unremunerative.'

Having been so closely linked with Wilde and other Decadents,
Smithers was, according to his son, anxious that these drawings should never
appear publicly, as they would have provided damning proof of his activities
as a pornographer. Later, according to Jack Smithers, they came into the
possession, by what means he knew not, of an associate of his father's whom
he refers to only as 'N—', no doubt meaning H. S. Nichols, a man even more
unscrupulous than Smithers himself. Jack suggests that 'N—' acquired them
by some unfair means, but it seems on the evidence of his odd, ill-written
book, that he really knew little or nothing of the true nature of his father's
affairs. 'The drawings themselves', he concluded, 'I have mentioned as being
truly awful, for I saw them, and if I refer those interested to Leviticus,
ch.xviii, verse 23, it will not be necessary to say anything further.' That par-
ticular text concerns the prohibition of women from lying with animals. If
one were to suppose for a moment that it were possible to place any weight
upon a story involving both Smithers and Nichols, and told forty years on
by a boy who was no more than eight or ten years old at the time, then it
would be tempting to imagine that somewhere there might still actually exist
lost drawings by Beardsley illustrating either the *Golden Ass* by Apuleius or
some missing erotic episodes of his own *Under the Hill*.

If Smithers did in later years issue sets of prints of some – but not all – of
the Juvenal drawings and a few others of Beardsley's more overt designs, it
seems that during the final period of the artist's life both he and Beardsley
actually became increasingly interested in less erotic and more literary texts
and images. For a number of typical, very slightly *risqué* Smithers titles
Beardsley produced covers or single pictures intended, no doubt, to enhance
their sales. These included such minor classics as *The Souvenirs of Léonard,
Coiffeur to Marie-Antoinette*, and Laclos's *Les Liaisons dangereuses*. During the prepa-
ration of the Laclos volume, Beardsley wrote to thank Smithers for an album
of illustrations by the French late eighteenth-century artist Prud'hon, of
which he wrote, 'the Prud'hon is simply *ravishing*. He is a *great* erotic, and I
shall find him hugely useful for the *Liaisons*'. From this point onwards, how-
ever, whatever his taste in reading, Beardsley seems in his work to have
sought, if anything, a greater degree of *gravitas* and a subtly implied eroti-
cism. In a final mysterious note scribbled close to the point of death he even
implored Smithers to destroy 'all obscene drawings'.

Just how far this shift in attitude coincided with a move towards the
Catholic Church, as urged by the patient Raffalovich, and to what extent both
were the result of rapidly increasing intimations of mortality and a consequent
desire to concentrate upon work of enduring quality, is difficult to fix exactly.
Several facts point towards such a reading. Even before leaving Epsom for
Boscombe, Aubrey had made his will (by which Mabel became his executrix
and sole beneficiary), and in an otherwise jovially chatty letter to Smithers
he had remarked that, 'there doesn't seem to be any time to lose over work…'

When Smithers came down to visit Aubrey in Boscombe they began to discuss the possibility of a de luxe, finely printed album of the artist's fifty best drawings. This idea clearly appealed to Beardsley, who, with Mabel's help, quickly threw himself into the writing of letters to the possessors of important drawings, such as Frederick Evans and to the publishers John Lane, J. M. Dent and others, seeking the necessary permissions to reprint designs from the earlier books. It cannot have escaped Beardsley's subtle eye for the nuances of things that all gave their agreement to co-operate with the highly unpopular Smithers with a remarkable readiness. Beardsley's life had all too clearly entered its final phase and, in spite of his own, still almost ironically boyish enthusiasm, the creation of *A Book of Fifty Drawings* already had the heavy feel of a memorial project.

Apollo pursuing Daphne, c.1896. From line-block. Stephen Calloway

This unfinished drawing, which hints so strongly at a new, magisterial eroticism in Beardsley's work, was unpublished in Beardsley's lifetime; it is known only from a late line-block print, the original being lost. It was one of the distinguished group of late Beardsley drawings originally owned by Herbert Pollitt; but at some time between 1907 and his death in 1921 it came into the possession of Beardsley's great admirer, the no less extraordinary model for Huysmans's bizarre fictional Aesthete, Des Esseintes, the comte Robert de Montesquiou.

Chapter eight
THE FINAL MONTHS

Immured at Pier View, Boscombe, Aubrey sank into an invalid's alternating pattern of gloom and alarm at the state of his health. Moments of hope and cheerfulness became fewer, and a further anxiety was his inability to settle to any one project, or, as he had once done so easily and so often, to sit up late into the night in his mystic pool of candlelight, drawing with rapt concentration. He had been cheered by the appearance of the *Book of Fifty Drawings*, and at the reception that it had received in certain friendly quarters, but both he and Smithers knew that the very creation of his 'Album' marked a stage in the realisation that serious concerted work was gradually becoming for Beardsley a thing of the past, beyond his ebbing strength or his fading effort of will. However, the *idea* of his work was crucial to Aubrey, perhaps the only thing that kept him going. The discussion of projects, of plans for new books and the endless to and fro of letters and notes between Smithers and himself had become almost his sole pleasure and link with a light-hearted, amusing, urban and urbane world.

The end of the year had brought also the end of *The Savoy*, expiring through lack of sufficient sales and Smithers's inability to prop up the enterprise any longer. Yeats gave a highly coloured version of the events. The failure of *The Savoy* was largely, he felt, brought about by lingering imputations of Wildean decadence, and by the now serious hostility in the Press towards Beardsley: 'his strange satiric art had raised the popular Press to fury . . .' recalled Yeats.

We might have survived but for our association with Beardsley; perhaps but for his Under the Hill, *a Rabelaisian fragment promising a literary genius as great maybe as his artistic genius; and for the refusal of the bookseller who controlled the railway bookstalls to display our wares. The bookseller's manager, no doubt looking for a design of Beardsley's, pitched upon Blake's* Antaeus setting Virgil and Dante upon the verge of Cocytus *as the ground of refusal, and when Arthur Symons pointed out that Blake was considered 'a very spiritual artist', replied, 'O, Mr. Symons, you must remember that we have an audience of young ladies as well as an audience of agnostics'. However, he called Arthur Symons back from the door to say, 'If contrary to our expectations the Savoy should have a large sale, we should be very glad to see you again.' Yet, even apart from Beardsley, we were a sufficiently distinguished body: Max Beerbohm, Bernard Shaw, Ernest Dowson, Lionel Johnson, Arthur Symons, Charles Conder, Charles Shannon, Havelock Ellis, Selwyn Image, Joseph Conrad; but nothing counted but the one hated name . . .*

When the magazine was banned from W. H. Smith's extensive chain of bookstalls, on the unlikely pretext of the supposed indecency of the Blake,

which was an illustration to one of a series of articles on his art by Yeats, it had been a blow; but with Beardsley's continuing illness and inability to provide his usual quota of arresting imagery the quarterly-turned-monthly had also begun to seem tired even to its supporters. Determined to put on a brave show, for Number VIII, the final issue, Arthur Symons wrote all the literary contents, both verse and prose, whilst, scraping together as many drawings as he could, Beardsley provided all the pictures, mustering somehow an array of a dozen illustrations.

At the very end Symons added, theoretically on behalf of Smithers, Beardsley and himself as editor, 'A Literary Causerie: By Way of Epilogue', which struck a note decidedly more plaintive than that of his cocky opening remarks at the beginning of the year. 'Our first mistake', he contended, 'was in giving so much for so little money . . . And then, worst of all, we assumed that there were very many people in the world who really cared for art, and really for art's sake.' But when he then spoke of plans for a new, half-yearly

Cover for *A Book of Fifty Drawings* (Leonard Smithers, 1897). Collection Anthony d'Offay

The scarlet cover is particularly striking; on 20 September 1896 Beardsley wrote to Smithers, 'I have stuck a pin in the cloth which I far and away prefer for my album. It's the only one of the lot you sent me that would print the cover really nicely, and in point of colour it is best; in fact just what I expected you would use.'

Herbert Pollitt's bookplate, before 1896. From line-block. Stephen Calloway

Beardsley made this design for his own bookplate, but added lettering with Pollitt's name when this useful patron pressed for *his* bookplate to be completed. Beardsley was especially proud of the drawing of the nude figure, writing to Smithers, 'it's all nonsense what they say about my early work. Just compare the drawing of the nude with the nudes in the *Morte* . . .'

publication, Aubrey, no longer in the midst of things, had to write asking Smithers what plans were afoot.

In the first week of December 1896 Beardsley was once again chirpy, Smithers having sold some books for him, thereby providing a much needed injection of funds. From being dunned for small bills ('Christian martyrs not in it with me', he wrote), he was suddenly in a position to order books he wanted and even wrote with enthusiasm about buying some French prints by contemporary artists he admired: 'It will be nice to get a Willette and a Rops', he informed Smithers, who, if he did not himself care much for the jollity of Willette, was no doubt highly familiar with the slick, lewd images of the pornographic Symbolist print-maker Felicien Rops.

Then on 10 December came the worst crisis so far, with a massive haemorrhage from the infected lung which occurred whilst Aubrey, accompanied by his mother, was walking in The Chine gardens. Ellen Beardsley chronicled the frightening event to Ross: 'We were out and nearly at the top of the hill leading onto the cliff. You might have tracked our path down, the bleeding was so profuse.' Only reaching a little summer house with a fountain of cool water staunched the flow, There she left him and went to fetch help; horribly weak Aubrey was carried home in a chair. As he recounted to Smithers, 'I expected I should make an *al fresco* croak of it . . . There seems to be no end to the chapter of blood.'

By Christmas he was a little better, but still highly impatient of his state and of the bourgeois dreariness of his surroundings and ancient fellow-guests. Soon though he was back to fretting about books and projects, showing his old fascination with every aspect of the block-making and printing of his designs. When Smithers sent one of the first copies of the de luxe edition of the *Book of Fifty Drawings*, Beardsley immediately responded with praise, saying, 'the large-paper copy of the Album is in every way worthy of its price, better than the small edition a thousand times. How well the half-tones have come out . . . the cover looks sumptuous.' Then, only three days later, he broke down again and hovered for a week in a truly critical condition. The problem, his doctor opined, was that the air at Pier View was quite wrong for him, and so, as soon as he was strong enough he was moved to another equally dreary boarding house in a villa called Muriel at Bournemouth, the very name of which caused him embarrassment every time he had to inscribe it at the head of a letter.

To Smithers he wrote, 'I . . . have of course lost long ago anything in the nature of hopefulness. Whom the gods love etc. . .', the cheerful pagan resignation of which seems to contrast oddly with the growing religious feeling which he, at first shyly, revealed to Raffalovich. Raffalovich, who had followed John Gray into the Catholic Church, had like many of the men of the nineties all the enthusiasm of the convert and something of the spiritual dandyism of the Aesthete. It was a potent mix. He had already succeeded in converting his housekeeper Miss Gribble and his butler, and now laid siege to Aubrey's soul. Politely, Beardsley tried hard to seem encouraging: 'Do not think, dear André,' he told him, 'that your kind words fall on such barren

ground. However I fear I am not a very fruitful soil. I only melt to harden again.' But melting he certainly was.

Two days after that letter to Raffalovich, however, he wrote with rather more worldly sentiments and wit to Smithers: 'My newly acquired virginity continues to be broken only by *rêves mouillés*. No news. Bournemouth is a *lee-tle* dull. Perhaps you've noticed it. Paris for instance, might be more lively.' Always he clung to the idea of the city. And always, it seems, Smithers and the now fading memory of a *louche* outside world provided the essential countervailing force to Raffalovich's pious urgings. Even when Aubrey received from Raffalovich a copy of his newly published novel *Self-Seekers*, for which he dutifully thanked him and promised to read, he dashed off a line to Smithers, who had published it, sniggering that 'the immortal novel has arrived. I shall get my mother to read it for me.'

Letters and a visit from Herbert Pollitt, an amusing character decidedly in the Smithers camp, were another welcome distraction, not least because Pollitt was rich and inclined towards patronage; 'insinuate a reference to Maecenas' Beardsley urged Smithers, knowing of his influence with the young Decadent. Pollitt, who later owned all but one of the *Lysistrata* drawings (the last was owned for a while by Herbert Horne, but lost in a fire) had for a long while wanted a bookplate, and so, not before many delays, Beardsley had finally drawn the appropriate freehand lettering directly on to the reproduction of his own bookplate design in Pollitt's copy of the Album. He advised Pollitt to have a block made by Carl Hentschel, the best specialist photo-engraver of his day, adding that 'I hope my crazy lettering will come out all right'. The outcome was a notable success, the plate probably one of the most original and best of Beardsley's few essays in this exacting field.

Pollitt was also keen to buy the *Impatient Adulterer* drawing, which Beardsley informed him 'may as well be catalogued at ten sovereigns, use however your own royal discretion'. He longed, he told him, to hear of Pollitt acquiring 'some superb quarto' of Juvenal into which he might have it bound up. This idea of inserting single drawings into fine copies of books seems to have appealed to the bibliophile in Beardsley, but it signals, too, the fact that Smithers's financial position was not what it had once been, and that unless Beardsley could produce all the pictures to make a saleable edition of a book it was becoming unlikely that his friend would be able to continue bearing the cost of making line-blocks on so a speculative a basis as hitherto.

The sharp winds of March Aubrey found particularly trying, and they prompted two rather self-pitying notes to Raffalovich; one reads, 'Oh how tired I am of hearing my lung creak all day, like a badly made pair of boots', whilst a second more pessimistically predicted, 'I fancy I can count my life in months now'. Perhaps for the first time he, and all those around him, began to realise that this was actually true. To Julian Sampson, a shadowy friend and tangential member of the old homosexual Cénacle, he couched the same sentiments in the more frivolous style of that circle, but in no less gloomily prophetic terms: 'As this month's *Idler* will inform you I have "not long to live". Still I hope to make out twelve more months before I go away

altogether. London will never see me again, for bacilli flourish rather too vigorously in its giddy atmosphere. Chastity' he added with a flash of the old brilliant repartee, 'has almost become a habit with me now, but, my dear Julie, it will never become a taste.' He had, in fact, just exactly a year to live.

To what extent the grim realisation of the reality of death reinforced the lavish campaign of spiritual attrition still being waged by Raffalovich is impossible to say, but on 31 March, almost a year after his sister's conversion, Beardsley wrote to André informing him, 'This morning I was received by dear Father Bearne into the Church, making my first confession. I was not well enough to go up to the church, and on Friday the blessed sacrament will be brought to me here. This is a very dry account of what has been the most important step in my life, but you will understand what those simple statements mean . . .' It has been cynically suggested that what it principally meant was that Raffalovich's quarterly 'kind presents' were secured at least for the time being. To Pollitt, Aubrey made another little confession, 'This morning I was closeted for two mortal hours with my Father Confessor, but my soul has long ceased to beat'.

For whatever reason, Aubrey's recovery of spirits and strength seemed, to all who observed it, quite extraordinary. Immediately he planned to make the devoutly desired escape from England and cross to France. Ten days later, having been moved with great care in André's carriage, put up in a good hotel in London *en route*, and accompanied all the way by a doctor, all at Raffalovich's generous insistence – and at his expense, Beardsley was in Paris, astounding even himself by his dramatic recovery. 'Paris is doing wonders for Aubrey,' his mother gushed, 'I can't believe my eyes seeing him prancing about as if he had never been ill.' Though in reality he had to be carried upstairs in his hotel, he did nevertheless begin to walk on the *quais*, exploring the book and print stalls which gave him intense pleasure, eating at good restaurants such as Lapérouse, or simply sitting writing letters in cafés. 'Paris is the blessed place it ever was', he told Mabel, whilst to Pollitt he spoke of 'a perfect resurrection'.

Though once he had worked easily in Paris, now he found it hard to settle to any task, and often too tiring even to try. Attempts to complete a coloured frontispiece for Smithers for a miniature edition of *The Rape of the Lock* dragged on and came to nothing, although he did manage to sketch out a little cover design. At first the lack of a sitting-room was the excuse, but eventually even he was forced to admit that he could not get back to work as he had of old, turning out drawings pretty much to order. To Smithers he sent the warning that the cover for the 'Rapelet' was corrected with Chinese white, a sort of bodging to which, with his utterly fluent penmanship, he had never before in the old days needed recourse.

Staying at the reasonably priced Hotel Voltaire, he had a delightful view, enjoyed his promenade and could still, through Raffalovich's munificence, indulge in certain small extravagances. On 26 April 1897, at the great sale of the collections formed by the Goncourt brothers, Aubrey was unable to resist bidding. He bought two engravings which he described as 'ravissants'.

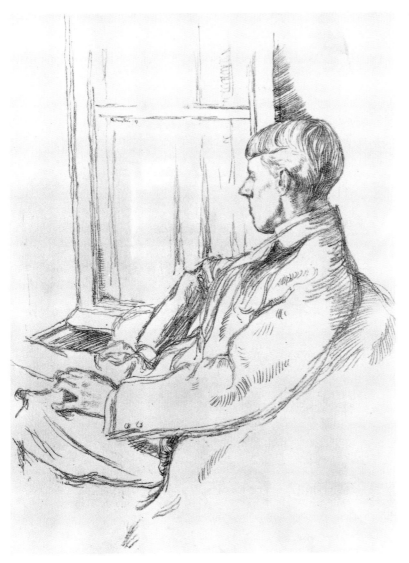

Highly typical of the Goncourts' eighteenth-century revival tastes and no less appealing to his own, by Beauvarlet after de Troy, their subjects were a *Toilette pour le Bal* and *Le Retour du Bal*. They were 'dreadfully depraved things', he told Mabel with glee.

The oncoming summer made the city impossible for him, and as he began, perhaps all too predictably, to fade again after six weeks of this over-hectic round, Aubrey, accompanied by his mother, proposed to move on to Saint-Germain. At first he was entranced by the unspoiled eighteenth-century charm of the place, and, as ever, buoyed up by the change of scene, was again full of new hopes. A local doctor examined him and pronounced that his recovery was quite certain; forest air taken between four and six in the morning was all that was needed. When Beardsley protested that this was the only time that he generally slept soundly, the doctor's barbaric sentence

William Rothenstein (1872–1945), *Aubrey Beardsley*, 1897. Lithograph. V&A, E2140-1920

A copy of the print in the Gallatin Collection was inscribed by the artist to the collector: 'drawn in Paris/Aubrey Beardsley/1897/to A.E. Gallatin.'

was commuted and sleeping with the window wide open to admit the ben-
eficially bosky atmosphere was deemed sufficient.

Predictably, after only a few weeks Aubrey had decided that he hated
this new place of imprisonment, and, seemingly unable still to settle to work,
was again anxious to move on. On the last day of May he scribbled to
Smithers, 'I live on thorns because I am more or less in the mortal funk of the
pauper's life – and death. Would to God I had done even *one* piece of black
and white work – transcendent or otherwise; whilst my present filthy life
goes on I shall do nothing . . .' To this heartfelt cry, he added the much
quoted enquiry, 'Do you want any erotic drawings?' Smithers's reply to that
question remains unknown. Shortly afterwards, Aubrey was cheered a little
by the appearance of his sister, and more still, in spite of an extremely diffi-
cult train journey, by the move to his favourite haunt, Dieppe.

At Dieppe a strange meeting occurred. Only a few days after ensconcing
himself at the fashionable Hotel Sandwich, Beardsley discovered that Oscar
Wilde, recently released from his terrible two years in Reading Gaol, had
been there shortly before, was living close by, and still called at the hotel
desk for his letters. Shunned by all but a few loyal friends, he travelled under
an assumed name, Sebastian Melmoth, which he had fancifully compounded
from that of the beautiful and saintly boy martyr and one borrowed from
the telling title of the gothick novel *Melmoth the Wanderer*, written in the early
nineteenth century by his Dublin relation, Charles Maturin. At first Wilde's
proximity alarmed and even rattled Aubrey seriously.

Probably fearful of Raffalovich's reaction, Beardsley dutifully wrote that
he was obliged to move hotels because 'unpleasant people come here'. But,
thus covered, he seems in fact to have remained on cordial, if not exactly
effusively friendly terms with the now sadly decayed and widely snubbed
Oscar. Even if many of those who had previously courted Wilde's acquain-
tance now chose to cut him, the old tales of Beardsley feebly crossing the
street to hide in a doorway rather than face him certainly are apocryphal.
On one evening at least, that of 19 July, they met at a dinner party and were
relaxed and convivial. Another day, this perhaps inherently unlikely pair
went shopping together, and Beardsley, always and ultimately the more truly
dandified of the two, but urged on by Wilde, the more naturally flamboyant,
bought for himself an ultra-fashionable, extravagantly pale top hat – an arti-
cle described by Wilde as 'a hat more silver than silver'.

Then Oscar asked Aubrey to dine with him at Berneval where he was
living; and, although it may well be that the latter did not go owing simply
to the difficulty of travel and his growing unwillingness to risk late evenings
and the cool night air, Wilde claimed that Beardsley sent no word and later
left for Boulogne complaining of the 'the people' one met at Dieppe. 'It was
lâche [cowardly] of Aubrey', Oscar reported snobbishly, 'if it had been one of
my own class I might perhaps have understood it.' They never met again.
To the last, neither perhaps ever quite understood the other, and neither
could ever really tolerate the other's pose or manner. Wilde however was
pleased and perhaps just a little flattered by Smithers's suggestion that

Mademoiselle de Maupin, 1897; from *Six
Drawings Illustrating Théophile Gautier's
Romance Mademoiselle de Maupin*
(Leonard Smithers, 1898). From
photogravure plate. V&A, Harari
Collection, E.416-1972

Beardsley's fascination with Gautier's
novel of transvestite romanticism
with its complex layers of ambiguous
eroticism was one of his most lasting
literary enthusiasms. Ultimately the
issue of a lavish illustrated edition of
the book proved beyond Smithers's's'
diminishing resources; he eventually
issued photogravures of the six
completed drawings in a portfolio
around the time of Beardsley' death.

Beardsley should provide an illustration for the projected edition of *The Ballad of Reading Gaol*. At first Beardsley also was enthusiastic, but Smithers subsequently reported to Wilde that his promise to draw the picture had been made 'in a manner which immediately convinced me he will never do it'. In spite of later protestations from Beardsley that he was at work on the frontispiece it never appeared, and Wilde's poem, one of Smithers's more successful ventures, appeared unadorned, with a simple gamboge cloth spine: a last, slim, ironic, yellow book of the era.

Back in Paris again by the middle of September, Beardsley wrote to Raffalovich immediately, and perhaps rather impishly in the circumstances, that his life for the past months had been skating on thin ice: 'a miraculous *patinage*' as he called it. To Pollitt, following the enthusiastic observation , 'I should like to see your framed collection of Aubreys', he added more poignantly, 'I don't see my own work half enough'. Now, for a while at least, he settled upon illustrating *Mademoiselle de Maupin*, and actually began to draw again. The new drawings, large and highly finished with touches of pencil

D'Albert in search of his Ideals, 1897; from *Six Drawings Illustrating Théophile Gautier's Romance Mademoiselle de Maupin* (Leonard Smithers, 1898). From photogravure plate. V&A, Harari Collection, E.418-1972

The image of the dandified d'Albert in all his finery, and with his impossibly corseted outline, recalls the fashion plates and caricatures of the 1830s.

shading and subtly graded washes of watered ink, are very fine, and mark a distinct departure in Beardsley's art. By 18 October three were ready and Beardsley duly dispatched them with considerable pride and expectation. A few days later another followed; this was *The Lady with the Monkey*. Beardsley was insistent that the blockmakers take extra care: 'There is pencil

work on the lady's face and a little on the hand, so threaten Swan [like Hentschel, a specialist line-block maker] with eternal punishment if they touch the drawing.'

Another complex crisis now loomed. Smithers, presumably without taking thought for the consequences, had revealed to Beardsley's Parisian tailor, Doré, that he was back in town, and Doré had begun to pursue him for a long-unpaid bill. Beardsley's immediate reaction, as always was to instruct Smithers to sell more of his books. This situation was bad enough, but it coincided with the moment when Smithers's own financial difficulties and, it should be said, his exasperation with Beardsley's capricious attitude to completing projects were conspiring to make it look unlikely that the book would ever appear, in parts or as a single volume, and either in French – as Beardsley wished – or translated, which Smithers seemed to think was essential if it was to sell enough copies to make the already chancey venture pay off.

'The question of Mdlle de Maupin is now pressing,' wrote Beardsley. 'I shall soon be more ready than you.' He then went on to change the proposed arrangement of pictures yet again and to issue several complicated technical instructions:

There are four full-page drawings for Part 1. I have dropped the idea of initial letters. The T must be taken off the Albert drawing and a small block be made of the picture that might be printed in sanguine on a gray [sic] cover???? Could you have this block made at once ⅓ reduction say, and let me see a proof. The initial should be painted out with white paint. Of course they mustn't rake out lights [cut away the surface of the block to intensify the lighter areas].

All this was the final straw for poor Smithers , who must at this stage have intimated his unwillingness – rather, perhaps, than his inability – to continue funding expensive half-tone blocks with no end in sight. Beardsley, panicked by what he heard, replied, 'I am utterly cast down and wretched. I have asked my sister to come and see you and talk with you. I must leave Paris. Heaven knows how things are to be arranged.' His next note fretted that he now could not see how Gautier's extraordinary, romantic, but nevertheless decadent and in part explicit text, dealing, as it did, so frankly with the theme of sexual ambivalence, could properly be illustrated 'without being insufficient or indecent'. A few days later, however, the *crise* was resolved. Anxious above all else to ensure that he would have funds to go south for the winter, Beardsley made great efforts to heal the breach with his old friend. He suggested to Smithers that he work instead at some simpler line drawings that could be cheaply reproduced as illustrations for a more instantly saleable, and 'possibly popular' text. The four *Maupin* wash drawings, beautiful works of art in their own right, could, he suggested, be sold to collectors, the artist to receive a share of any profits forthcoming from such a deal. Smithers made his peace, but naturally he did not part with such major drawings.

'Really nothing but work amuses me at all', Aubrey told his sister. To Smithers he explained, 'I ask for nothing better than to send you *chefs d'oeuvres,*

The Lady with the Monkey, 1897; illustration for Mademoiselle de Maupin. Pen, ink and wash. V&A, Harari Collection, E.308–1972

In the brief final phase of his career Beardsley began again to explore the use of carefully graded washes of diluted ink to render his forms. This, the most exquisite of the drawings in this manner, was first intended to form part of the a projected suite of 24 illustrations to *Volpone*. When it became clear that his health would not permit so ambitious a plan, the artist capriciously transferred it to take its place in the set of illustrations for Gautier's *Mademoiselle de Maupin*, later issued by Smithers just after Beardsley's death in 1898.

to have them published soon and printed well, and to *toucher* as often as can be a modest cheque or two. I will send you without fail (DV) within the next two months six drawings for some small and quite possible work. I by no means shelve the Maupin.' Finally he asked Smithers to send him his copy of Ben Jonson's plays; it was a clue to his intentions, which unknown to Smithers was echoed in a note to Pollitt, written on the same day, in which Aubrey informed him that he had spent the entire day combing Paris for a picture of a fox. Clearly his mind had turned to the last of old Gosse's three recommendations of 'great books', Jonson's tough, sly, satirical masterpiece *Volpone*.

On 11 November Beardsley told Smithers that he had completed a cover design intended for *Ali Baba*, the chosen popular book. His other project he intended to keep secret, but a few days later, he sent off the elaborate arabesque design, inscribed, as he now informed Smithers, with a new name so that it would serve as the 'cover for a well-considered trifle I have on

Arbuscula; illustration for *A History of Dancing* by Gaston Villier (William Heinemann, 1898, reprinted in *Under the Hill*, 1904 ed.). Photogravure in green.
Collection Anthony d'Offay.

Arbuscula was a dancer in ancient Rome; Beardsley, commissioned by Heinemann to supply a picture for the book, chose his own subject, giving Arbuscula a strangely hybrid Baroque costume and setting. An exercise in richness of modelling in pen, pencil and wash, Beardsley inscribed on the back of the original drawing a crucial injunction to the block-maker 'Don't rub (pencilling)'.

EX LIBRIS
OLIVE
CVSTANCE

A B.

hand'. Later used for *Volpone* it is one of his most elaborate cover designs, an exuberant swirling vortex of ornamental elements, that would seem to derive almost certainly from the artist's familiarity with a rare kind of engraved ornament print of the early seventeenth century. These 'blackwork prints', as they are known, display a similar dynamic movement of precisely drawn elements, and feature in particular decorative arrangements of those conventionalised vegetable forms known as *cosse de pois* (pea-pods). Whether Beardsley had ever actually had the opportunity to examined such ornament prints as these at first hand in the print rooms of the British Museum or the South Kensington (now the Victoria and Albert) Museum cannot now be determined; it is perhaps more likely, given his lifelong dependence upon books, that he would have found examples in the growing literature of the day on such subjects, in books such as D. Guilmard's great illustrated catalogue, *Les Maîtres ornemanistes* (1881).

With the arrival of the latest cheques, Aubrey decided that he had sufficient money to make his exit from Paris and thus to escape the already troubling cold and fogs of the city. After considerable thought and much poring over maps, he and his mother had settled upon Menton; it had first been recommended by one of Raffalovich's priestly acquaintances, and besides being a place where the climate was considered beneficial for 'consumptives', the town also possessed the crucial factor in its favour of being a

Bookplate of Olive Custance, 1897. Photogravure in green. V&A, Gleeson White Collection, E.554-1899

Olive Custance, a minor writer of the nineties, later married Lord Alfred Douglas. Like *Arbuscula* and the *Mademoiselle de Maupin* illustrations, the bookplate which Beardsley drew for her is in his last, rich, Baroque mode. The decorative details, such as the elaborate stand bearing a basket of flowers, reveal the artist's new interest in tonal qualities, and suggest all the richness and imaginative resource of 17th-century ornament prints.

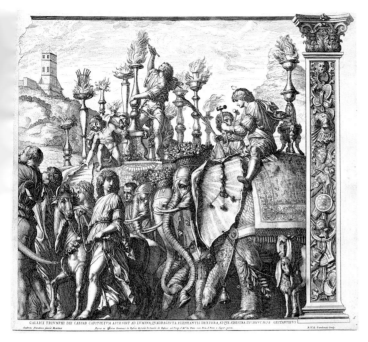

The Triumph of Caesar: The Elephants (canvas V). Engraving after Mantegna, 17th century. V&A 14956

From his early years Beardsley had loved the great *Triumph of Caesar* pictures at Hampton Court, and throughout his career kept prints after Mantegna beside his work-table as an inspiration. Although Beardsley's elephant in his initial V for *Volpone* is placed upon a pedestal and resembles Bernini's celebrated Roman elephant in the Piazza Minerva in Rome, it clearly derives more closely from the artist's reminiscence of the elephants in Mantegna's great parade.

Initial V from *Ben Jonson his Volpone: or the Foxe* (Leonard Smithers, 1898). From half-tone block. V&A E.1096-1996

The five historiated initials completed for *Volpone* shortly before his death, represented a new, baroque departure in Beardsley's art. Using pencil-work to achieve a robust richness of tone and modelling, these last five drawings completed by the artist only just before he finally ceased to be able to work remain both as a testament and as a tantalising glimpse of how his work might have developed with more time.

cheaper place to stay than other comparable Riviera resorts. Their departure was set for 19 November, with an overnight stay at Marseilles. Packing up and sending Smithers as a parting gift the two French prints from the Goncourt sale, which he had always admired, Beardsley gathered his other now meagre possessions, his books and his precious work and boarded the train to the south. It was to be his final journey.

At first, as always, the change of scene seemed to have an instant, if short-lived tonic effect. Aubrey and his mother established themselves at the Hotel Cosmopolitain, and immediately he threw himself with what seemed like renewed vigour into the *Volpone* project. Smithers responded with an equal enthusiasm, and indicated his willingness to publish a splendid volume, even more lavish in scale than *The Rape of the Lock*. He proposed that the volume should have twenty-four plates in half-tone, in order that Beardsley could work in his new richly shaded style. As a result Beardsley started to plan out a sequence of designs, admitting that the text offered so many 'chances' to create illustrations that it was difficult to make a definitive

OPPOSITE
Volpone adoring his Treasure; frontispiece from *Ben Jonson his Volpone: or the Foxe* (Leonard Smithers, 1898). From line-block. Stephen Calloway

This design, one of the artist's very finest conceptions, drawn to be reproduced on a larger scale for the prospectus of the book, was actually printed by Smithers as the frontispiece for the posthumously published edition of Jonson's sharp, satirical play, for which Beardsley was also working upon a highly perceptive introductory essay. His last great design, this *Volpone*, shows all too poignantly that, in spite of his rapidly deteriorating health, Beardsley was at the very height of his powers both technically and imaginatively.

Jacques Toutin (*fl.* early 17th century)
Ornament print, 1619. Engraving.
V&A E.470-1971

A number of artists in the first years
of the 17th-century adopted a form
of ornament with swirling foliage
and a distinctive motif of lines of
diminishing dots. This style, known
as *cosse de pois*, and which has such
obvious affinities with the flowing
asymmetry of Art Nouveau, is
clearly the basis for Beardsley's
Volpone cover and for other
ornamental details in the drawings
of his last few months.

Initial S from *Ben Jonson his Volpone: or
the Foxe* (Leonard Smithers, 1898).
From half-tone block. V&A E.1094-
1996

choice. Having sent Smithers a fragmentary sample of the kind of pen-work that he intended for the whole series, Beardsley set to work on a drawing for a prospectus for the volume depicting *Volpone adoring his Treasure.* Intended to be reproduced larger than the actual page size of the book, this drawing would prove to be Beardsley's last great masterpiece, a miracle of sustained invention and steely control of the linear representation of form. In style curiously like a seventeenth-century line engraving, it possesses a cool graphic precision that seems almost to deny the intervention of so feeble an instrument as the nib of the pen and the failing strength of the human hand. Beardsley, alive as ever to the subtlest of nuance in the effect of his work when reproduced, told Smithers, 'I want you to use a soft paper with plenty of warmth in it so that the drawing will look as rich and velvety as possible . . . the drawing is a trifle cold in the original'. Intended to be a 'less elaborate, line version' of the finished design for the book, Beardsley noted that whilst it was not to appear in the finished volume, it would nevertheless be 'precious and worth having'.

In a letter to Pollitt, in which he tells him that it would be 'delightful beyond archangels' dreams to have you here', he makes the first mention of the series of large initial letters for *Volpone* to which he next turned his attention, Encouraged by Smithers, who offered the luxury of half-tone blocks, Beardsley began to explore more fully the possibilities of working in a sumptuous Baroque manner, using pen, pencil shading and a sort of *sfumato* technique which suggested a superb, decadent opulence wonderfully in tune with the play and quite new in Beardsley's work. The first and best of these initials, which Smithers eventually reproduced on a larger scale in the de luxe edition of the book, shows a massive, Bernini-like elephant which derives from Beardsley's old favourite prints of the Hampton Court Mantegna *Triumphs of Caesar.*

Describing these tiny but hauntingly monumental images to Pollitt, Beardsley no longer felt any need for false modesty: 'I wax greatly in gifts of the pencil, someone must be praying for me. Nowadays I adore my own drawings, but really they are becoming capital.' Nevertheless, he was relieved when Smithers wired 'drawings splendid'; 'and so they are' he added when quoting the Smithers telegram to his sister. Not content with work on these designs in his new Baroque manner, Beardsley was also working at an introductory essay for the book, a piece of writing that demonstrates an extraordinary critical faculty at work and reveals, too, a stylist in prose of the first order. His characterisation of Volpone is incisively brilliant: 'Volpone is a splendid sinner,' he wrote,

*and compels our admiration by the fineness and very excess of his wickedness. We are
scarcely shocked by his lust, so magnificent is the vehemence of his passion, and we marvel
and are aghast rather than disgusted at his cunning and audacity . . . The qualities
which the Latin nations admire most are beauty, strength, cunning and versatility, and
Volpone is Latin to his fingertips. He is as perfect an epitome of the Southern races as
Hamlet is of the Northern.*

Able to work at most for only three hours a day, did Beardsley know that these were the last drawings he would ever finish? In letters to Smithers he remained confident of completing this and other projects, and talked animatedly about the proposal for yet another quarterly, to be called this time *The Peacock*. Beardsley was full of vigorous ideas: 'let us give birth to no more little back-boneless babies' he told Smithers, offering his services on one, now familiar condition: 'I will contribute cover and what you will . . . if it be quite understood that Oscar Wilde contributes nothing . . . anonymously, pseudonymously or otherwise.' In the light of his newest drawing style, his other pronouncement is highly interesting: 'on the art side I suggest that [the magazine] should attack *untiringly and unflinchingly* the Burne Jones and Morrisian mediaeval business and set up a wholesome seventeenth and eighteenth-century standard of what picture making should be.'

Tragically, at the very moment that Beardsley was writing to his new French friend, Henry Davray, the young writer who did so much to

Cover for *Ben Jonson his Volpone: or the Foxe* (Leonard Smithers, 1898). Collection Anthony d'Offay

Drawn in Paris, this most opulent of Beardsley's cover designs was originally intended for *Ali Baba*; Beardsley changed the lettering when he fixed upon an, at first, secret project. *Volpone* was to prove his last project. The design clearly shows the influence of 17th-century 'blackwork' ornament prints.

Initial V from *Ben Jonson his Volpone:
or the Foxe* (Leonard Smithers, 1898).
From half-tone block. V&A
E.1095-1996

One of Beardsley's last drawings;
finally unable to draw any more,
Aubrey flung his famous gold-
nibbed pen across the floor in
despair.

popularise his work in France, of 'my present work' as a 'a great advance on
anything I have yet done', the climate of Menton, which he had trusted to
help with his condition, began to take its toll. From this point onwards
Aubrey began to fade more rapidly. A local photographer had come to the
hotel and taken a portrait of the artist, his last, in the hotel room. It shows
Aubrey seated at a writing table, a still elegant, attenuated figure, surrounded
by a few pathetic, but never entirely abandoned attempts to impose upon a
bourgeois world some vestiges of the Aesthete's sensibility. Against the over-
whelming background of the hotel wallpaper (of a kind with which the
dying Oscar Wilde also had to contend), Beardsley pinned up his Mantegna
prints, those talismanic images that he had carried with him everywhere,
from house to house and from hotel to hotel; on his bookshelf a mixture of
French and English books, and, above, a line of photographs of those who
meant most to him: his mother, his sister Mabel, André Raffalovich, a
woman who may be his once close friend Ada Leverson, and also a likeness
of his hero Richard Wagner. Close at hand it is also possible to make out his
crucifix, and the distinctive form of his famous pair of French ormolu can-
dlesticks, by the light of which, even to the last, he still preferred to write or
draw or read.

Later used as the frontispiece of Lane's 1904 edition of *Under the Hill*, this image has a rich poignancy. Max Beerbohm possessed a copy of the photograph on which, at his own death, it was discovered he had pasted a note: 'This photograph of Aubrey Beardsley was taken in the bedroom of an hotel at Menton – the room in which he died. It was given to me either by his mother or by his sister. The Mantegnas are a queer contrast with the wallpaper and the furniture; and the contrast must have delighted him greatly. Tragically frail and dying tho' he looks here, my memory is that he looked hardly less so when first I met him. Max Beerbohm, 1925.'

At the beginning of 1898 the cold and damp air caused a congestion of the lungs and made Aubrey's breathing increasingly difficult. From 26 January he did not again leave his room. Now he was unable to draw and began to write with greater difficulty, using only a pencil. One tale has it that his mother found his famous gold-nibbed pen stuck in the floorboards, where he had tossed it in irritation or despair. He maintained at first a brave fiction that it was a touch of rheumatism in his right arm that prevented him from work, but in due course he informed Mabel and also Herbert Pollitt of

Aubrey Beardsley in his room at the Hotel Cosmopolitain, Menton, in which he died. *From Under the Hill* (John Lane, 1904).
Collection Anthony d'Offay.

Taken by a local photographer, this is the last image of the artist.

the true seriousness of his case. Minor haemorrhages became more frequent, but on the 6 March an appallingly severe one signalled that the consumption had touched an artery and that there could be no hope; the doctors began from this point to administer morphine.

Beardsley's last letter to Smithers, dated 7 March 1898. Henry Huntingdon Library, San Merino, California

Smithers did not take Beardsley's supposed deathbed injunction very seriously, and fortunately neither he nor Pollitt destroyed the Lysistrata illustrations and other 'bad' drawings they possessed. In his last, more desperate years Smithers sold not only this last letter of Aubrey's but also copies or outright forgeries of it.

On the next day, the 7th, Beardsley is supposed to have written the note to Smithers which has occasioned so much speculation; scrawled in pencil on a miserable scrap of paper, it is headed 'Jesus is our Lord and Judge', and reads, 'Dear Friend, I implore you to destroy all copies of Lysistrata and bad drawings. Show this to Pollitt and conjure him to do same. By all that is holy *all* obscene drawings. In my death agony, Aubrey Beardsley.' It was posted in an envelope addressed by his mother, and it has often been asserted that, if not actually written by Ellen Beardsley, it was dictated by her to her son, by now weak and possibly confused, in a strange effort to prevent Smithers

from continuing to publish the sort of material that she believed would damage Beardsley's posthumous reputation. Whether, in fact, Mrs Beardsley actually had enough knowledge of this aspect of Aubrey's life and work to have framed the note is by no means certain. But neither is there any other evidence to suggest that such a dramatic death-bed repentance and cock-crow disavowal of so important a part of Aubrey's life's work was at all likely. In either event, Smithers ignored the injunction and for a decade continued his trade in Beardsley's erotica; *in extremis* he even resorted to selling copies of the note.

Fearful lest further severe haemorrhaging would cause him the horror of suffocating as the lungs filled, the doctors sedated Beardsley further with morphine. On 12 March Mabel wrote to Robert Ross, 'Dear Aubrey is very ill, we fear he cannot live many hours. He's touchingly patient and resigned and longs for eternal rest. He holds always his crucifix and rosary.' It would be hard, even for those who remain cynical about the initial nature of Beardsley's conversion, to doubt that it was his faith that sustained him now. The end came quite quickly. On the morning of 16 March 1898 Mabel wrote again to Ross; she must have been sitting still in the room: 'Our dear one passed away this morning very early. He looks so beautiful. He died as a saint. Pray for him and for us. The funeral is tomorrow at nine. . . He sent sweet messages to all his friends. He was so full of love and patience and repentance'.

Shortly after hearing of Beardsley's death, the poet Lionel Johnson, himself devoutly religious, wrote to a friend,

I can say, emphatically that his conversion was a spiritual work and not an half-sincere aesthetic act of change, not a sort of emotional experience or experiment: he became a Catholic with a true humility and exaltation of soul, prepared to sacrifice much. He withdrew himself from certain valued intimacies, which he felt incompatible with his faith ...I do not for a moment mean that his conversion was a kind of feverish snatching at comfort and peace, a sort of anodyne or opiate for his restless mind: I only mean, that, being under sentence of death, in the shadow of it, he was brought swiftly face to face with the values and purposes of life and of human activity ...He was strangely gentle and winning though passionate and vehement in his intellectual and aesthetic life: such passion and vehemence tempered by his spiritual docility, might have achieved great and perfect things. So I have suggested there was a side to his nature which might have led him far into the direction of technical excellence in the extreme, coupled with spiritual perversity in the extreme: he lived long enough to show that his course would have been otherwise. I ascribe all in his work which even great friends and admirers find unwelcome partly to his febrile consumptive suffering state of body, with its consequent restlessness and excitability of mind; partly to sheer boyish insolence of genius, love of audaciousness, consciousness of power. He was often ridiculed, insulted, misconstrued: and he sometimes replied by extravagance. But despite all wantonness of youthful genius, and all the morbidity of disease, his truest self was on the spiritual side of things, and his conversion was true to that self ...He died in quiet peace and happiness. Requiescat; with all my heart.

Aubrey Beardsley, artist, man of letters, wit and dandy was dead; he had been the most original and most startling draughtsman of the century, and the quintessential figure of his era. He was just twenty-five.

Chapter nine
THE AFTERMATH AND
THE MYTH

Austin Osman Spare (1888–1956),
Portrait of Mabel Beardsley, c.1909.
Pencil. V&A, Given by Canon John
Gray in memory of André
Raffalovich, E.1969-1934

André Raffalovich also extended his
protective friendship to Mabel
Beardsley, both before and after her
brother's death; he owned this
portrait drawing of her by Spare,
who was for a time also his protégé.
Spare did not fulfil his early promise
as a draughtsman, turning to an
obscure and highly personal form of
mysticism as inspiration for his later
'automatic drawings'.

'Dandyism is the last glimmer of heroism amid decadence; like the sunset of
a dying star, it is glorious, without heat, and full of melancholy.' For
Beardsley, a true artist, but also no less a literary, intellectual and religious
dandy in a true nineties way, this key passage from Baudelaire's *The Painter of
Modern Life*, a passage and sentiment so admired in the last decade of the cen-
tury, could hardly be more poignant. With his death an aspect of the deca-
dence came to a close. His career had epitomised for many the strengths
and, no less, the fallibilities of this late flowering of the Aesthetic Movement,
and, as in the world of letters with the death of Wilde two years later, which
seemed to many to have a similar symbolic importance, there would be a
distinct feeling that henceforth things would be different, new stances taken
and fresh poses struck. The *diminuendo* of the nineties had begun, the rest
would be the stuff of legend.

So all-pervading was Beardsley's influence, or rather his aura or presence
in the culture of *fin-de-siècle* England, that with his death the mythologising
process which had already been a part of his life, began immediately, and
with a renewed vigour to add to the legend. As a result, the aftermath of his
strange, intense life and career, and the workings of its self-generating
mythologies on those of his immediate circle who remained and those in
the wider sphere, have a fascination perhaps as great as any reality.

On the day after his death Aubrey Beardsley was buried in the public
cemetery high on a hill overlooking Menton, in a place that his mother
described as beautiful and such as he would himself have chosen. There was
a service at the cathedral and many local people, including most of the staff
of the hotel, accompanied the coffin on the steep climb. Back in England, a
requiem mass was performed in the fashionable Jesuit church in Farm Street
on 12 May. Arranged with his usual panache and attention to detail by
Robert Ross, but no doubt at the expense of André Raffalovich, it concluded
with the *Marche funèbre* by Beardsley's beloved Chopin.

Rather as had been the case when Dante Gabriel Rossetti had died in
1882 and it was widely quipped that Hall Caine, his first biographer, 'went in
with the undertakers', so too at Beardsley's death the literary vultures began
to circle overhead. A spate of obituaries, articles and, in due course, books
began to appear. First in were friends such as Ross and Aymer Vallance, fol-
lowed later in the year by Arthur Symons, whose little book was perhaps the
first fully considered account of Beardsley's art rather than a mere collection
of recollections. But not all that was written was in so sympathetic a vein,

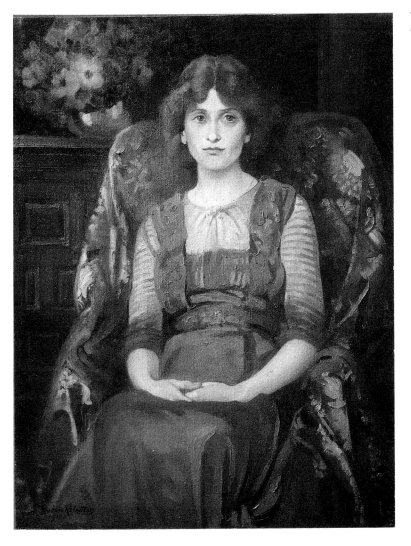

W. Graham Robertson ,
Portrait of Mabel Beardsley, 1911. Oil
(present location unknown). From a
photograph by Frederick Hollyer.
Stephen Calloway

Graham Robertson painted Mabel
twice: in one well-known portrait
she wears men's clothes, which has
contributed to speculation that both
she and her brother had at least some
interest in transvestism. In this
second portrait, painted in the same
year, her already somewhat wasted
features appear remarkably similar to
those depicted in her brother's self-
portrait sketch (illustration p.22).

and the obituary in *The Times* of 18 March 1898 was almost hostile, pointing to the degeneracy of Beardsley's art, and suggesting a direct link between lung disease and a 'morbid imagination'.

Burne Jones and his studio assistant T.M.Rooke, who assiduously recorded his master's conversations, discussed Beardsley on that day. Burne Jones was positively vituperative about the boy he had once tried so hard to help: 'Yes, he's dead. Quickly run his course...So stupid and conceited...' Then Burne Jones recalled a much later visit Beardsley made, when he was already bored with the *Morte Darthur* and cynical about the sacred text and his style of work, which had shocked the old painter. Burne Jones continued,

I never saw such a pitiful exhibition of vanity in my life. I wondered why it was he took the trouble to come and see me, unless it was to show off and let me know my influence with him was over. As if it mattered in the least whether it was or not. Then he got into that horrid set of semi-Sodomites, and after Oscar Wilde disappeared had almost to

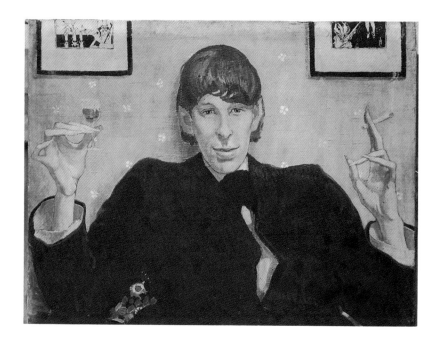

*Portrait of 'Mr Watkins', c.1914.
Photogravure after the original
painting. V&A E.263-1997*

This celebrated reproduction was
exhibited in 1966, purporting to
represent 'Mr Watkins', a young man
who claimed to be the son of Aubrey
and Mabel Beardsley. It later
transpired that the portrait was of
the illustrator Alan Odle, painted by
his friend Adrian Allanson
(1890–1959). The original picture,
along with its supposed history, had
been acquired, it was said, in Paris
from 'Mr Watkins' himself by the
equally curious and dissolute Lord
Tredegar. The picture surfaced in
1991 and was sold through the
London saleroom of Christie's. The
portrait, having earned a strange
place in the Beardsley legend, even
now remains a potent image of the
perceived decadence of the
'Beardsley period'.

*disappear himself. Damned young fool. The drawings were as stupid as they could be.
Empty of any great qualities and detestable... more lustful than any I've seen, not that
I've seen many such...*

Three months later Burne Jones was also dead; his widow Georgie, know-
ing that Aubrey's mother and sister had no fine example of his mature work,
took down from its place the *Siegfried* drawing, and gave it back to them.

Of the ensuing events and of the lives of Aubrey's immediate circle, the
facts are easily told. Mabel Beardsley, in spite of occasional, and at first
unexplained collapses, continued with her never very successful career as a
touring actress and eventually married one of her professional acquain-
tances, a charmingly boyish rep. actor, George Bealby-Wright. Still well
known in certain circles, her appearance in London was often remarked,
for long after the conventional period of mourning was over she continued
to affect a 'magpie' scheme of black-and-white costumes, which set off her
striking looks but also, it was supposed, paid curious tribute to her brother's
art. But she was to achieve a yet more poignant fame, for it was the tragedy
of Ellen Beardsley to watch her second child die slowly in increasing pain
from a cancer.

Mabel's extraordinary fortitude, her spiritual intensity and quiet dignity
won the admiration of her friends, and in her last sad days she was constantly
attended by, among many others, Charles Ricketts, who brought her exquis-
itely costumed dolls which he made to amuse her, and by W. B. Yeats, who
wrote the sequence of poems *On a Dying Lady* in which he pictured 'her
lovely piteous head amid dull red hair'. Yeats in a letter to his friend Lady
Gregory wrote of how the sight of Mabel near death had vividly recalled to
him Aubrey, to whom he had perhaps only briefly, during year of *The Savoy*,
been close: 'It was her brother, but her brother was not I think loveable, only

astounding and intrepid.' Mabel died in 1916; she was forty-four. Ellen Beardsley, proud and poor, lived on until 1932, her existence eased a little by a small civil-list pension secured through the thoughtful intervention of Robert Ross.

Ross, who was such a good friend to both Beardsley and Wilde during their lives, continued to serve them in death. He contributed the touching 'Eulogy of the Artist' to the immediately posthumous edition of *Volpone* which Smithers put together using the few, but superb drawings that Beardsley had completed. Later, in 1909, he enlarged this account into one of the most sensitive and informative of the early books; it was published by Lane and reprinted the useful 'Iconography' originally prepared by Aymer

Sidney Sime (1867–1941), Cover for *Black and White*, Christmas number, 1899. From line-block. V&A E.3114-1921

Like many of the popular publications of the day, *Black and White* often called upon illustrators to produce covers or other designs cashing in on the easy notoriety of Beardsley's style. Sime was among those who could be relied upon to turn in a competent fricassee of Beardsleyesque motifs reheated and served up to titillate the jaded palate of the reading public. He later discovered his own, more authentic vein of fantasy in the many illustrations that he made for several books of eerie tales by Lord Dunsany.

Ilbery Lynch (fl. 1905–25), *Just Published;* illustration for an advertisement for *Aubrey Beardsley* by Robert Ross, 1909. Pen and ink. V&A E.5400-1919

Robert Ross's little monograph on Beardsley, published in 1909 and one of the most perceptive and sympathetic of the early studies, grew out of his 'Eulogy of the Artist' included in Smithers's edition of *Volpone.* Lynch's drawing, inscribed to Ross, has long been described as an illustration for a showcard or advertisement for the book; it is filled with references to the literary world of the nineties in which Beardsley and Ross had moved.

Vallance for Beardsley's *Book of Fifty Drawings*. He also ran the tiny Carfax Gallery, from which he fought a rearguard action against the new century, organising exhibitions of the finest graphic work of artists such as William Blake and Edward Calvert, and his friends Ricketts and Shannon's woodcuts and lithographs, and of course drawings by Beardsley.

At the turn of the century John Gray had trained for the Catholic priesthood. Appointed to a parish in Edinburgh, where his lifelong friend Raffalovich built a church for him, Gray became, it was said, a good if rather surprisingly austere priest. There, in two separate houses they established themselves in a pious, quietly decorous life which revolved like clockwork for another thirty years in a round of early masses, elegant lunches, carriage rides and teas. Gray, once the companion of Wilde and perhaps the model for his fictional namesake, Dorian, kept all his books, but with many of those of the nineties with their spines turned in. On Raffalovich's death, Gray gave to the Victoria and Albert Museum in his memory a small group of numinous nineties things: the beautiful, Decadent watercolour *Sappho* by Gustave Moreau, Beardsley's unused frontispiece to his poems and a delicate portrait drawing of Mabel by the mystical Symbolist Austin Osman Spare.

Smithers, as has been recounted earlier, continued his precarious operations for almost another decade after Beardsley's death. Over the years he issued in addition to the *Volpone*, which remained his last truly sumptuously produced volume, at least three further important editions of previously unseen Beardsley items. These were the text of *Under the Hill* and slender portfolios of the six *Mademoiselle de Maupin* illustrations (reproduced from the wash drawings in velvety half-tone) and of Beardsley's unpublished line drawings for Juvenal, together with two bizarre images from his once-planned but never completed volume of Lucian.

Another curious point underlined by the later editions of Beardsley's books, especially in the crucial few years immediately following his death – years in which the artist's still equivocal reputation hung very much in the balance – was the extent to which he was simultaneously perceived by some critics to be an ornament to the increasingly wholesome and respectable catalogue of John Lane's Bodley Head publications, whilst for others he remained an arch-degenerate, a Decadent forever mired by his contact with the infamous Smithers's circle. In fact, as is so often the case with Beardsley, the distinction between these two readings is by no means clear cut. The truth lies somewhere between these two equally simplistic extremes of popular perception; one possible explanation for this ambiguity is particularly intriguing.

It seems highly likely that between Lane and Smithers there existed occasional, complicated, but of necessity clandestine arrangements concerning

Alastair (pseudonym of Hans Henning Voight; 1887–1933), illustration for *Mademoiselle de Maupin* by Théophile Gautier. Pen and ink. V&A E.3502-1913

The novelist Carl van Vechten wrote of Alastair that 'he was a mysterious figure . . . trailing behind him certain clouds of glory from the Nineties.' Many, including John Lane, saw him as Beardsley's most likely successor, and the illustrator who came closest to preserving the self-consciously precious decadence of the *fin-de-siècle.*

E. T. Reed (1860–1933), *Britannia à la Beardsley;* from *Punch,* Christmas Number 1895. Stephen Calloway

One of the best-observed of the parodies of Beardsley's drawing style. *Punch* had kept up its good-humoured attacks on the Aesthetes and Decadents ever since the early days of Oscar Wilde's espousal of the creed of Beauty.

AND PUNCH'S ALMANACK FOR 1895.

BRITANNIA À LA BEARDSLEY.
(By Our " Yellow " Decadent.)

OPPOSITE
Illustration from the 'Nichols' group of fakes, from *Fifty Drawings by Aubrey Beardsley, Selected from the Collection owned by Mr. H. S. Nichols* (New York, 1920).
Collection Anthony d'Offay

By 1920 the first glimmerings of a revival of interest in the nineties and a rise in the price of Beardsley originals made it worthwhile to attempt to forge drawings. The exhibition staged by Nichols who claimed to have 'discovered' a major cache of lost originals, was the most ambitious attempt to pass off spurious examples; many of these bogus drawings are still, even now, in circulation.

the publication of various works by Beardsley and Wilde. No direct evidence appears to survive, but it must of course be remembered that Smithers always naturally favoured an opaque *modus operandum* in his undertakings and usually tried hard to cover his tracks. Indeed, Wilde, disappointed by Smithers's inability to meet the unexpectedly brisk demand for copies of the openly issued *Ballad of Reading Gaol,* made the joke at his expense that the roguish publisher was so fond of suppressed books that he even suppressed his own. Even when it came to the more legitimate aspects of his operations, his affairs were seldom straightforward, and over and over again he embroiled himself in labyrinthine business associations and dark dealings with other printers, 'publishers' and the most scurrilous booksellers of Paris and London, such as H. S. Nichols.

Equally though, there can be no doubt that John Lane had by this date become a very smooth operator on the London literary scene. Later, he famously boasted that it had been he who revolutionised the pattern of publishing in the nineties and, for the first time perhaps since the era of Byron and John Murray, 'made poetry pay'. Following Smithers's first financial

crash, brought on by a prolonged bout of ill-health in 1899, it was Lane who adroitly moved in to pick up the more desirable pieces of the business, including copyrights, line-blocks and perhaps also the major portion of Smithers's stocks of printed sheets and illustrations. As a result, Lane's lists of publications (as printed in books which he issued around 1899–1905, or even as late as the 1920s) regularly include a number of 'Smithers items' such as copies of *The Rape of the Lock* and *Volpone* by Beardsley, Ernest Dowson's verses and, most ironically of all, complete runs of the eight numbers of *The Savoy*, bound up in three volumes and stamped 'John Lane' on their spines.

This ostensibly left Smithers, during the unhappy period in which he attempted, unsuccessfully, to rebuild his fortunes in the few remaining years before his mysterious death in 1909, increasingly in the position of literary pirate, issuing unauthorised and downright spurious editions of works by Wilde and Beardsley; titles which in all fairness he probably still considered rightfully to be his own. Prospectuses which he put out for the 'limited' but never now quite sufficiently sumptuous editions to be published by 'Melmoth and Co.' (a name amusingly derived from Wilde's pseudonym adopted in exile, Sebastian Melmoth), or under other deliberately misleading

Antony Little (b.1942), untitled illustration, *c*.1967. Antony Little, Esq.

Like the illustrator Beresford Egan (1905–1984), who had drawn caricatures in the Beardsley manner to accompany his bitterly humorous writing in the inter-war period and well into the 1950s and 60s, Antony Little, who later became a celebrated designer of wallpapers, used a readily recognisable Beardsleyesque style to create illustrations with a satirical edge.

AUBREY BEARDSLEY

Paul Christadoulou (b.1937), Poster for Elliott's Shoes, 1967. Screen print. V&A E.343-1973

Much of the graphic design of the later 1960s was heavily influenced by the work of Beardsley. His imagery, either directly lifted, as in this example which borrows recognisable figures and other details from at least 18 original drawings, or adapted with more or less ingenuity, appeared on everything from posters, and carrier-bags to plastic aprons, mirrors and coffee mugs. Eventually overkill debased the images and the second 'Beardsley boom' subsided around 1972–3, to be replaced by a new craze for Art Deco.

imprints such as 'The Jesus Press', often contain an extra inserted printed sheet offering *Works by the late Mr Oscar Wilde*, among which feature *The Sphinx* (in an edition of 250, with 50 special copies on Japanese vellum) and *Salome* with Beardsley's illustrations in either duodecimo format or in a de luxe edition, similar to *The Sphinx* and priced at one guinea for ordinary copies or at two for the special Japanese vellum edition.

Now both these books of Wilde's were by this time Bodley Head properties, but Lane seems to have taken no action against Smithers or his sometime associate Nichols, even though both were regularly harried by other owners of infringed copyrights, including Robert Ross. What seems quite certain is that Lane would have been aware that Smithers was behind such piracies and would, equally, have known where to find him and how to make the legal moves needed to prevent his operations. Could it not simply and more plausibly be the case that the successful and well-capitalised Lane, having been frightened by the ferocity of public outrage during the scandals of 1895, and ever after distinctly cautious about his acknowledged stable of writers, found it more expedient to carry on at least some of the dubious, but still profitable trade in the Decadents through the agency of the financially troubled, but in this field nonetheless still well-connected Leonard Smithers?

In this way Lane could be seen to promote from Vigo Street the immortal works of Mrs Meynell, so full of beautiful and moral thoughtfulness, the

Martin Sharp (b.1942),
Toad of Whitehall; caricature of
Harold Wilson, from *Oz,*
March 1967. Offset lithography.
Stephen Calloway. Reproduced by
courtesy of Martin Sharp

The most intriguing of the
underground magazines of the late
sixties, *Oz* might plausibly be said to
have stood in the same relation to its
time as the *Yellow Book* had to the
1890s. The trial of its editors on the
charge that the magazine tended to
'deprave and corrupt' had the effect
of crystallising the ideals of a
generation, and of polarising
attitudes for and against those ideals,
in a way extraordinarily similar to
that of the trial of Oscar Wilde in
1895. Martin Sharpe, the best of the
'psychedelic' graphic designers,
whose work appeared on record
sleeves, posters and the pages of *Oz,*
employed imagery that reflected a
general Art Nouveau revival, but
here seems to borrow more
specifically from the look of the
Yellow Book, which had gained a new
currency following the 1966
exhibition at the V&A.

robustly patriotic poetry of William Watson, and all that was new, 'healthy' and vigorous in Edwardian verse and fiction. As the new century progressed, Lane's shop had ceased to be considered as a sink of iniquity, and Beardsley's reputation and artistic standing began quite distinctly to rise. Significantly, all the Bodley Head editions of Beardsley's works continued to use the 'acceptable' versions of each of the pictures. In the collections *The Early Work of Aubrey Beardsley* (first published in 1899, reissued in 1911–12) and *The Later Work* (1900, reissued 1911–12), made possible by Lane's official acquisition of Smithers's copyrights, which form Beardsley's 'official' monument, the *Salome* drawings were still given in their expurgated versions, while only the heavily censored excerpted details of the *Lysistrata* pictures appeared.

Similarly Lane's 1904 edition of *Under the Hill,* although it adds a number of the extra illustrations which were not included when Beardsley's uncompleted tale originally appeared in *The Savoy,* prints only a severely cut version of the text. It excludes many of the more outrageous and curious passages considered by Lane and his conservative advisers to be unpublishable at that time. Only with the issue of Smithers's still somewhat expurgated 1907 edition of three hundred copies ('for private circulation', poorly printed and lacking any illustrations at all), which reverts to Beardsley's favourite title, *The Story of Venus and Tannhäuser,* did it finally become possible to obtain anything even approaching a fuller version of the scurrilous but highly amusing text as Beardsley left it in his heavily worked holograph manuscript.

At just about the same time Wilde's claim to a lasting place in the world of letters, so carefully rehabilitated and nurtured by his tireless literary executor, Robbie Ross, had begun, slowly at first, to gain a new and more general acceptance. In particular the first publication in 1905 of Wilde's 'testament', *De Profundis*, seems to have initiated or a least ushered in a curious mood of contrition and desire for expiatory repentance that suited the temper of the times. It was a new pose that would come to affect a good many of the 'survivors' of the decadence of the nineties, and which set the prevailing tone until the moment when W. B. Yeats and other writers such as Holbrook Jackson, Bernard Muddiman and Osbert Burdett began to mythologise the period in a more romantic and overtly celebratory way.

Among other illustrators, Beardsley always had his admirers, but his was an art so idiosyncratic that mere imitation of his mannerisms must have seemed pointless. Most of those who tried to ape his style produced feeble work. There can be no doubt however that publishers, and in particular Lane, still wishing to bring out de luxe illustrated books for a lucrative market, actively sought a 'new Beardsley'. Some of these new illustrators, such as W. T. Horton, originally published by Smithers and at first promoted by W. B. Yeats, failed to fulfil their promise. Others such as John Austen and Harry Clarke, who drew to a greater or lesser degree in a Beardsleyesque manner, both prospered as their styles developed more towards the fantastic and decorative. In America Will Bradley, a poster artist of genius, built a career upon the foundations of Beardsley's most Art Nouveau phase. Perhaps Beardsley's most direct heir, however, was the strange German illustrator Hans Henning Voight who worked, mostly in London, under the single name of Alastair. His few highly charged essays in exquisite eroticism, beautifully printed editions of *The Sphinx*, *Salome*, *Manon Lescaut* and Pater's *Sebastian van Stork*, take not only Beardsley's mannered attenuation of form, but also his sense of evil and the very atmosphere of his perverse world as their given starting point. Published by Lane, they point the way to a new kind of exotic design and a new hothouse sensibility more immediately redolent of the 1920s.

That Beardsley's style was more or less inimitable was sadly proved by almost all those, and there were many, who attempted to fake his work. From the period immediately after the First World War, at a time when A. E. Gallatin and a number of other American collectors were beginning, really for the first time, to make Beardsley originals more valuable, forgeries began to abound. In 1919 a celebrated fraud was attempted when H. S. Nichols reappeared on the scene, claiming to have an important and sizeable cache of previously unknown Beardsley drawings. They were put on a show in New York. Considerable excitement was generated, especially when doubts about the authenticity of the works began to be voiced in several important quarters.

Denounced as fakes by Gallatin, Joseph Pennell and other connoisseurs, these hopelessly inept specimens of the forger's pen were vigorously defended by Nichols, who claimed in the *New York Evening Post*, 'I know a great deal more about Beardsley than either Mr Pennell or Mr Gallatin, but

I absolutely decline to make known to the world what I do know'. In fact, he claimed to have had more intimate dealings with the artist than even his erstwhile partner Smithers. The drawings, fifty in number, were published in an expensively produced album; like the Van Meegeren Vermeers, it is difficult now, with hindsight, to see how anyone could possibly have been taken in even then. But, in spite of a useful essay on *How to Detect Beardsley Forgeries* by the great Beardsley scholar R. A. Walker, which specifically alludes to these efforts at deception, examples from this very group and others of their like still circulate and surface from time to time. Sadly, the supposed genuine erotic drawings – the 'Levitical' set, said by Jack Smithers to

Love Life-Marijke Koger
18x23-Red & Black

Book a Trip-Marijke Koger
18x23-Green & Black

Love Bob Dylan-Marijke Koger
18x23-Red on Saffron

'Stomach Dancer' by Aubrey Beardsley
18x23-Black on White

Peacock Train' by Aubrey Beardsley
18x23-Black on White

'Danger Marihuana'
18x23- Black,Red,Yellow

The Lord's Prayer
18x23 Gold&Black

Friday? Good ! by Jacob & The Coloured Coat
18x23-Silver on Black

All posters 7/6 each.
Cheques & P.O.s to
J.L.T.Y. & Co.
49 Kensington Park Road
LONDON W.II.
Add 1/6 Postage to all
orders up to 12.

WHOLESALE
ENQUIRIES FOR POSTERS
AND BUTTON BADGES
INVITED.

The Head Shop advertisement for posters based on Beardsley designs, published in *Oz*, May 1967. Offset lithography. Stephen Calloway

Cheap offset lithography made decorative posters a phenomenon of the sixties. Used not for advertising purposes, but for the decoration of rooms. Beardsley was among the most popular of the artists whose work was revived for this purpose. Some posters were simply enlarged reprints of his original illustrations, whilst others were reworked using elements from one or more designs.

have been stolen from his father by Nichols – did not then, and have never subsequently come to light.

By the mid and later 1920s it is already possible to detect the earliest glimmerings of what can only be described as a first Beardsley revival. Among the dandy-aesthetes at Oxford, such as Harold Acton, in the novels – as well as in the personal affectations – of writers such as Ronald Firbank and in the tastes of youthful art historians such as the young Kenneth Clark there is a distinct sensibility sympathetic to Beardsley's perverse charm that is discernible. Clark recalled that the older generation at that time – presumably remembering the aura of unnameable sins which still hung over Wilde 'and his kind' – disapproved strongly; his housemaster at school, when he discovered Clark's attempts to draw in a pastiche Beardsleyesque manner, thundered, 'it's erotic and neurotic, and I won't have it in my house'. Kenneth Clark characterised Beardsley's work as it was then perceived: the drawings, he said 'not only lacked the manlier virtues; they positively suggested vice as a more interesting alternative; and they did so with an adolescent intensity which communicated itself through every fold and tightly drawn outline of an ostensibly austere style.'

Herein, thought Lord Clark, lay the reason for Beardsley's continuing interest and for the sudden dramatic rise in his popularity in the 1960s. It is certainly the case that when, by the twenties, almost all other aspects of Victorian art and culture were scorned, Beardsley's reputation never suffered that near total eclipse that dimmed the glorious figures of the Victorian era, such as Leighton, say, not to mention Millais. Perhaps it was because, just like Rossetti, his private life and personality and the inherently subversive nature of much of his art set him apart in death, as it had in life, from bourgeois culture.

Beardsley scholarship grew throughout this period. Books such as Burdett's *The Beardsley Period*, set the artist in a wider picture, whilst more specific studies such as Haldane MacFall's offered a rather more personalised and focused mix of reminiscence and analysis. But it was the researches and publications over a period of more than twenty years by R. A. Walker that put Beardsley studies on a new footing. Walker, who had been employed at the Bodley Head, where he prepared the monumental 1927 edition of *Le Morte Darthur*, laboured to collect the minutiae of Beardsley's existence. He interviewed the then elderly Ellen Beardsley, he rediscovered old family photographs, sought out lost drawings, and rescued Beardsley's only known attempt at oil painting, abandoned by the artist when he left the Cambridge Street house in 1895. Walker's great enterprise, a vast catalogue raisonné, to expand and supplant that of A. E. Gallatin was, however, never completed.

Although in the 1940s and 1950s a certain limited revival of interest in the 1890s, and in particular in the work of English and French writers including Wilde and Huysmans, was signalled by the publications of Martin Secker's Unicorn Press, these were the wilderness years for Beardsley, but a period of happy hunting for the few collectors such as Ralph Harari and W. G. Good who still prized his original drawings and the rare early editions of his books.

Gallery Five poster advertising decorative posters by Beardsley, Kay Nielsen and others, c.1967. Reproduced courtesy of Gallery Five. V&A E.1592-1974

Gallery Five was a more mainstream operation than many of the essentially underground producers of decorative posters. Reviving imagery by Beardsley and a number of his contemporaries and immediate successors, these decorative posters offended purists by their recolouring of images originally intended to be in black and white.

Then in the sixties interest in Beardsley's work received two at first unrelated stimuli. Kenneth Clark recalled selecting Beardsley as an interesting, if recherché subject upon which to lecture in 1965. By this time Brian Reade of the Victoria and Albert Museum's Department of Prints and Drawings was already preparing a large exhibition of Beardsley's books, prints and original drawings. Opening in 1966 this hugely popular and well-attended show launched a Beardsley boom no less extraordinary than that of 1893–4. Beardsley's distinctive linear style became the key element of a dramatic and widespread Art Nouveau revival. His imagery was everywhere, adapted to ornament everything from clothes to coffee mugs, plagiarised not just for the decoration of posters, wallpaper, record sleeves, carrier bags and the other phenomena of the new sixties lifestyle, but also reworked for the pages of magazines and in other graphic media, including film and animation.

At first, promoted by the mainstream fashion and journalistic world, Beardsley seemed to fit easily into the new Carnaby Street image of 'Swinging London'; Beardsleyesque clothes appeared, and even un-Beardsleyesque things used his imagery for promotional purposes, supplanting a previously more generalised use of 'Victoriana' motifs as an epitome of retro-chic. But Beardsley's work, and the world at which it hinted, also had a distinct and far more precise and appropriate appeal to the contemporary 'underground' and psychedelic culture which flourished between 1967 and 1972, the epicentre of which was to be found in Notting Hill Gate and the Portobello Road. Here were published a number of magazines such as *Oz* and *It*, and even more esoteric, small-circulation efforts, in the pages of which the influences of Art Nouveau in general, and Beardsley in particular, were clearly revealed. For the so-called 'alternative' generations, these graphic styles were used by 'hippy' designers such as Martin Sharp and Michael English to encode an anti-establishment, anti-modernist message.

In the same way, Beardsley's imagery, unlike that of almost any other 'historic' artist, (other perhaps than a few of the more obscure and bizarre of the Symbolists), was perceived as something subversive in itself and fascinating, not least for the way in which his characters seemed to offer role-models of overt sexuality, sexual ambiguity and self-proclaiming decadence. Such interpretations of Beardsley's life and character as appeared at this time seemed in an abstract way to confirm such a reading; the publication in 1966, for the first time openly, of editions of both the *Lysistrata* and, especially, of the complete unexpurgated text of *Under the Hill* removed all doubt.

With the inevitable passing of a temporary fashion, this phase of Beardsley's considerable, but essentially visual and quite unscholarly popularity waned, and subsequent books about him, including several biographical studies and, most importantly, the collected edition of his letters, tended to centre once again on a more historically based appraisal of his unique achievement. More recently still, by contrast, the newest Beardsley boom has been in interpretative studies of his art, seen in relation to themes of particular contemporary interest such as textual criticism and so-called 'gender issues'.

It is the fate of enduringly important artists and of all great art to be constantly interpreted and reinterpreted by succeeding ages, according to their intellectual lights and their canons of taste. Born into a conservative and supremely bourgeois century, but maturing, with a startling precociousness, in a heady *fin-de-siècle* era, it was Beardsley's lot to be mistaken at first, like Oscar Wilde's *Remarkable Rocket*, merely as a sensation, and condemned for his decadence and deliberate perversity. Having in our own century passed through periods of both neglect and over-popularity, of unthinking dismissal and of uncritical praise, it is to be hoped that at last, in his centenary year, and as we reach our own *fin-de-siècle*, that we may at last judge Aubrey Beardsley fairly and intelligently, appraise his genius less upon our terms than on his own, and accord him the position merited by his unique and inimitable abilities.

As Robert Ross said, 'at one time or another everyone has been brilliant about Beardsley'; but it was Ross himself who made, in the 'Eulogy' that he wrote immediately on hearing of his friend's death, one of the simplest and truest of all statements about the nature of Beardsley's genius: 'He has decorated white sheets of paper as they have never been decorated before.' His art was once described as 'a beautiful handwriting, a calligraphy of taste'; his life, like that of Keats was a caprice in the face of eternity. In Aubrey Beardsley the Aesthetic ideal found its truest expression.

ARS LONGA, VITA BREVIS

Chris James (b.1946), Animation cells for the film *After Beardsley*, 1982. Pen and ink on acetate film. Reproduced courtesy of Chris James. V&A E.431, 431a-1982

One of the most imaginative reinterpretations of Beardsley's imagery was a short animated work by the film-maker Chris James. Taking known images as a starting point, James imagined Beardsley brought up to date in a frightening, drug-haunted contemporary New York. The final powerfully realised scenes show Beardsley, clutching his crucifix, dying in a chilling hospital setting, surrounded by the paraphernalia of intensive care.

Working late at night when he had to be at his office during the day had at one time obliged Beardsley to draw in artificial light. It was A. W. King, his school housemaster, who had first shown him the advantages of this, demonstrating the greater beauty of a room illuminated only by the light from two candles rather than by the harsher glare of gas, and explaining how, once the eyes adjusted, immersion in a single pool of light could be a powerful aid to concentration. Working in this way had become for Aubrey a habit; ever after he preferred to work, even in the daytime, with his candles lit and the curtains drawn to exclude the daylight. Of course this also suited his consciously *à rebours* image.

A certain interest naturally attaches to Beardsley's working methods as a draughtsman. These were highly idiosyncratic, mainly, it appears, as a result of his lack of any serious instruction and his consequent invention of his own way of going about making a drawing. This was to remain essentially unchanged throughout his career, and though he did not ever like to be observed at work, there are accounts which accord very well with the evidence of the drawings themselves. By comparison with, for example, Charles Ricketts, one of his nearest rivals, who was a trained wood-engraver as well as a practised illustrator steeped in the old traditions of the trade, Beardsley remained essentially an amateur.

Robert Ross's description of the method Beardsley had evolved for himself is the best. He recalled that Beardsley

sketched everything in pencil, at first covering the paper with apparent scrawls, constantly rubbed out and blocked in again, until the whole surface became raddled from pencil, india-rubber, and knife; over this incoherent surface he worked always in Chinese ink with a gold pen, often ignoring the pencil lines, afterwards carefully removed. So every drawing was invented, built up, and completed on the same sheet of paper.

To this it might be added that he preferred always to work on a medium-grade cartridge paper, rather than the hard smooth 'Bristol board' more usually favoured by the illustrators of the day.

Putative Beardsley drawings on such board are almost invariably forgeries. Brian Reade believed that Beardsley preferred a Gillott's fine drawing nib; the exact nature of his celebrated 'gold pen' has never been established.

Many of Beardsley's original drawings reveal very clearly this method of work, the pencil work – incompletely erased – being still easily visible. Whilst a few designs reveal another drawing abandoned at an early stage on the reverse of the sheet, very few unfinished drawings, as such, have actually survived; generally it seems Beardsley either carried a drawing through to successful completion or destroyed it. It also appears that, by and large, in his earlier phases he worked upon one design at a time; later a letter to Leonard Smithers reveals that he had several sheets 'ready' at the pencil stage to be 'inked'. Rothenstein, one of the very few people that he ever allowed to sit with him for any length of time as he worked, vouched for the fact that he drew rapidly and with the greatest concentration and precision, but that he could also talk at the same time as drawing.

At the height of his powers he could draw very much to order; only later, in the last year or eighteen months of his life, did his concentration and ability to finish work become more capricious. His largest and best drawings mostly seem to have taken him two or three days of concerted work to complete; as a result he seems to have valued them at about ten pounds apiece. Once to Smithers he complains of having lost two whole days' work when a sheet was spoiled by getting damp and turning to 'the consistency of blotting paper'. Often, however, he had been able to make three, four or even more illustrations in a week. In the early days, under great pressure when trying to complete his 'weekly batch' of *Morte Darthur* designs for J. M. Dent, he was sometimes forced to dash off as many, rather hasty or sometimes downright slipshod chapter headings in a single night's session.

Comparisons with other illustrators' methods suggest that Beardsley in his mature years knew very precisely what he wanted to achieve and how to make the techniques of the photo-mechanical line-block work for his purposes. Many of his last letters to Smithers reveal a remarkable understanding of the subtleties of block-making and printing. Of the work of his contemporaries he also knew, perhaps, a great deal, but certainly cared for very little of it. Mantegna offered him more than Phil May, although he is said to have admired that most perceptive observer of the nineties scene for his very different fluency with the drawing pen. Of the older generation, the celebrated illustrators of the sixties, only the richly worked and often perverse literary illustrations of Frederick Sandys held any real fascination for Aubrey and allowed that artist to escape Beardsley's general condemnation of the 'old black and white duffers'.

Any listing of books by and about Beadsley necessarily runs to many pages; Mark Samuels Lasner's definitive bibliographical checklist of Beardsley's works fills more than a hundred close-printed pages, whilst Nicholas Salerno's exhaustive 'secondary bibliography' runs to more than fifteen hundred entries. The following highly selective list aims to be no more than a simple guide, giving references only to the basic tools of reference and some of the more useful or intriguing volumes that have appeared on the subject of Beardsley's life and work.

All books are published in London unless otherwise noted.

I MAIN WORKS OF REFERENCE

Vallance, Aymer. 'Iconography' [the first catalogue of the artist's drawings], *Aubrey Beardsley: A Book of Fifty Drawings* (Leonard Smithers 1897; rev. and repr. in Robert Ross, *Aubrey Beardsley*, John Lane 1909)

Gallatin, A. E. *List of Drawings by Aubrey Beardsley* (New York, Mansfield and Wessels 1900)

Gallatin, A. E. *Aubrey Beardsley's Drawings: A Catalogue and a List of Criticisms* (New York, A. S. Wieners 1903)

Gallatin, A. E. *Aubrey Beardsley: Catalogue of Drawings and Bibliography* (New York, The Grolier Club 1945; repr. by Paul Appel, New York 1980)

Reade, Brian. *Aubrey Beardsley*, with an introduction by John Rothenstein (Studio Vista 1967; repr. 1974, 1987, etc.)

Salerno, Nicholas A. 'Aubrey Beardsley: An Annotated Secondary Bibliography', in R. Langenfeld (ed.), *Reconsidering Aubrey Beardsley* (Ann Arbor, Mich., and London, UMI Research Press 1989)

Lasner, Mark Samuels. *A Selective Checklist of the Published Work of Aubrey Beardsley* (Boston, Mass., Thomas Boss 1995)

II ALBUMS AND COLLECTIONS OF THE DRAWINGS

Beardsley, Aubrey. *A Book of Fifty Drawings*, with the 'Iconography' by Aymer Vallance (Leonard Smithers 1897)

Beardsley, Aubrey. *A Second Book of Fifty Drawings* (Leonard Smithers 1899)

Beardsley, Aubrey. *The Early Work of Aubrey Beardsley*, with a prefatory note by H. C. Marillier (John Lane 1899; 2nd, rev. edn, 1912)

Beardsley, Aubrey. *The Later Work of Aubrey Beardsley* (John Lane 1901; 2nd, rev. edn, 1912)

Beardsley, Aubrey. *The Uncollected Work of Aubrey Beardsley*, with an introduction by C. Lewis Hind (John Lane 1925)

Walker, R. A. *Some Unkown Drawings of Aubrey Beardsley* (Bedford Park, R. A. Walker 1923)

Beardsley, Aubrey. *The Best of Beardsley*, collected and edited by R. A. Walker (Bodley Head 1948)

Wilson, Simon. *Beardsley* (Oxford, Phaidon Press 1976; rev. edn 1983)

Clark, Kenneth. *The Best of Aubrey Beardsley* (John Murray 1979)

III BEARDSLEY'S WRITINGS

Beardsley. Aubrey. *Under the Hill, and Other Essays in Prose and Verse* (John Lane 1904)

Beardsley. Aubrey. *The Story of Venus and Tannhäuser, a Romantic Novel* (for private circulation [Leonard Smithers] 1907)

Beardsley, Aubrey. *A Beardsley Miscellany*, selected and edited by R. A. Walker (Bodley Head 1949)

Beardsley, Aubrey. *Under the Hill* [the complete text] (Paris and London, Olympia Press: New English Library 1966)

Maas, Duncan and Good, eds. *The Letters of Aubrey Beardsley* (Cassell 1970)

IV EARLY BIOGRAPHICAL AND CRITICAL STUDIES

Symons, Arthur. *Aubrey Beardsley*: At the Sign of the Unicorn (1898; repr.1948 etc.; rev. and enlarged edn, J.M.Dent 1905, and as *The Art of Aubrey Beardsley*, New York, Boni & Liveright 1918; and repr. c.1925)

Ross, Robert. *Aubrey Beardsley*, with a rev. 'Iconography' by Aymer Vallance (John Lane 1909; repr.1921)

King. A.W. *An Aubrey Beardsley Lecture* (R. A. Walker 1924)

MacFall, Haldane. *Aubrey Beardsley: The Man and his Work* (John Lane 1928)

V LATER BIOGRAPHICAL STUDIES AND MONOGRAPHS

Stanford, Derek. *Aubrey Beardsley's Erotic Universe* (Four Square Books 1967)

Weintraub, Stanley. *Aubrey Beardsley: A Biography* (New York, George Brazilier 1967)

222 Brophy, Brigid. *Black and White* (Jonathan Cape 1968)

Easton, Malcolm. *Aubrey and the Dying Lady: A Beardsley Riddle* (Secker & Warburg 1972)

Brophy, Brigid. *Beardsley and his World* (Thames & Hudson 1976)

Weintraub, Stanley. *Aubrey Beardsley: Imp of the Perverse* (Pennsylvania State University Press 1976)

Benkowitz, Miriam. *Aubrey Beardsley: An Account of his Life* (Hamish Hamilton 1981)

Langenfeld, Robert, ed. *Reconsidering Aubrey Beardsley* (Ann Arbor, Mich., and London, UMI Research Press 1989)

Reade, Brian. *Beardsley Re-mounted* (The Eighteen-Nineties Society 1989)

Zatlin, Linda. *Aubrey Beardsley and Victorian Sexual Politics* (Oxford, Clarendon Press 1990)

Snodgrass, Chris. *Aubrey Beardsley: Dandy of the Grotesque* (Oxford, Oxford University Press 1995)

VI EXHIBITION CATALOGUES

The catalogues of most of the earlier exhibitions of Beardsley's works are little more than handlists of the shows.

London, Victoria and Albert Museum. *Aubrey Beardsley Exhibition: Catalogue of the original drawings, letters, manuscripts, paintings, books, posters, photographs, documents, etc.*, by Brian Reade and Frank Dickinson (HMSO 1966)

New York, Gallery of Modern Art. *Aubrey Beardsley: An Exhibition arranged by Brian Reade*, 1967

Tokyo, Tokyo Shinbun. *Aubrey Beardsley, 1872–1898: An Exhibition*, 1983

Munich, Villa Stuck. *Aubrey Beardsley in den 'Yellow Nineties', 1891–1898: Dekadenz oder Modernität*, with an essay by Rüdiger Kampmann, 1984

Milan, Palazzo Bagatti Valsecchi. *Aubrey Beardsley, 1872–1898* (Milan, Mazzotta 1985)

Rome, Galleria Nazionale d'Arte Moderna. *Aubrey Beardsley, 1872–1898*, 1985

London, Victoria and Albert Museum. *High Art and Low Life: 'The Studio' and the Artists of the 1890s*, eds. L. Lambourne and S. Calloway, 1993

Cambridge, Mass., The Houghton Library. *The Yellow Book: A Centenary Exhibition*, ed. Mark Samuels Lasner and Margaret Stetz, 1994

Cambridge University Library. *The Yellow Book, 1894–1897*, ed. S. J. Hills, 1994

VII GENERAL STUDIES OF THE 1890s WITH REMARKS ON BEARDSLEY

Meier-Graefe, Julius. *Modern Art*, trans. Symonds and Chrystal (William Heinemann 1908)

Jackson, Holbrook. *The Eighteen-Nineties* (Grant Richards 1913; rev. edn 1922)

Muddiman, Bernard. *The Men of the Nineties* (Henry Danielson 1920)

Burdett, Osbert. *The Beardsley Period* (John Lane, The Bodley Head 1925)

Rothenstein, John. *The Artist of the 1890s* (George Routledge 1928)

Mix, Katherine Lyon. *A Study in Yellow* (Kansas, University of Kansas Press 1960; repr. New York, Greenwood Press 1969)

Russell Taylor, John. *The Art Nouveau Book in Britain* (Methuen 1966; repr. Edinburgh, Paul Harris 1980)

Fletcher, Ian, ed. *Romantic Mythologies* (Routledge & Kegan Paul 1967)

James G. Nelson. *The Early Nineties: A View from the Bodley Head* (Cambridge, Mass., Harvard University Press 1971)

Beckson, Karl. *London in the 1890s* (New York, Norton & Co. 1992)

Houfe, Simon. *Fin-de-Siècle: The Illustrators of the Nineties* (Barrie & Jenkins 1992)

Sturgis, Mathew. *Passionate Attitudes* (Macmillan 1995)

VIII MEMOIRS CONTAINING SIGNIFICANT REFERENCES TO BEARDSLEY

The memoirs and biographies of many of the major or more minor figures of the period afford glimpses of Beardsley and his world; those of the following are particulary illuminating:

Max Beerbohm, Edward Burne Jones
 (in *Burne Jones Talking*, ed. Mary Lago),
J. M. Dent, John Gray (by Fr. Brocard Sewell),
C. Lewis Hind, John Lane (by J. Lewis May),
Richard Le Gallienne, Ada Leverson (by Violet Wyndham),
Robert Ross (by Maureen Borland),
William Rothenstein, Walter Sickert, Jack Smithers, Count
 Stenbock (by John Adlard),
Arthur Symons (by Roger Lhombreaud),
Netta Syrett, W. B. Yeats
 ('The Tragic Generation' in *Autobiographies*)
Oscar Wilde (by Richard Ellmann).